ABRAHAM IN MEDIEVAL CHRISTIAN, ISLAMIC AND JEWISH ART

INDEX OF CHRISTIAN ART

RESOURCES IV

ABRAHAM

IN MEDIEVAL CHRISTIAN, ISLAMIC AND JEWISH ART

Edited by

COLUM HOURIHANE

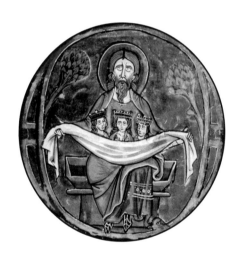

INDEX OF CHRISTIAN ART
DEPARTMENT OF ART & ARCHÆOLOGY
PRINCETON UNIVERSITY
in association with
PENN STATE UNIVERSITY PRESS
2013

DISTRIBUTED BY THE
PENNSYLVANIA STATE UNIVERSITY PRESS
820 NORTH UNIVERSITY DRIVE, USB 1, SUITE C
UNIVERSITY PARK, PA 16802

CONTENTS

ACKNOWLEDGEMENTS

ABRAHAM (Abram, Avraham, 'A<u>b</u>rāhām, Avrohom, Avruhom, Ibrāhīm) is the founder of the Abrahamic religions of Christianity, Judaism, and Islam, and is depicted in all three faiths. This fourth volume in the Index of Christian Art Resources series represents the collaboration of the Index with scholars of the two other great religions. Even though publications from the Index of Christian Art have not extended outside of the Index's own religious borders before, it is time that we did so!

The extensive files devoted to Abraham in the Index of Christian Art were developed over the ninety-five years of its existence, and many of those involved in the collection of these files have remained nameless. My thanks go to all of them for their input. There are also many Index contributors who can be named, including the current researchers in the archive, Lois Drewer (who died before this was published), Judith Golden, Adelaide Hagens, Beatrice Radden Keefe, Jessica Savage, and Henry Schilb. All have contributed much to these files and my thanks go to them. Robin Dunham worked on the files before she left the Index, and her work was ably continued by Fiona Barrett, and I thank both for all their help. Fiona checked all the entries and contributed significantly to the final publication. John Blazejewski, the Index photographer, and Jon Niola, our Database Manager, also assisted in many ways and thanks go to both of them for meeting my requests with charm and ease.

The entries in the Islamic art section of this volume were developed by Rachel Milstein from the Hebrew University of Jerusalem, one of the foremost experts on Islamic iconography. Although images of Abraham are not found in large numbers in the Islamic faith of the medieval period, representations of him are an intrinsic part of the visual legacy of Islam, and my thanks go to Rachel for all of her work, which reflects her extensive knowledge of the subject. The Islamic section of the catalogue goes beyond our medieval time frame and includes works from the eighteenth century.

The Bezalel Narkiss Index of Jewish Art (formerly the Jerusalem Index of Jewish Art), based at the Center for Jewish Art, Jerusalem, is committed to the preservation of the artistic heritage of the Jewish people. The Index of Jewish Art was founded in 1979 by the late Bezalel Narkiss, Israel Prize laureate, who used the Index of Christian Art as his model. We at the Index of Christian Art have looked affectionately

on this archive as our younger sister. Catalogue holdings on Abraham from the rich files of the Index of Jewish Art were compiled by Ariella Amar and Michal Sternthal of the Center for Jewish Art, Hebrew University of Jerusalem. The files on Abraham in the Index of Jewish Art are extensive, and I am grateful to my colleagues there for willingly sharing them with us in this publication. In particular, I wish to thank Aliza Cohen-Mushlin, Ariella Amar, and Michal Sternthal, as well as the entire staff of the Center for all their work in getting these files to a publishable state.

I should also like to thank the Morgan Library and Museum in New York, whose images are used extensively in this book, for generously giving of their resources for this publication. Catherine Jolivet Lévy also provided images from her extensive collection and my thanks go to her.

This volume could not be in the state you now see it without the help and guidance of Mark Argetsinger, who has served the Index as copy-editor and designer for the last seven or so years. He has painstakingly edited these entries and improved accuracy, completeness, and consistency, and my thanks go to him for all his help.

This volume is gratefully dedicated to Rosalie Green, former Director of the Index of Christian Art (1917–2012), who died at the age of ninety-four years a few months ago, and who gave her life and scholarship to the development of the archive. Many of the files found in this volume were created under her direction.

—COLUM HOURIHANE
Index of Christian Art

INTRODUCTION

ABRAM (The Father is Exalted), who was later to be called Abraham (The Father of the Many), was the son of Terah (a descendant of Noah through Shem) or Azar (in the Muslim faith), and founder of the Hebrew Nation. He was brother to Nahor and Haran, as well as husband to Sarai (later Sarah) and uncle to Lot. Born in Ur, in Chaldaea, he died in Haran (Gen. 11:32), although the modern-day locations of these sites are disputed amongst the various religions.

Abraham left Ur in Mesopotamia (Ur Kasdim, according to the Hebrew text, which is believed to be the modern-day Tall al-Muqayyar, some 200 miles southeast of Baghdad) to found a new nation that God had ordained. He traveled to Canaan (Gen. 12:1), but first stopped at Haran in Upper Mesopotamia (in the Balikh Valley in modern-day Harran, Turkey), where Terah died at the age of 205 years (Gen. 15:7). It was in Bethel (present-day Baytin, north of Jerusalem) that he next stopped and "built an altar to the Lord, and called upon his name" (Gen. 12:8). It was at Mamre that Abraham became a prosperous shepherd, despite being a septuagenarian. It was also here that he received the word that his race would live on. He entered into a covenant with God whereby he had but to obey God's command so that his offspring would be the nation of all people. Despite his many journeys, Abraham was still destined to travel. He left Canaan before famine struck and brought his wife and family to Egypt. Here, he lied about Sarah's identity when Pharaoh expressed a desire for her, telling him that she was his unmarried sister. Abraham's deceit and Pharaoh's lust brought pestilence and disease upon Pharaoh, who was told that Sarah must be returned untouched to Abraham. Returning from Egypt, Abraham saved Lot from imprisonment by Chedorlaomer, king of Elam, and was anointed by Melchizedek, king of Salem.

While still married to Sarah, at her behest, Abraham slept with Hagar who was her maidservant. Hagar gave birth to Ishmael. At the age of ninety-nine years God returned to Abraham to announce that he would again be a father and a year later Isaac was born to Sarah. Abraham's life is characterized by a series of tests, many of which were self inflicted. He was to lie a second time about Sarah's identity—this time to King Abimelech, who also desired her because of her beauty. His greatest test came when God commanded him to sacrifice his son Isaac. On the verge of killing Isaac, God intervened and substituted a ram for the intended victim. After Sarah's death, he bought the Cave of Machpelah

near Hebron as a burial place. He died at the age of 175 years and was buried at the Cave of Machpelah with Sarah.

Abraham's life is described in Genesis (2:26–17:5), and references to him are found in Exodus 2:24, Acts 7:2–8, Romans 4, and Hebrews 2, 6, 7, 11, where he is described variously as a man of steadfast faith, and as a human character who was willing to do whatever was needed to save his own skin. His entire life narrative is underpinned by his faith in God's will. It was a faith that, while frequently tested, was unwavering in its strength.

Venerated in the Christian, Jewish, and Islamic religions, Abraham's iconography differs between faiths, but there is also considerable overlap. In the Jewish faith, Abraham is seen as the First Patriarch and founder of Hebrew Monotheism. In destroying all the idols in his father's workshop—except for the largest image—he is seen as believing in one God and rejecting false worship. It was King Nimrod who forced him, because of his heretical views, into the fiery furnace from which he emerged untouched. These are scenes that are represented in the Jewish faith but not elsewhere. It was also the Rabbinic tradition that gave rise to the term "Bosom of Abraham," which, however, is not represented in Jewish iconography. The term's origins lie in the Parable of Dives and Lazarus, which states, "and it came to pass that the beggar died and was carried by the angels into Abraham's bosom" (Luke 16:22). The term is usually taken as symbolic of the Limbo of the Patriarchs, or else of Heaven itself. At its core lies the belief that upon death the souls of the faithful are welcomed by Israel's ancestors, including Abraham, Isaac, and Jacob. In the Index of Christian Art this iconography is called "Abraham, representing Paradise."

Abraham is depicted most extensively in Christianity, and the Index of Christian Art is able to represent his near complete life narrative. As in Judaism and Islam, Abraham is seen in Christianity as a model of obedience and belief, but his sacrifice of Isaac is usually seen as a prefiguration of Christ's sacrifice on the cross. In much the same way as Abraham was willing to sacrifice his own son, God the Father sacrificed his son on Golgotha. Patron saint of hospitality, it is the strength of Abraham's beliefs that is held as a model for successive generations in the Christian Church. This was initially described by Paul (Romans 4:11, Galatians 3:7), and Abraham was held by successive early Christian Fathers as a model of faith and belief in the Lord. Abraham is commemorated in the calendars of saints in the Coptic Church (August 28th), the Maronite Church (August 20th), and the Roman Catholic Church (October 9th and October 22nd).

The Muslim faith regards Abraham, or Ibrahim, as the Father of Islam, which faith is frequently referred to as Millat Ibrahim (the Faith

of Ibrahim). He is celebrated as a prophet and apostle and once again it is his unbending faith that lies at the core of his veneration. Not only is Abraham seen as the Father of Islam, but he is also characterized as a compassionate and caring person of the highest moral standing—a role model for life. He is referred to in the Qur'an as a prophet and as an ideal to which to aspire. He is believed to have had many children and to have been married to Sarah and Hagar. Abraham is recognized in the Muslim faith as having considerable wisdom and knowledge, and that from a very young age. In one of the earliest episodes in his life narrative, he preaches to his father on the perils of idolatry. He credits his knowledge to God who had communicated with him. Despite his warnings, Abraham's father refuses to correct his ways and eventually Abraham has nothing more to do with him. He has another argument with his followers who refuse to follow Abraham's belief in one god, and when he destroys all except for the largest idol some legends recall that his followers were cross with him and threw him into a fire. God protected Abraham and, instead of burning him, the fire cooled and calmed Abraham and he was unhurt.

The sacrifice of his son is also central to the Muslim faith, but, unlike Judaism and Christianity, Islam believes that his son was also aware of his father's need to sacrifice him and was willing to die. At the last moment, the son, who is generally believed to have been Ishmael rather than Isaac, was replaced with either a ram, sheep, or a goat. In the Qur'an, Isaac's birth is recorded after this episode, leading scholars to suppose that it was Ishmael who was the intended sacrifice rather than Isaac. Abraham's near sacrifice of his son is commemorated at Eid al-Adha every year when a sheep is slaughtered. Another variant from the Bible is found when the birth of Isaac (and a grandson named Jacob) is announced. It is three angels who make the announcement and they are offered a substantial meal of a calf, which they refuse to eat. Abraham, in old age, is also credited with founding the Kaaba—the chief mosque in Islam—in Mecca. It was there that Abraham prayed and spent the rest of his life with his family.

A popular subject in both the eastern and western world, depictions of Abraham are first found in the early Christian period, where he is well represented on sarcophagi, in catacombs, on glass, and in manuscripts. The most popular scenes at this early stage are Abraham Entertaining the Angels and the Sacrifice of Isaac, which were to remain in this premier position for the entire medieval period—most popular of all scenes, and central to all three religions, is the Sacrifice of Isaac. This scene is closely followed in frequency by Abraham Entertaining the Angels (called The Hospitality of Abraham in Jewish art), and The Bosom of Abraham (called Representing Paradise in the Index

files). Only one or two examples are found, however, of the Journey to Gerar, the Instruction of Sarah, or the Marriage with Keturah. It is not clear why some episodes from his life narrative were chosen over others and why some fell out of popularity. Abraham's greatest popularity in the Christian faith seems to have been in the Anglo-Saxon period, when, along with better-known episodes of his life, minor scenes are frequently found. In general, there are comparatively few examples of extended episodes of Abraham's life. One of the longest cycles is that from the choir at Erfurt Cathedral, which dates to the second half of the fourteenth or early fifteenth century.

Usually depicted as an aged man with a long, white, flowing beard, Abraham's attribute is often the knife with which he was to sacrifice Isaac, although the visual repertoires between Judaism, Christianity, and Islam differ considerably. Seen as a patriarch in all three faiths, he is prominently placed as a symbol of steadfast faith and belief in God. His gentle and compassionate nature is stressed in all three faiths and his role as a model is to the fore.

It is hoped that these collections of references will provide the basis for future research on Abraham and enable us to better understand his central role in Christianity, Islam, and Judaism. It is also hoped that these files will unite the study of medieval iconography across religious boundaries and enable us to better understand similarities rather than differences.

ABRAHAM IN
MEDIEVAL CHRISTIAN, ISLAMIC
AND JEWISH ART

LIST OF ABRAHAM SCENES IN THE INDEX
OF CHRISTIAN ART CATALOGUE

The following sixty-two subject terms are used to classify representations of
Abraham in The Index of Christian Art

1. Abraham. Göreme, El Nazar Kilise, fresco in chapel, naos, vault of the west arm. Cappadocian, 2nd quarter of the twelfth century (photo: Catherine Jolivet Lévy).

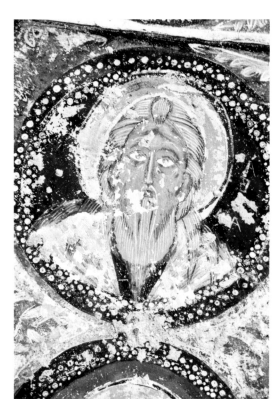

2. Abraham. Göreme, Karanlik Kilise, fresco in sanctuary, south apse. Cappadocian, middle of the eleventh century (photo: Catherine Jolivet Lévy).

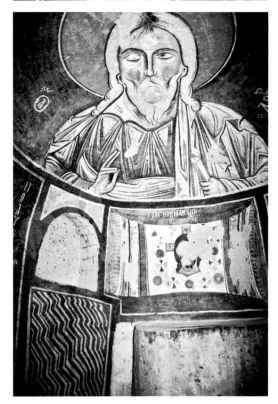

CATALOGUE OF ABRAHAM SCENES IN THE INDEX OF CHRISTIAN ART

Abraham

ENAMEL

Klosterneuburg: Monastery
Retable
Date: 1181

Randazzo: Church, Sta. Maria
Chalice (silver-gilt)
Date: 2nd half 14th cent.

Xanten: Cathedral, St. Victor
Plaques (on portable altar)
Date: 1175–1185

FRESCO

Abu Gosh: Church
Aisle, south
Date: 1165–1175

Arilye: Monastery, Church of St. Achillius
Crossing
Date: late 13th–14th cent.

Bawit: Monastery, St. Apollo
Chapel VI
Date: 500–699

Bawit: Monastery, St. Apollo
Chapel VIII, south wall
Date: 500–699

Cologne: Church, St. Maria-Lyskirchen
Nave
Date: mid 13th cent.

Dura-Europos: Synagogue
Decoration, west wall, zone 2, no. 3
Date: 245–256

Florence: Church, Sta. Maria Novella
Chapel, Strozzi
Date: 14th cent.

Göreme: Chapel, El Nazar Kilise
Naos, west arm, vault
Date: 2nd quarter 12th cent. (Fig. 1)

Göreme: Church, Karanlik Kilise
sanctuary Apse, south,
Date: mid 11th cent.
(Fig. 2)

Hildesheim: Church, St. Michael
Nave
Date: 2nd quarter 13th cent.

Homs: Church, Mar Elian
Nave, south wall
Date: 12th–13th cent.

Karan: Church, Annunciation
Naos
Date: 1300–1349

Lambach: Church, Stiftskirche
Choir, west
Date: 1080–1099

Lipna: Church, St. Nicholas
Decoration
Date: 1292–1300

Naples: Church, Sta. Maria di Donna Regina
Nave
Date: 1st half 14th cent.

Novgorod: Church, St. Theodore Stratilates
Choir
Date: 14th–15th cent.

Orvieto: Cathedral, Sta. Maria Assunta
Choir
Date: 14th–15th cent.

Padua: Baptistry
Decoration
Date: late 14th cent.

Padua: Church, S. Antonio
Felice Chapel
Date: 2nd half 14th cent.

Pera Chorio: Church, Apostles
Sanctuary
Date: 1160–1180

Pistoia: Casa Tonini
Decoration
Date: 2nd half 14th cent.

S. Giovanni Valdarno: Gallery, Pinacoteca Parrocchiale
Polyptych
Date: 1350–1399

(5)

Santa Maria di
Vezzolano: Abbey
Nave
Date: 1189

Sennevières: Chapel,
St.-Jean du Liget
Decoration
Date: 12th–early 13th
cent.

Sigena: Monastery,
Chapter House
Date: 12th–13th cent.

Sopoćani: Church,
Trinity
Crossing
Date: 1250–1299

Volotovo: Church,
Assumption
Crossing
Date: 1363

Wadi al-Natrun: Mon-
astery, Deir Abu Maqar
Qasr (Keep),
Chapel of the Hermits,
north wall
Date: 1517

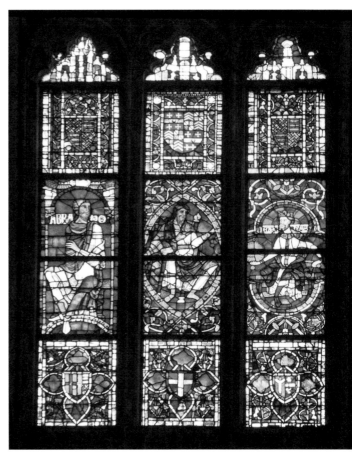

Werden: Church,
Peterskirche
Aisle
Date: 943–1040

Winchfield: Church,
St. Mary
Nave
Date: 13th cent.

GLASS

Canterbury: Cathedral,
Christ
Clerestory, northeast
transept, east window
Date: c. 1180 (Fig. 3)

Canterbury: Cathedral,
Christ
Window 3, choir, aisle N
Date: 12th–13th cent.

Canterbury: Cathedral,
Christ
Southwest transept,
South window
Date: 12th–14th cent.

Cologne: Cathedral
Window, Kapitelsaal
Date: 1st half 14th cent.

Cologne: Cathedral
Window, Magi Chapel
Date: late 13th cent.

Legden: Church
Window
Date: 13th cent.

Rouen: Church, St.-Ouen
Window 1, choir
clerestory
Date: 14th cent.

Strasbourg: Cathedral
Windows, south transept
Date: 13th cent.

Wells: Cathedral,
St. Andrew
Windows, choir
Date: 1st half 14th cent.

Wells: Cathedral,
St. Andrew
Window, Lady Chapel
Date: early 14th cent.

ILLUMINATED
MANUSCRIPT

Abbeville: Library, Bibl.
de la Ville, 4
Gospel Book of Charle-
magne, fol. 18r
Date: 790–814

3. Abraham, seated (*left panel*). Stained glass from Canterbury Cathedral, clerestory, northeast transept, east window, *c.* 1180 (photo: Colum Hourihane).

Belgrade: Library,
Narodna Bibl., 297
Gospel Book, Serbian,
fol. 90ᵛ
Date: 13th cent.

Berlin: Museum,
Staatliches Museen,
Kupferstichkab., 78.A.6
Psalter, fol. 2ᵛ
Date: 2nd half 12th cent.

Boulogne: Library, Bibl.
de la Ville, 11
Gospel Book, fol. 10ᵛ
Date: c. 980–990

Boulogne: Library, Bibl.
de la Ville, 14
Gospel Book, 1, fol. 22ᵛ
Date: 12th cent.

Cambridge: Library, Cor-
pus Christi College, 83
Miscellany, fol. 3ʳ
Date: 13th cent.

Cambridge: Library,
Trinity College, R.17.1
Canterbury Psalter,
fol. 135ʳ
Date: mid 12th cent.

Cambridge: Library,
Trinity College, R.17.1
Canterbury Psalter,
fol. 185ʳ
Date: mid 12th cent.

Cambridge: Library,
Trinity College, R.17.1
Canterbury Psalter,
fol. 277ᵛ
Date: mid 12th cent.

Cambridge: Museum,
Fitzwilliam, 20
Miscellany, fol. 1ʳ
Date: 1323

Cambridge: Museum,
Fitzwilliam, 20
Miscellany, fol. 2ʳ
Date: 1323

Cambridge: Museum,
Fitzwilliam, 20
Miscellany, fol. 3ʳ
Date: 1323

Cleveland: Museum of
Art, 73.5
Peter of Poitiers, *Compen-
dium Veteris Testamenti*
Date: 13th cent.

Cologne: Archive, Stad-
tarchiv, wf 276a
Speculum Virginum, fol. 55ʳ
Date: 12th cent.

Douai: Library, Bibl.
Municipale, 257
Augustine, *De Trinitate*
Date: 12th cent.

Florence: Library, Bibl.
Laurenziana, Plut. VI.23
Gospel Book, fol. 138ʳ
Date: 11th cent.

Florence: Library, Bibl.
Laurenziana, Plut. VI.23
Gospel Book, fol. 186ᵛ
Date: 11th cent.

Florence: Library, Bibl.
Laurenziana, Plut. XVI.21
Burchardus of Worms,
Collectio Canonum,
fols. 3ᵛ, 4ʳ
Date: 11th cent.

Heidelberg: Library,
Univ.-Bibl., Sal. X.16
Hildegardis, *Tiber Scivias*,
fol. 111ᵛ
Date: 12th – 13th
cent.

Ivrea: Library, Bibl.
Capitolare, 86
Sacramentary of
Warmundus, fol. 24ᵛ
Date: 969–1002

Kraców: Museum, Czar-
toryski, 1207
Gospel Book, fol. 8ʳ
Date: late 11th cent.

Kremsmünster: Library,
Stiftsbibl., 243
*Speculum Humanae Salva-
tionis*, fol. 56ᵛ
Date: 1st half 14th cent.

Leiden: Library, Bibl.
der Universiteit,
Voss. lat. oct. 15
Prudentius, *Psychomachia*,
fol. 2ʳ
Date: 11th cent.

Lilienfeld: Library,
Stiftsbibl., 151
Ulrich of Lilienfeld,
Concordantiae caritatis,
fol. 13ᵛ
Date: mid 14th cent.

Lilienfeld: Library,
Stiftsbibl., 151
Ulrich of Lilienfeld,
Concordantiae caritatis,
fol. 25ᵛ
Date: mid 14th cent.

Lilienfeld: Library,
Stiftsbibl., 151
Ulrich of Lilienfeld,
Concordantiae caritatis,
fol. 72ᵛ
Date: mid 14th cent.

Lilienfeld: Library,
Stiftsbibl., 151
Ulrich of Lilienfeld,
Concordantiae caritatis,
fol. 76ᵛ
Date: mid 14th cent.

Lilienfeld: Library,
Stiftsbibl., 151
Ulrich of Lilienfeld,
Concordantiae caritatis,
fol. 115ᵛ
Date: mid 14th cent.

London: Library, British,
Add. 19352
Theodore Psalter, fol. 44ᵛ
Date: 1066
Attribution: Theodore
the Studite

London: Library, British,
Add. 19352
Theodore Psalter,
fol. 109ᵛ
Date: 1066
Attribution: Theodore
the Studite

London: Library, British,
Add. 39627
Gospel Book of John
Alexander, fol. 6ʳ
Date: 1356

London: Library, British,
Add. 47682
Holkham Picture Bible,
fol. 10ʳ
Date: 1320–1330

London: Library, British,
Add. 47682
Holkham Picture Bible,
fol. 10ᵛ
Date: 1320–1330

London: Library, British,
Arundel 44
Speculum Virginum, fol. 70ʳ
Date: 12th cent.

London: Library, British,
Arundel 83, 1
Howard Psalter, fol. 14ʳ
Date: 1310–1320

London: Library, British,
Burney 3
Bible, Robert of Battle,
fol. 402ʳ
Date: 13th cent.

London: Library, British,
Cott. Claudius B.IV
Ælfric, *Paraphrase*,
fol. 19ᵛ
Date: 1025–1049

London: Library, British,
Cott. Claudius B.IV
Ælfric, *Paraphrase*, fol. 20ʳ
Date: 1025–1049

London: Library, British,
Cott. Claudius B.IV
Ælfric, *Paraphrase*,
fol. 28ʳ
Date: 1025–1049

London: Library, British,
Cott. Claudius B.IV
Ælfric, *Paraphrase*,
fol. 38ᵛ
Date: 1025–1049

London: Library, British,
Cott. Otho B.VI
Cotton Genesis, fol. 23ᵛ
Date: 400–599

London: Library, British,
Egerton 1894
Genesis, fol. 6ʳ
Date: 14th cent.

London: Library, British,
Egerton 1894
Genesis, fol. 6ᵛ
Date: 14th cent.

London: Library, British,
Egerton 1894
Genesis, fol. 10ʳ
Date: 14th cent.

London: Library, British,
Egerton 1894
Genesis, fol. 11ʳ
Date: 14th cent.

London: Library, British,
Harley 603
Psalter, fol. 52ᵛ
Date: *c.* 11th–12th cent.

London: Library, British,
Harley 1526-27
Bible, Moralized, II,
fol. 99ʳ
Date: 1st half 13th cent.

London: Library, British,
Lansdowne 383
Shaftesbury Psalter,
fol. 15ʳ
Date: 1130–1140

Los Angeles: Univ. of
Calif., Research Library,
Armenian 1
Gladzor Gospels,
p. 28
Date: 1300–1307

Los Angeles: Museum,
Getty, 64/97.MG.21
Stammheim Missal,
fol. 11ʳ
Date: 1170–1180

Madrid: Library, Bibl.
Nacional, E.R.8
Bible, Ávila, fol. 1ᵛ
Date: 11th–13th cent.

Milan: Collection,
Trivulzio, 2139
Bible, fol. 435ʳ
Date: 14th cent.

Milan: Library, Bibl.
Ambrosiana, E.49-50 inf.
Gregory Nazianzen,
Homilies, p. 422
Date: 800–899

Milan: Library, Bibl.
Ambrosiana, E.49-50 inf.
Gregory Nazianzen,
Homilies, p. 597
Date: 800–899

Milan: Library, Bibl.
Ambrosiana, E.49-50 inf.
Gregory Nazianzen,
Homilies, p. 660
Date: 800–899

Milan: Library, Bibl.
Ambrosiana, E.49-50 inf.
Gregory Nazianzen,
Homilies, p. 664
Date: 800–899

Mount Sinai: Monastery
Library, 48
Psalter, fol. 53ᵛ
Date: 1074

Munich: Library, Staats-
bibl., Clm. 4453, Cim. 58
Gospel Book of Otto III,
fol. 25ᵛ
Date: 10th–11th cent.

Munich: Library, Staats-
bibl., Clm. 13601, Cim. 54
Gospel Book of Uta,
fol. 5ᵛ
Date: 11th cent.

New York: Library,
Morgan, M. 12
Hours, fol. 25ᵛ
Date: 1495–1505

New York: Library,
Morgan, M. 192
Giovanni da Udine,
*Compilatio Historium Totius
Biblae et Historiarium
Scholasticarum*, fol. 6ᵛ
Date: *c.* 1420
(Fig. 4)

New York: Library,
Morgan, M. 315
Hours, fol. 11ʳ
Date: *c.* 1400

New York: Library,
Morgan, M. 689
Peter of Poitiers,
*Compendium Historiae in
Genealogia Christi*, fol. 4ʳ
Date: 14th cent.
(Fig. 5)

New York: Library,
Morgan, M. 748
Gospel Book,
fol. 132ʳ
Date: 1000–1099

New York: Library,
Morgan, M. 751
Peter of Poitiers,
*Compendium Historiae in
Genealogia Christi*, fol. 1ʳ
Date: 1300–1310

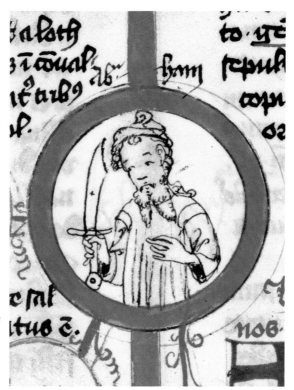

4. Abraham, half-figure, holding saber. Miniature from
Giovanni da Udine, *Compilatio Historiarum Totius Bibliae et
Historiarum Scholasticarum*, now in The Morgan Library and
Museum, New York, Ms. M. 192, fol. 6ᵛ. Austrian, *c.* 1420
(photo: Morgan Library and Museum).

New York: Library,
Morgan, M. 803
Lectionary, fol. 332ʳ
Date: 1334
(Fig. 6)

Oxford: Library,
Bodleian, Auct. D.3.4
Bible, fol. 3ᵛ
Date: 1st half 14th cent.

Oxford: Library,
Bodleian, Auct. D.4.4
Psalter, fol. 107ᵛ
Date: 2nd half 14th cent.

Oxford: Library,
Bodleian, Auct. D.4.4
Psalter, fol. 122ᵛ
Date: 2nd half 14th cent.

Paris: Library, Bibl. de
l'Arsenal, 591
Gospel Book, fol. 14ᵛ
Date: 12th cent.

Paris: Library, Bibl.
Nationale, gr. 64
Gospel Book, fol. 10ᵛ
Date: 1000–1099

Paris: Library, Bibl.
Nationale, gr. 74
Gospel Book, fol. 1ʳ
Date: 1000–1099

Paris: Library, Bibl.
Nationale, gr. 923
John of Damascus,
Sacra Parallela, fol. 252ʳ
Date: 800–899

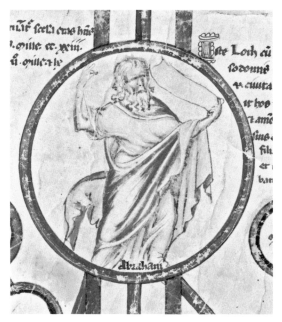

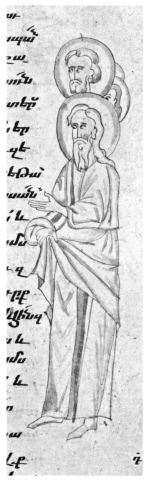

5 (*above*). Abraham. Three-quarter length figure from Peter of Poitiers, *Compendium Historiae in Genealogia Christi*, now in The Morgan Library and Museum, New York, Ms. M. 689, fol. 4ʳ. Italian, 14th century (photo: Morgan Library and Museum).

6 (*right*). Abraham before heads of nimbed prophets. Full-length figure from an Armenian Lectionary, now in The Morgan Library and Museum, New York, Ms. M. 803, fol. 332ʳ. Armenian, Vahnashen, 1334 (photo: Morgan Library and Museum).

Paris: Library, Bibl. Nationale, gr. 923
John of Damascus, *Sacra Parallela*, fol. 387ᵛ
Date: 800–899

Paris: Library, Bibl. Nationale, Nouv. Acq. Lat. 2334
Ashburnham Pentateuch, fol. 18ʳ
Date: 550–699

Paris: Library, Bibl. Nationale, Nouv. Acq. Lat. 2334
Ashburnham Pentateuch, fol. 21ʳ
Date: 550–699

Paris: Library, Bibl. Nationale, Supp. Turc. 190
Mirajnama, fol. 5ᵛ
Date: 1400–1499

Paris: Library, Bibl. Nationale, Supp. Turc. 190
Mirajnama, fol. 7ʳ
Date: 1400–1499

Paris: Library, Bibl. Nationale, Supp. Turc. 190
Mirajnama, fol. 28ᵛ
Date: 1400–1499

Prague: Library, University, XIV.A.13 —*cont.*

Pericope, Vyšehrad, fol. 2ʳ
Date: 11th cent.

Prague: Library, University, XXIII.C.124
Velislaus Miscellany, fol. 19ᵛ
Date: 14th cent.

Prague: Library, University, XXIII.C.124
Velislaus Miscellany, fol. 26ʳ
Date: 14th cent.

Princeton: Library, University, Garrett 40
Carmelite Missal —*cont.*

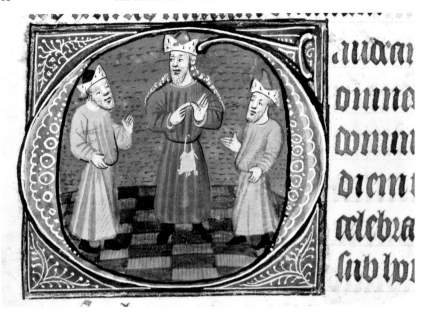

7. Abraham flanked by Isaac and Jacob. Carmelite Missal of Nantes, now in Princeton University Library, Ms. Garrett 40, fol. 208ʳ. French, *c.* 1442–1450 (photo: Princeton University Library).

of Nantes, fol. 208ʳ
Date: *c.* 1442–1450
(Fig. 7)

Rome: Library, Bibl.
Vaticana, Barb. gr. 372
Barberini Psalter,
fol. 141ᵛ
Date: 1050–1099

Rome: Library, Bibl.
Vaticana, gr. 746
Octateuch, fol. 76ʳ
Date: 1100–1199

Rome: Library, Bibl.
Vaticana, gr. 747
Octateuch, fol. 34ʳ
Date: 11th cent.

Rome: Library, Bibl.
Vaticana, gr. 747
Octateuch, fol. 340ᵛ
Date: 11th cent.

Rome: Library, Bibl.
Vaticana, gr. 1156
Lectionary, fol. 273ʳ
Date: 11th cent.

Rome: Library, Bibl.
Vaticana, gr. 1613
Menologium of Basil II,
p. 146
Date: 976–1025

Rome: Library, Bibl.
Vaticana, gr. 1613
Menologium of Basil II,
p. 250
Date: 976–1025

Rome: Library, Bibl.
Vaticana, gr. 1613
Menologium of Basil II,
p. 372
Date: 976–1025

Rome: Library, Bibl.
Vaticana, Pal. lat. 565
Speculum Virginum,
fol. 71ʳ
Date: 12th–13th cent.

Rome: Library, Bibl.
Vaticana, Ross. 135–138
Gospel Book, 1, fol. 4ʳ
Date: 11th cent.

Rome: Monastery,
S. Paolo fuori le Mura
Bible, fol. 49ᵛ
Date: *c.* 870

Rovigo: Library,
Bibl. Accademia dei
Concordi, 212
Picture Bible, fol. 14ʳ
Date: 14th cent.

Rovigo: Library,
Bibl. Accademia dei
Concordi, 212
Picture Bible, fol. 14ᵛ
Date: 14th cent.

Rovigo: Library,
Bibl. Accademia dei
Concordi, 212
Picture Bible, fol. 16ʳ
Date: 14th cent.

Saint-Omer: Library,
Bibl. Municipale, 56
Gospel Book, fol. 36ʳ
Date: early 11th cent.

Smyrna: Library,
Evang. School, A.1
Octateuch, fol. 32r
Date: 12th cent.

Smyrna: Library,
Evang. School, A.1
Octateuch, fol. 35v
Date: 12th cent.

Troyes: Library,
Bibl. Municipale, 252
Speculum Virginum, fol. 70r
Date: 12th–13th cent.

Utrecht: Library, Bibl.
der Universiteit, 32
Psalter, fol. 45r
Date: 820–835

Utrecht: Library, Bibl.
der Universiteit, 32
Psalter, fol. 60v
Date: 820–835

Utrecht: Library, Bibl.
der Universiteit, 32
Psalter, fol. 89r
Date: 820–835

Vienna: Library,
Nationalbibl., 341
De origine monachorum,
fol. 1v
Date: late 14th cent.

Vienna: Library,
Nationalbibl.,
Hist. gr. 6
Menologium, fol. 3v
Date: c. 1055–1056

Washington: Museum,
Freer Gallery of Art,
32.18
Gospel Book, p. 2
Date: 1250–1299

Washington: Museum,
Freer Gallery of Art,
32.18
Gospel Book, p. 141
Date: 1250–1299

Wiesbaden: Library,
Landesbibl., 1
Hildegardis, *Liber Scivias*,
fol. 35r
Date: 2nd half 12th cent.

Wiesbaden: Library,
Landesbibl., 1
Hildegardis, *Liber Scivias*,
fol. 145v
Date: 2nd half 12th cent.

Wolfenbüttel: Library,
Herzog August Bibl.,
Guelf. 105, Noviss. 2°
Gmunden Gospels,
fol. 19v
Date: c. 1175

IVORY

Darmstadt: Museum,
Hessisches Landes-
museum
Reliquary (713, bone)
Date: 1150–1199

Paris: Museum, Musée
de Cluny
Casket (bone)
Date: 1150–1199

St. Petersburg: Museum,
Hermitage
Casket (bone)
Date: 1150–1199

St. Petersburg: Museum,
Hermitage
Plaque
Date: 1150–1199

Tournai: Cathedral,
Notre Dame
Casket (reliquary)
Date: 1150–1199

Turin: Gallery,
Sabauda
Casket
Date: 12th–13th cent.

METAL

Berlin: Museum,
Staatliche Museen
Plaque (on reliquary;
silver-gilt)
Date: 1st half 13th
cent.

London: Museum,
Victoria and Albert
Pyxis (copper-gilt)
Date: 12th cent.

Monreale: Cathedral
Door (bronze)
Date: 1185
(Fig. 8)

Mortain: Church,
St.-Évroul
Casket
Date: 600–799

Novgorod: Cathedral,
St. Sophia
Door
Date: 1152–1156

Paris: Museum, Louvre
Casket (reliquary;
Potentinus)
Date: 12th–13th cent.

Płock: Cathedral
Chalice
Date: 1239–1247

Xanten: Cathedral,
St. Victor
Vessel (liturgical)
Date: 12th cent.

MOSAIC

Bethlehem: Church,
Nativity
Sanctuary, apse
Date: 1140–1199

Cefalù: Cathedral
Sanctuary, south wall,
zone 1
Date: 1130–1149 (Fig. 9)

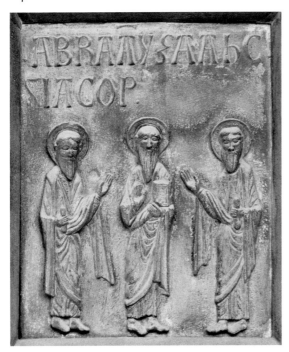

8. Abraham, flanked by Isaac and Jacob. Monreale Cathedral, west portal doors, left valve. Bonanus of Pisa, Italian, Pisan, c. 1185 (photo: Colum Hourihane).

Florence: Baptistry
Decoration,
gallery, walls
Date: early 14th cent.

Florence: Baptistry
Decoration,
apse, vault
Date: 2nd half 13th
cent.–early 14th cent.

Istanbul: Church,
Kahrie-Djami
Narthex, inner
Date: early 14th cent.

Monreale: Cathedral
Crossing
Date: late 12th cent.
(Fig. 10)

Rome: Church,
Sta. Maria Maggiore
Nave, triumphal arch
Date: 432–440

Rome: Church,
Sta. Maria Maggiore
Nave
Date: 432–440

Toulouse: Church, Notre
Dame de la Daurade
Decoration, peacock
Date: 400–599

Venice: Church, S. Marco
Atrium, bay 5, dome
Date: 1200–1299

Venice: Church, S. Marco
Baptistry, bay 1, vault,
zone 2
Date: 1340–1360

PAINTING

Berlin: Museum,
Staatliche Museen
Panel
Date: 580–599

Florence: Gallery, Uffizi
Retable, 8343
Date: late 13th cent.
Attribution: Cimabue

London: Gallery,
National
Triptych, 566
Date 1280–1320

London: Museum,
Victoria and Albert
Banner, 781-1894
Date: 1365–1375

Mount Sinai: Monastery
Panel
Date: 1150–1199

Siena: Gallery,
Pinacoteca Nazionale
Polyptych, 47
Date: 1300–1320

SCULPTURE

Airvault: Church
Choir, vault
Date: 1230–1240

Arles: Museum, Musée
de l'Arles Antique
Sarcophagus
Date: 333–366

Ciudad Rodrigo:
Cathedral
Exterior, south
Date: 1100–1299

Florence: Church,
Orsanmichele
Tabernacle
Date: 1352–1360

Freiburg: Cathedral
Narthex
Date 1280–1320

Genoa: Cathedral,
S. Lorenzo
Exterior, west
Date: 1225

9. Abraham. Half-figure in mosaic from the south wall of the sanctuary of Cefalù Cathedral. Italian, 1130–1149 (photo: Index of Christian Art).

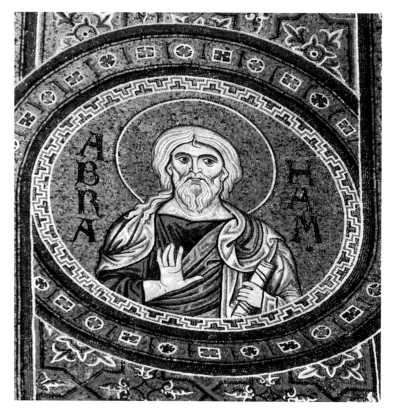

10. Abraham. Medallion bust. Monreale Cathedral, mosaic, east wall, soffit arch. Italian, late 12th century (photo: Colum Hourihane).

Maestricht: Cathedral,
St. Servatius
Hall, vault 1, left,
lower zone
Date: *c.* 1220–1230
(Fig. 11)

Mons (Charente):
Church, Notre Dame
Nave
Date: 12th cent.

New York: Museum,
Metropolitan, Cloisters
Portal (32.147; 40.51.1, 2)
Date: *c.* 1250

Orvieto: Cathedral,
Sta. Maria Assunta
Exterior, west
Date: 14th cent.

Paris: Museum, Louvre
Door
Date: early 14th cent.

Parma: Baptistry
Exterior
Date: 13th–14th cent.

Saint-Loup-de-Naud:
Church
Exterior, west
Date: 2nd half 12th cent.

Saint-Thibault-en-
Auxois: Church
Exterior, north
Date: 2nd half 13th cent.

Santiago de Compostela:
Cathedral
Altar-canopy
Date: before 1135

Santiago de Compostela:
Cathedral
Exterior, south
Date: early 12th cent.

Santiago de Compostela:
Cathedral
Narthex
Date: 1188

11. Abraham. Full-length standing figure from The Ca-
thedral of St. Servatius, Maestricht. Mosan, *c.* 1220–1230
(photo: Colum Hourihane).

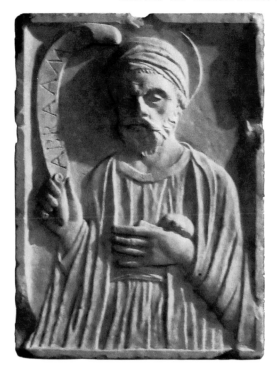

12. Abraham. Bust-length portrait. Stone plaque now in The Museo Civico di Castelvecchio, Verona (inv. no. 120-127). Italian, 2nd half of the fifteenth century. Originally from the Church of San Bovo, Verona (photo: Colum Hourihane).

Tarragona: Cathedral Cloister
Date: 13th cent.

Verona: Museum, Museo Civico di Castelvecchio
Plaque
Date: 2nd half 15th cent. (Fig. 12)

Zwolle: Church, St. Michael
Relief
Date: 1200–1220

TEXTILE

Aachen: Cathedral, Treasury
Vestment (cope)
Date: 13th cent.

Florence: Palace, Palazzo Pitti
Hanging (embroidery)
Date: 1336

London: Museum, Victoria and Albert
Vestment (Jesse Cope, inv. 175-1899)
Date: late 13th cent.

Abraham: Angels Departing

GLASS

Erfurt: Cathedral Windows, choir
Date: 2nd half 14th– 15th cent.

ILLUMINATED MANUSCRIPT

New York: Library, Morgan, M. 338
Psalter, fol. 191ᵛ
Date: c. 1200
Attribution: Ingeborg Psalter, workshop (Fig. 13)

Paris: Library, Bibl. Nationale, fr. 15397
Bible, Jean de Sy, fol. 26ʳ
Date: c. 1356

Rovigo: Library, Bibl. Academic dei Concordi, 212
Picture Bible, fol. 10ʳ
Date: 14th cent.

Rovigo: Library, Bibl. Academic dei Concordi, 212
Picture Bible, fol. 10ᵛ
Date: 14th cent.

Abraham: Battle Against Kings

FRESCO

Bury St. Edmunds: Church, Abbey
Choir
Date: 1100–1199

Parma: Baptistry
Decoration
Date: 1250–1299

GLASS

Erfurt: Cathedral Windows, choir
Date: 2nd half 14th– 15th cent.

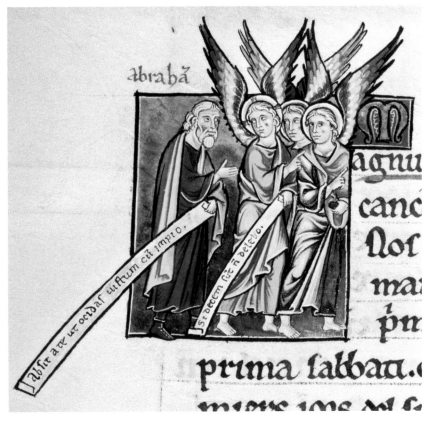

13. Abraham, holding scroll, extends his hands towards departing angels. Historiated initial from a Psalter now in The Morgan Library and Museum, New York, Ms. M.338, fol. 191ᵛ. French, possibly by the Ingeborg Psalter workshop, *c.* 1200 (photo: Morgan Library and Museum).

ILLUMINATED
MANUSCRIPT

Amiens: Library, Bibl. de
la Ville, 108
Pamplona Picture Bible,
I, fol. 6ᵛ
Date: 1197

Augsburg: Library, Uni-
versitätsbibl., 1.2.qu.15
Pamplona Picture Bible,
II, fol. 14ʳ
Date: 1195–1205

London: Library, British,
Cott. Claudius B.IV
Ælfric, *Paraphrase*,
fol. 24ᵛ
Date: 11th cent.

London: Library, British,
Egerton 1894
Genesis, fol. 8ᵛ
Date: 14th cent.

New York: Library,
Morgan, M.394
Bible Historiale of
Guyart des Moulins,
fol. 15ʳ
Date: 1400–1425
Attribution: Boucicaut
Master, workshop
(Fig. 14)

Oxford: Library,
Bodleian, 270b
Bible, Moralized, fol. 13ᵛ
Date: 1st half 13th cent.

Oxford: Library,
Bodleian, Auct.D.4.4
Psalter, fol. 70ʳ
Date: 2nd half 14th cent.

Prague: Library, Univer-
sity, XXIII.C.124
Velislaus Miscellany,
fol. 14ᵛ
Date: 14th cent.

Rome: Library, Bibl.
Vaticana, gr. 746
Octateuch, fol. 66ᵛ
Date: 1100–1199

Rome: Library, Bibl.
Vaticana, gr. 746
Octateuch, fol. 67ʳ
Date: 1100–1199

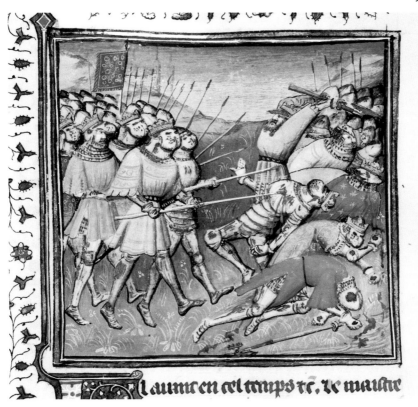

14. Five kings (*right side*) are slain by soldiers who are lead by four crowned kings (*left side*). Miniature from the Bible Historiale of Guyart des Moulins, now in The Morgan Library and Museum, New York, Ms. M. 394, fol. 15ʳ. French, possibly by the Boucicaut Master workshop, 1400–1425 (photo: Morgan Library and Museum).

Rome: Library, Bibl. Vaticana, gr. 747 Octateuch, fol. 35ᵛ Date: 11th cent.

Rome: Library, Bibl. Vaticana, gr. 747 Octateuch, fol. 36ʳ Date: 11th cent.

Rovigo: Library, Bibl. Accademia dei Concordi, 212 Picture Bible, fol. 8ᵛ Date: 14th cent.

Smyrna: Library, Evang. School, A.1 Octateuch, fol. 27ᵛ Date: 12th cent. (Fig. 15)

Vienna: Library, Nationalbibl., Ser. Nov. 2611 Psalter, fol. 7ʳ Date: 1260–1270

Abraham: Begging Sepulcher

ILLUMINATED MANUSCRIPT

Amiens: Library, Bibl. de la Ville, 108 Pamplona Picture Bible, 1, fol. 13ʳ Date: 1197

Augsburg: Universitätsbibl., 1.2.qu.15 —*cont.*

Pamplona Picture Bible, 11, fol. 22ʳ Date: 1195–1205

Istanbul: Library, Topkapi Sarayi, Cod. G.I.8 Seraglio Octateuch, fol. 89ᵛ Date: 11th cent.

London: Library, British, Cott. Claudius B.IV Ælfric, *Paraphrase*, fol. 38ᵛ Date: 1025–1049

London: Library, British, Cott. Otho B.VI Cotton Genesis, fol. 38ʳ Date: 400–599

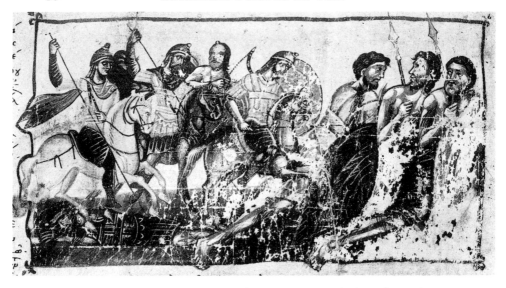

15. Battle against Kings. Miniature from the Smyrna Octateuch, formerly in The Evangelical School, Smyrna (Ms. A.1, fol. 27ᵛ). Constantinople, 12th century (photo: Index of Christian Art).

London: Library, British, Cott. Otho B.VI
Cotton Genesis, fol. 40ʳ
Date: 5th–6th cent.

London: Library, British, Cott. Otho B.VI
Cotton Genesis, fol. 41ʳ
Date: 5th–6th cent.

Prague: Library, University, XXIII.C.124
Velislaus Miscellany, fol. 23ʳ
Date: 14th cent.

Prague: Library, University, XXIII.C.124
Velislaus Miscellany, fol. 23ᵛ
Date: 14th cent.

Rome: Library, Bibl. Vaticana, gr. 746
Octateuch, fol. 84ʳ
Date: 1100–1199

Rome: Library, Bibl. Vaticana, gr. 747
Octateuch, fol. 44ʳ
Date: 11th cent.

Rovigo: Library, Bibl. Accademia dei Concordi, 212
Picture Bible, fol. 14ᵛ
Date 14th cent.

Smyrna: Library, Evang. School, A.1
Octateuch, fol. 35ᵛ
Date: 12th cent.

SCULPTURE

Lyons: Cathedral
Exterior, west
Date: 1308–1332

Abraham: Birth
•—•—•—•—•—•—•—•—•—•—•—•—•—•—•

ILLUMINATED MANUSCRIPT

Cambridge: Library, Corpus Christi College, 51
Chronicle, p. 8
Date: late 12th–13th cent.

Abraham: Blessed by Melchisedek
•—•—•—•—•—•—•—•—•—•—•—•—•—•—•

ENAMEL

Paris: Museum, Louvre
Plaque
Date: 1100–1199

Xanten: Cathedral, St. Victor
Altar (portable)
Date: 1175–1185

FRESCO

Anagni: Cathedral, Sta. Maria
Crypt, decoration
Date: c. 1173–1250

Anagni: Cathedral, Sta. Maria
Crypt, vault
Date: 13th cent.
(Fig. 16)

Bury St. Edmunds: Church, Abbey —*cont.*

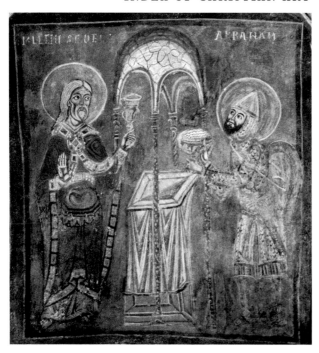

16. Abraham, dressed in armor, faces Melchisedek, both standing on either side of an altar under a canopy. Abraham gives tithes to Melchisedek who in turn blesses him. Fresco from the crypt of the Cathedral of Santa Maria in Anagni. Italian, 13th century (Photo: Index of Christian Art).

Choir
Date: 1100–1199

Fasano: Church, Tempietto di Seppannibale
Aisle, south, western bay, east wall
Date: late 8th cent.

Peterborough: Cathedral Decoration (choir screen)
Date: 12th cent.

Regensburg: Church, St. Emmeram
Choir
Date: 12th cent.

Saint-Savin: Church, Abbey
Nave
Date: 11th–12th cent.

Tivoli: Church, S. Silvestro
Choir, triumphal arch
Date: 1200–1220

Wadi al-Natrun: Monastery, Deir Abu Maqar, St. Macarius
Haykal, south wall, zone 1
Date: 11th–12th cent.

Wadi al-Natrun: Monastery, Deir al-Baramus Al-'Adra
Haykal, east wall
Date: 13th cent.

Wadi al-Natrun: Monastery, Deir Anba Antonius
Haykal, north wall, zone 2
Date: 1232–1233

Worcester (Eng.): Cathedral, Chapter House Decoration
Date: 13th cent.(?)

GLASS

Canterbury: Cathedral, Christ Church
Windows, choir
Date: 1175–1180

Erfurt: Cathedral
Windows, choir
Date: 2nd half 14th–15th cent.

Wissembourg: Church, Sts. Pierre et Paul
Windows
Date: late 13th cent.

ILLUMINATED MANUSCRIPT

Amiens: Library, Bibl. de la Ville, 108
Pamplona Picture Bible, I, fol. 7r
Date: 1197

Augsburg: Library, University, I.2.qu.15
Pamplona Picture Bible, II, fol. 14v
Date: c. 1200

Berlin: Museum, Staatliches Museen, Kupferstichkab., 78.A.6
Psalter, fols. 1v–2r
Date: 2nd half 12th cent.

Berlin: Museum,
Staatliches Museen,
Kupferstichkab., 78.D.2
Biblia Pauperum,
fol. 5ʳ
Date: mid 14th cent.

Berne: Library,
Stadtbibl., 264
Prudentius, *Psychomachia*,
fol. 32ᵛ
Date: 900–920

Brussels: Library, Bibl.
Royale, 9961-2
Psalter, fol. 12ᵛ
Date: 13th cent.

Brussels: Library, Bibl.
Royale, 9961-2
Psalter, fol. 32ᵛ
Date: 13th cent.

Brussels: Library, Bibl.
Royale, 9968-72
Prudentius, *Psychonachia*,
fol. 76ᵛ
Date: 11th cent.

Brussels: Library, Bibl.
Royale, 9987-91
Prudentius, *Psychonachia*,
fol. 98ᵛ
Date: 10th cent.

Brussels: Library, Bibl.
Royale, 10066-77
Prudentius, *Psychonachia*,
fol. 113ʳ
Date: 900–1049

Cambridge: Library, Cor-
pus Christi College, 23
Prudentius, *Psychomachia*,
fol. 5ʳ
Date: 980–999

Cambridge: Library,
St. John's College, K.26
Holland Psalter,
fol. 8ᵛ
Date: 1270–1280

Cambridge: Library,
Trinity College, B.11.4
Psalter, fol. 10ʳ
Date: 1220–1230 (Fig. 17)

Constance: Museum,
Rosgarten, 31
Bible Pauperum, p. 8
Date: 14th cent.

Darmstadt: Library,
Univ.- und Landesbibl.,
2505
*Speculum Humanae Salva-
tionis*, fol. 29ʳ
Date: 2nd half 14th cent.

Douai: Library, Bibl.
Municipale, 90
Missal, Anchin, I,
fol. 59ʳ
Date: late 12th cent.

Eton: Library,
College, 177
Miscellany, fol. 3ᵛ
Date: 13th cent.

Kremsmünster: Library,
Stiftsbibl. 243
*Speculum Humanae Salva-
tionis*, fol. 22ʳ
Date: 1st half 14th cent.

Leiden: Library, Bibl. der
Universiteit, Burm. Q.3
Prudentius, *Psychomachia*,
fol. 121ᵛ
Date: 825–849

Leiden: Library, Bibl.
der Universiteit, Voss.
lat. oct. 15
Prudentius, *Psychomachia*,
fol. 37ᵛ
Date: 11th cent.

Lilienfeld: Library,
Stiftsbibl., 151
Ulrich of Lilienfeld,
Concordantiae caritatis,
fol. 72ᵛ
Date: mid 14th cent.

London: Library, British,
Add. 24199
Prudentius, *Psychomachia*,
fol. 3ᵛ
Date: 980–1099

London: Library, British,
Cott. Claudius B.IV
Ælfric, *Paraphrase*,
fol. 26ʳ
Date: 1025–1049

London: Library, British,
Cott. Cleo. C.VIII
Prudentius, *Psychomachia*,
fol. 2ᵛ
Date: 980–999

London: Library, British,
Cott. Otho B.VI
Cotton Genesis, fol. 21ʳ
Date: 400–599

London: Library, British,
Cott. Titus D.XVI
Prudentius, *Psychomachia*,
fol. 3ᵛ
Date: *c.* 1115–1120

London: Library, British,
Egerton 1894
Genesis, fol. 9ʳ
Date: 14th cent.

London: Museum,
Victoria and Albert, 413
Miniature, verso
Date: *c.* 1150
(Fig. 18)

Lyons: Library, Palais du
commerce et des Arts, 22
Prudentius, *Psychomachia*,
fol. 5ʳ
Date: 11th cent.

Manchester: Library,
John Rylands University,
fr. 5
Old Testament Picture
Bible, fol. 17ᵛ
Date: 2nd quarter 13th
cent. (Fig. 19)

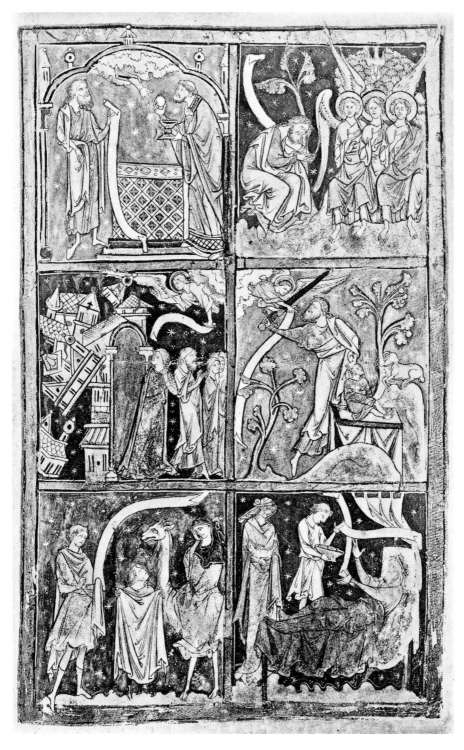

17. Abraham blessed by Melchisedek (*upper left*), entertaining the angels (*upper right*), departure from Sodom (*center left*), sacrifice of Isaac (*center right*), Rebecca sought in marriage (*lower left*) and Isaac blessing Jacob (*lower right*). Full-page prefatory miniature from a Psalter now in Trinity College Library, Cambridge (Ms. B.11.4, fol. 10ʳ). Pen drawing with color wash. English, 1220–1230 (photo: Index of Christian Art).

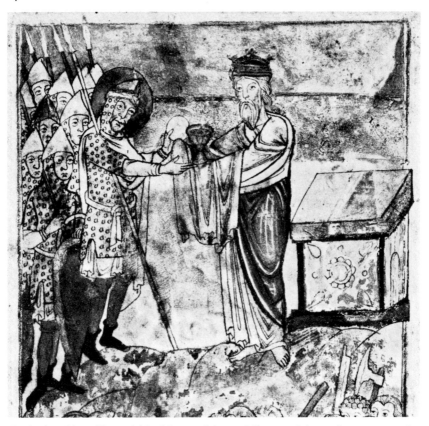

18. Abraham blessed by Melchisedek. Detail from a full-page miniature from a manuscript now in the Victoria and Albert Museum, London (Ms. 413). Mosan, *c.* 1150 (photo: Index of Christian Art).

Munich: Library,
Staatsbibl., Clm. 146
*Speculum Humanae
Salvationis*, fol. 19ʳ
Date: 14th cent.

Munich: Library,
Staatsbibl., Clm. 835
Munich Psalter, fol. 11ʳ
Date: 1200–1210

New York: Library,
Morgan, H. 5
Hours, fol. 65ᵛ
Date: *c.* 1500

New York: Library,
Morgan, M. 43, Hunting-
field Psalter, fol. 10ʳ
Date: 1210–1220
(Fig. 20)

New York: Library,
Morgan, M. 140
*Speculum Humanae
Salvationis*, fol. 19ʳ
Date: late 14th cent.
(Fig. 21)

New York: Library,
Morgan, M. 158
*Speculum Humanae
Salvationis*, fol. 34ʳ
Date: *c.* 1476
(Fig. 22)

New York: Library,
Morgan, M. 230
Weigel-Felix Biblia
Pauperum, fol. 8ᵛ
Date: *c.* 1435 & 16th cent.
(Fig. 23)

New York: Library,
Morgan, M. 385
*Speculum Humanae
Salvationis*, fol. 19ʳ
Date: mid 15th cent.
(Fig. 24)

New York: Library,
Morgan, M. 638
Miniature,
fol. 3ᵛ
Date: *c.* 1250
(Fig. 25)

New York: Library,
Morgan, M. 649
Typological
Life of Christ,
fol. 2ʳ
Date: 1435–1445

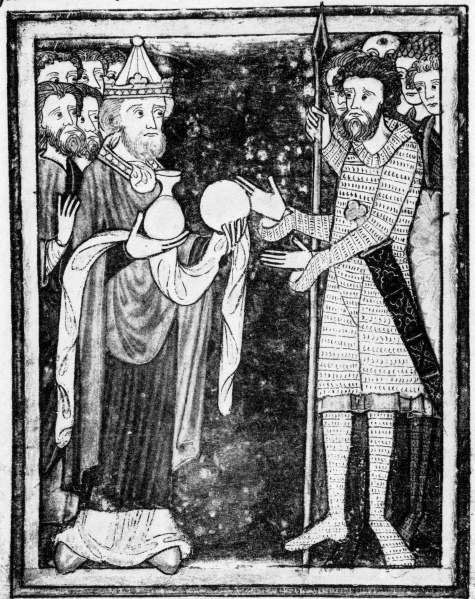

19. Abraham blessed by Melchisedek. Full-page miniature from an Old Testament Picture Book now in John Rylands University Library, Manchester (Ms. fr. 5, fol. 17ᵛ). French, 2nd quarter of the 13th century (photo: Index of Christian Art).

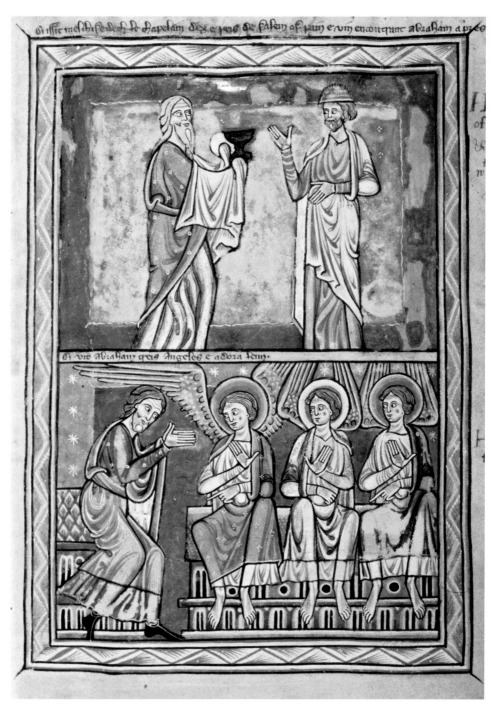

20. Abraham blessed by Melchisedek (*upper zone*) and Abraham entertaining the angels (*lower zone*). Full-page prefatory miniature from the Huntingfield Psalter, now in The Morgan Library and Museum, New York, Ms. M.43, fol. 10ʳ. English, possibly Oxford, 1210–1220 (photo: Morgan Library and Museum).

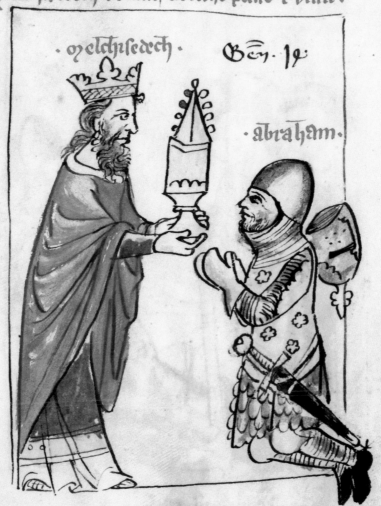

21. Abraham blessed by Melchisedek. Pen-and-color-wash drawing from *Speculum Humanae Salvationis*, now in The Morgan Library and Museum, New York, Ms. M. 140, fol. 19ʳ. German, late 14th century (photo: Morgan Library and Museum).

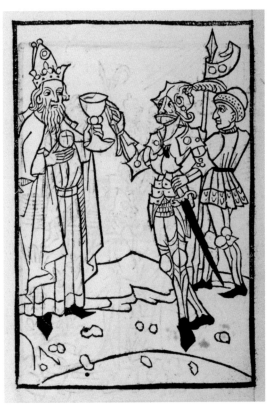

22. Abraham blessed by Melchisedek. Quarter page woodcut from *Speculum Humanae Salvationis*, now in The Morgan Library and Museum, New York, Ms. M. 158, fol. 34ʳ. Swiss, *c.* 1476 (photo: Morgan Library and Museum).

23. Abraham blessed by Melchisedek. Pen drawing from the Weigel-Felix Biblia Pauperum, now in The Morgan Library and Museum, New York, Ms. M. 230, fol. 8ᵛ. Austrian, *c.* 1435 and 16th century (photo: Morgan Library and Museum).

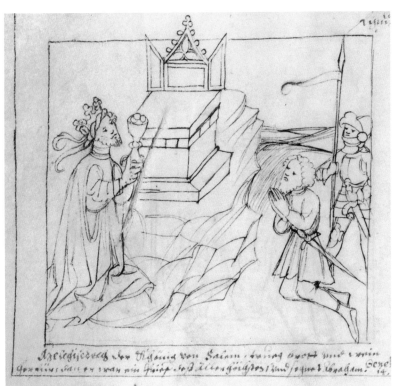

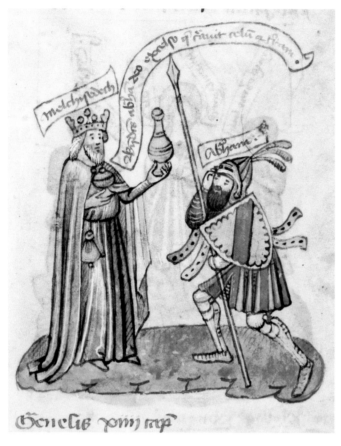

24. Abraham blessed
by Medclisedek.
Pen drawing with
color wash, minia-
ture from *Speculum
Humanae Salvationis*,
now in The Morgan
Library and Mu-
seum, New York,
Ms. M.385, fol. 19ʳ.
Flemish, mid 15th
century (photo:
Morgan Library and
Museum).

New York: Library,
Morgan, M.739
Hedwig of Silesia Hours,
fol. 10ᵛ
Date: 1204–1219

New York: Library,
Morgan, M.766
*Speculum Humanae
Salvationis*, fol. 38ʳ
Date: *c.* 1400 (Fig. 26)

New York: Library,
Morgan, M.769
Christ-Herre Chronik,
fol. 40ʳ
Date: *c.* 1360 (Fig. 27)

New York: Library,
Morgan, M.782
*Speculum Humanae
Salvationis*, fol. 27ᵛ
Date: 1450–1460 (Fig. 28)

New York: Library,
Morgan, M.1046
Breviary
Date: *c.* 1500
(Fig. 29)

Paris: Library, Bibl.
Nationale, lat. 8085
Prudentius, *Psychomachia*,
fol. 56ʳ
Date: 9th cent.

Paris: Library, Bibl.
Nationale, lat. 8846
Psalter, fol. 1ᵛ
Date: 12th – 13th cent.

Paris: Library, Bibl.
Nationale, lat. 10525
Psalter, St. Louis,
fol. 6ʳ
Date: 1260s (Fig. 30)

Prague: Library,
University, XXIII.C.124
Velislaus Miscellany,
fol. 15ᵛ
Date: 14th cent.

Rome: Library, Bibl.
Vaticana, gr. 746
Octateuch, fol. 68ʳ
Date: 1100–1199

Rome: Library, Bibl.
Vaticana, gr. 747
Octateuch, fol. 36ᵛ
Date: 11th cent.

Rovigo: Library,
Bibl. Accademia dei
Concordi, 212
Picture Bible,
fol. 9ʳ
Date 14th cent.

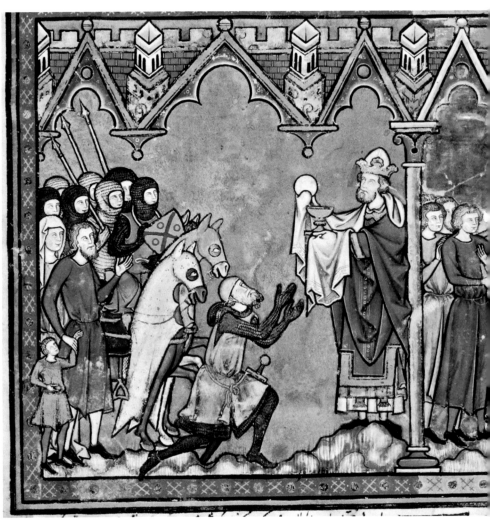

26. Abraham blessed by Melchisedek. Pen drawing from *Speculum Humanae Salvationis*, now in The Morgan Library and Museum, New York, Ms. M.766, fol. 38ʳ. English, possibly Yorkshire, *c.* 1400 (photo: Morgan Library and Museum).

25. Abraham blessed by Melchisedek. Lower register of a full-page miniature from the Morgan Picture Bible, now in The Morgan Library and Museum, New York, Ms. M. 638, fol. 3ᵛ. French, c. 1250 (photo: Morgan Library and Museum).

Saint Florian: Library, Stiftsbibl., III.207 Biblia Pauperum, fol. 5ʳ Date: c. 1310

Salzburg: Library, Stiftsbibl., Peter a.VII.43 Biblia Pauperum, fol. 139ᵛ Date: late 14th cent.

Smyrna: Library, Evang. School, A.1 Octateuch, fol. 28ʳ Date: 12th cent.

Strasbourg: Library, Bibl. de la Ville Herradis of Landsberg, *Hortus Delic.*, fol. 34ʳ Date: 12th cent.

Toledo: Library, Bibl. del Cabildo, 10.8 *Speculum Humanae Salvationis*, fol. 19ʳ Date: 1320–1340

Valenciennes: Library, Bibl. Publique, 563 Prudentius, *Psychomachia*, fol. 2ᵛ Date: 800–899

Vienna: Library, Nationalbibl., 1198 Biblia Pauperum, fol. 5ʳ Date: 1st half 14th cent.

Vienna: Library, Nationalbibl., Ser. Nov. 2611 Psalter, fol. 7ʳ Date: 1126–1270

Vienna: Library, Nationalbibl., Theol. gr. 31 Genesis, fol. 4ʳ Date: 6th cent. (Fig. 31)

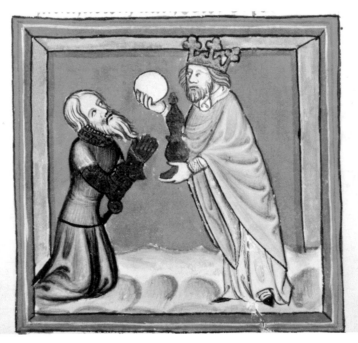

27. Abraham blessed by Melchisedek. Miniature from a chronicle (Christ-Herre Chronik) now in The Morgan Library and Museum, New York, Ms. M. 769, fol. 40ʳ. German, possibly Bavarian, c. 1360. (photo: Morgan Library and Museum).

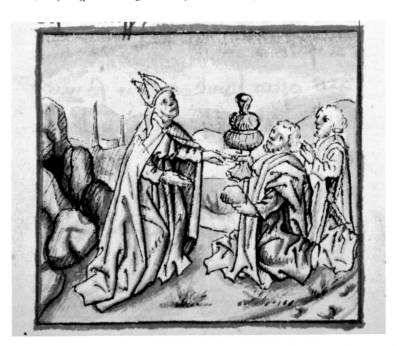

28. Abraham blessed by Melchisedek. Pen drawing and color wash, miniature from *Speculum Humanae Salvationis*, now in The Morgan Library and Museum, New York, Ms. M. 782, fol. 27ᵛ. German, possibly by Hector and Georg Mülich, 1450–1460 (photo: Morgan Library and Museum).

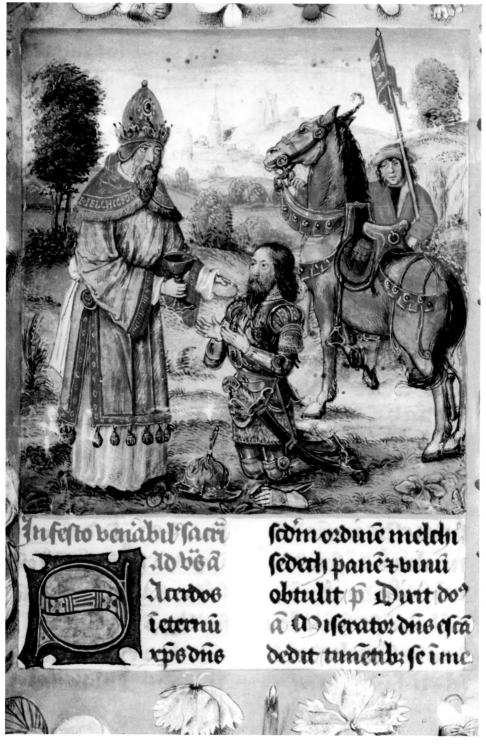

In festo venabil sacñ scdm ordinē melchi
ad vē ā sedech panē ꝯ binū
acrdos obtulit p Durt do⁹
i eternū ā Miserator dñs ē scā
ꝛpo dñs dedit tumētibʒ se i me

29. Abraham blessed by Melchisedek. Three-quarter-page miniature from a Breviary now in The Morgan Library and Museum, New York, Ms. M. 1046. Flemish, possibly Bruges, by a follower of the Master of James IV of Scotland, *c.* 1500 (photo: Morgan Library and Museum).

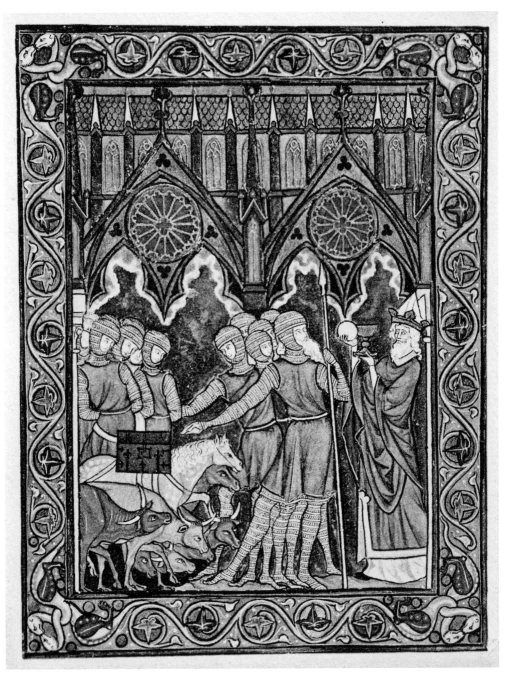

30. Abraham blessed by Melchisedek. Full-page prefatory miniature from the St. Louis Psalter now in the Bibliothèque Nationale de France, Paris (Ms. lat. 10525, fol. 6ʳ). French, 1260s (photo: Index of Christian Art).

31. Abraham blessed by Melchisedek. Detail of a miniature from the Vienna Genesis now in The Nationalbibliothek, Vienna (Ms. Theol. gr. 31, fol. 4ʳ). Early Christian, 6th century (photo: Index of Christian Art).

Weimar: Library,
Landesbibl., fol. max. 4
Biblia Pauperum, fol. 4ᵛ
Date: 1st half 14th cent.

IVORY

Rome: Museum,
Artistico Industriale
Casket (bone)
Date: 2nd half 14th cent.

Trier: Museum, Rheinisches Landesmuseum
Plaque
Date: 6th cent.

METALWORK

Werben: Church,
St. Johannes der Täufer
Chalice (silver-gilt)
Date: 1200–1299

MOSAIC

Hildesheim: Cathedral
Pavement
Date: 1153–1161

Rome: Church,
Sta. Maria Maggiore
Nave, left wall
Date: 432–440

Venice: Church, S. Marco
Atrium
Date: 1200–1299

SCULPTURE

Cismar: Church,
Benedictine
Retable (triptych; reliquary)
Date: 1300–1320

Coire: Cathedral
Nave
Date: 1180–1299

Conques: Church,
Ste.-Foy
Exterior, west
Date: 1st half 12th cent.

Dorlisheim: Church,
Protestante
Capital
Date: 1100–1199

Orvieto: Cathedral,
Sta. Maria Assunta
Exterior, west
Date: 14th cent.

Reims: Cathedral,
Notre Dame
Nave, retro-façade
Date: 1255–1275 (Fig. 32)

Abraham Builds Altar
•⦁•⦁•⦁•⦁•⦁•⦁•⦁•⦁•⦁•⦁•⦁•⦁•

GLASS

Erfurt: Cathedral
Windows, choir
Date: 2nd half 14th–
15th cent.

ILLUMINATED
MANUSCRIPT

Augsburg: Library,
Universitätsbibl.,
Cod. I.2.4° 15
Picture Bible–*Vitae Sanctorum*, fol. 12ᵛ
Date: *c.* 1200

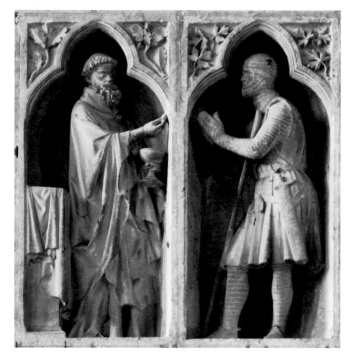

32. Standing priest giving communion to warrior, possibly representing Abraham blessed by Melchisedek. Reims Cathedral, carving on the retro-façade. French, 1255–1275 (photo: Colum Hourihane).

London: Library, British, Cott. Claudius B.IV
Ælfric, *Paraphrase*, fol. 24ʳ
Date: 1025–1049

London: Library, British, Egerton 1894
Genesis, fol. 6ᵛ
Date: 14th cent.

London: Library, British, Egerton 1894
Genesis, fol. 8ʳ
Date: 14th cent.

London: Library, British, Roy. 2 B.VII
Queen Mary Psalter, fol. 9ʳ
Date: 1310–1320

New York: Library, Morgan, M.338
Psalter, fol. 176ᵛ
Date: *c.* 1200
Attribution: Ingeborg Psalter, workshop
(Fig. 33)

Oxford: Library, Bodleian, Junius 11
Cædmon, *Poems*, p. 87
Date: 980–1020

Prague: Library, University, XXIII.C.124
Velislaus Miscellany, fol. 12ᵛ
Date: 14th cent.

Prague: Library, University, XXIII.C.124
Velislaus Miscellany, fol. 14ᵛ
Date: 14th cent.

Rome: Library, Bibl. Vaticana, gr. 746
Octateuch, fol. 64ᵛ
Date: 1100–1199

Rome: Library, Bibl. Vaticana, gr. 746
Octateuch, fol. 66ᵛ
Date: 1100–1199

Rome: Library, Bibl. Vaticana, gr. 747
Octateuch, fol. 34ᵛ
Date: 1000–1099

Rome: Library, Bibl. Vaticana, gr. 747
Octateuch, fol. 35ᵛ
Date: 1000–1099

Rovigo: Library, Bibl. Accademia dei Concordi, 212
Picture Bible, fol. 7ʳ
Date: 14th cent.

Smyrna: Library, Evang. School, A.1
Octateuch, fol. 26ʳ
Date: 12th cent.
(Fig. 34)

Smyrna: Library, Evang. School, A.1
Octateuch, fol. 27ʳ
Date: 12th cent.

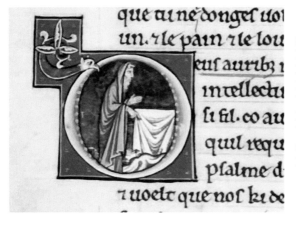

33. Abraham builds an altar. Historiated initial from a Psalter now in The Morgan Library and Museum, New York, Ms. M.338, fol. 176ᵛ. French, possibly by the Ingeborg Psalter workshop, *c.* 1200 (photo: Morgan Library and Museum).

Vienna: Library, Nationalbibl., 2576
Chronicon Mundi, fol. 15ʳ
Date: late 14th cent.

IVORY

Salerno: Museum, Museo Diocesano
Altar frontal
Date: late 11th cent.

Abraham: Burial

FRESCO

Saint-Savin: Church, Abbey
Nave
Date: 11th – 12th cent.

ILLUMINATED MANUSCRIPT

Augsburg: Library, Universtätsbibl., I.2.qu.15
Pamplona Picture Bible, II, fol. 24ᵛ
Date: 1195–1205

Klagenfurt: Museum, Landes, VI.19
Millstatt Miscellany, fol. 32ʳ
Date: 1180–1220

Lilienfeld: Library, Stiftsbibl., 151
Ulrich of Lilienfeld, *Concordantiae caritatis*, fol. 99ᵛ
Date: mid 14th cent.

London: Library, British, Cott. Claudius B.IV
Ælfric, *Paraphrase*, fol. 40ʳ
Date: 1025–1049

London: Library, British, Egerton 1894
Genesis, fol. 13ʳ
Date: 14th cent.

Maihingen: Library, Wallerstein, I.2.qu.15
Picture Bible—*Vitae Sanctorum*, fol. 24ᵛ
Date: *c.* 1200

Prague: Library, University, XXIII.C.124
Velislaus Miscellany, fol. 26ʳ
Date: 14th cent.

Rome: Library, Bibl. Vaticana, gr. 746
Octateuch, fol. 89ʳ
Date: 1100–1199

Rome: Library, Bibl. Vaticana, gr. 747
Octateuch, fol. 46ᵛ
Date: 1000–1099

Rovigo: Library, Bibl. Academia dei Concordi, 212
Picture Bible, fol. 16ᵛ
Date: 14th cent.

Smyrna: Library, Evang. School, A.1
Octateuch, fol. 38ʳ
Date: 12th cent.

Abraham: Circumcising

ENAMEL

Klosterneuburg: Monastery
Retable
Date: 1181

London: Museum, Victoria and Albert
Kennet Pyxis
Date: 1100–1199

London: Museum, Victoria and Albert
Warwick Pyxis
Date: 1150–1174

New York: Museum, Morgan
Malmesbury Pyxis
Date: 1155–1175

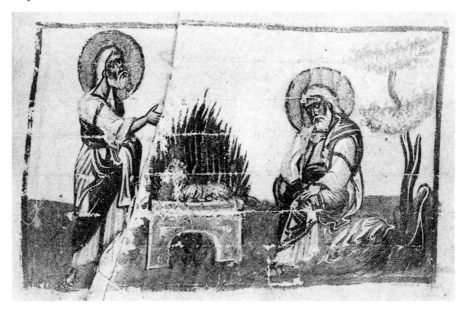

34. Abraham builds altar. Miniature from the Smyrna Octateuch, formerly in The Evangelical School, Smyrna (Ms. A.I, fol. 26ʳ). Constantinople, 12th century (photo: Index of Christian Art).

FRESCO

Worcester: Cathedral,
Chapter House
Decoration
Date: 13th cent.(?)

GLASS

Klosterneuburg:
Monastery
Windows
Date: late 13th–
14th cent.

ILLUMINATED
MANUSCRIPT

Klagenfurt: Museum,
Landes, VI.19
Millstatt Miscellany,
fol. 27ʳ
Date: 1180–1220

Klagenfurt: Museum,
Landes, VI.19
Millstatt Miscellany,
fol. 28ʳ
Date: 1180–1220

Lilienfeld: Library,
Stiftsbibl., 151
Ulrich of Lilienfeld,
Concordantiae caritatis,
fol. 13ᵛ
Date: mid 14th cent.

London: Library, British,
Cott. Otho. B.VI
Cotton Genesis, fol. 32ʳ
Date: 5th–6th cent.

London: Library,
British, Egerton 1894
Genesis, fol. 9ᵛ
Date: 14th cent.

London: Library,
British, Egerton 1894
Genesis, fol. 11ʳ
Date: 14th cent.

New York: Library,
Morgan, M.394
Bible Histoirale of Gu-
yart des Moulins, fol. 17ʳ
Date: 1400–1425
Attribution: —cont.

Boucicaut Master, work-
shop (Fig. 35)

New York: Library,
Morgan, M.649
Typological Life of
Christ, fol. 1ᵛ
Date: *c.* 1440

Oxford: Library,
Bodleian, 270b
Bible, Moralized, fol. 14ʳ
Date: 1st half 13th cent.

Prague: Library,
University, XXIII.C.124
Velislaus Miscellany,
fol. 17ʳ
Date: 14th cent.

Rome: Library, Bibl.
Vaticana, gr. 746
Octateuch, fol. 69ʳ
Date: 1100–1199

Rome: Library, Bibl.
Vaticana, gr. 746
Octateuch, fol. 73ʳ
Date: 1100–1199

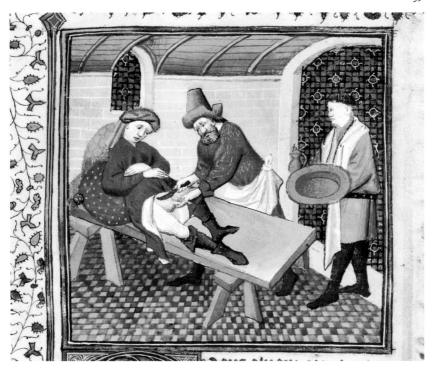

35. Abraham circumcising Ishmael. Miniature from the Bible Historiale of Guyart des Moulins now in The Morgan Library and Museum, New York, Ms. M.394, fol. 17ʳ. French, possibly by the Boucicaut Master workshop, 1400–1425 (photo: Morgan Library and Museum).

Rome: Library, Bibl.
Vaticana, gr. 746
Octateuch, fol. 79ʳ
Date: 1100–1199

Rome: Library, Bibl.
Vaticana, gr. 747
Octateuch, fol. 38ʳ
Date: 1000–1099

Rome: Library, Bibl.
Vaticana, gr. 747
Octateuch, fol. 38ᵛ
Date: 1000–1099

Rome: Library, Bibl.
Vaticana, gr. 747
Octateuch, fol. 42ʳ
Date: 1000–1099

Rovigo, Library,
Bibl. Academic dei
Concordi, 212
Picture Bible, fol. 9ᵛ
Date: 14th cent.

Rovigo: Library,
Bibl. Academic dei
Concordi, 212
Picture Bible, fol. 10ʳ
Date: 14th cent.

Rovigo: Library,
Bibl. Academic dei
Concordi, 212
Picture Bible, fol. 12ᵛ
Date: 14th cent.

Smyrna: Library,
Evang. School, A.1
Octateuch, fol. 29ᵛ
Date: 12th cent.

Smyrna: Library,
Evang. School, A.1
Octateuch, fol. 30ᵛ
Date: 12th cent. (Fig. 36)

Smyrna: Library, Evang.
School, A.1 —cont.

Octateuch, fol. 33ᵛ
Date: 12th cent.

MOSAIC

Venice: Church, S. Marco
Atrium, bay 5, dome
Date: 1200–1299

Venice: Church, S. Marco
Atrium, bay 5, west wall
Date: 13th cent.

*Abraham Communi-
cating with God*

•—•—•—•—•—•—•—•—•—•—•—•—•—•

FRESCO

Arilye: Monastery,
Church of St. Achillius
Narthex, inner
Date: late 13th–
14th cent.

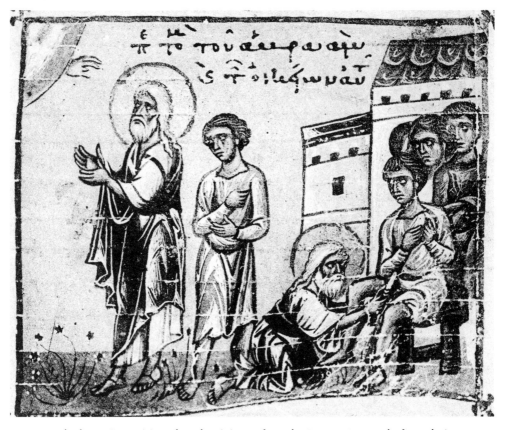

ε μι
π το τοῦ ἀ εραδν
ὶς τ̂ οιληῶνᾶν

36. Abraham Circumcising Ishmael. Miniature from the Smyrna Octateuch, formerly in The Evangelical School, Smyrna (Ms. A.1, fol. 30ᵛ). Constantinople, 12th century (photo: Index of Christian Art).

Bury St. Edmunds: Church, Abbey Choir
Date: 1100–1199

Lekhne: Church Decoration
Date: 13th–14th cent.

Milan: Church, S. Ambrogio Wall
Date: 4th cent.

Saint-Savin: Church, Abbey Nave
Date: 11th–12th cent.

Wienhausen: Convent, Church Nuns' choir
Date: *c.* 14th cent.

GLASS

Erfurt: Cathedral Windows, choir
Date: 2nd half 14th–15th cent.

ILLIMINATED MANUSCRIPT

Amiens: Library, Bibl. de la Ville, 108 Pamplona Picture Bible, 1, fol. 5ʳ
Date: 1197

Amiens: Library, Bibl. de la Ville, 108 Pamplona Picture Bible, 1, fol. 7ᵛ
Date: 1197

Amiens: Library, Bibl. de la Ville, 108 Pamplona Picture Bible, 1, fol. 11ᵛ
Date: 1197

Amiens: Library, Bibl. de la Ville, 108 Pamplona Picture Bible, 1, fol. 12ᵛ
Date: 1197

Arras: Library, Bibl. Municipale, 561 *—cont.*

Bible, fol. 4ᵛ
Date: 13th cent.

Augsburg: Library, Universitätsbibl., I.2 qu.15
Pamplona Picture Bible, II, fol. 12ᵛ
Date: 1195–1205

Augsburg: Library, Universitätsbibl., I.2 qu.15
Pamplona Picture Bible, II, fol. 15ʳ
Date: 1195–1205

Augsburg: Library, Universitätsbibl., I.2 qu.15
Pamplona Picture Bible, II, fol. 19ᵛ
Date: 1195–1205

Augsburg: Library, Universitätsbibl., I.2 qu.15
Pamplona Picture Bible, II, fol. 20ʳ
Date: 1195–1205

Augsburg: Library, Universitätsbibl., I.2 qu.15
Pamplona Picture Bible II, fol. 21ᵛ
Date: 1195–1205

Berlin: Museum, Staatliches Museen, Kupferstichkab., 78.A.6
Psalter, fol. 1ʳ
Date: 2nd half 12th cent.

Berlin: Museum, Staatliches Museen, Kupferstichkab., 78.A.6
Psalter, fols. 1ᵛ–2ʳ
Date: 2nd half 12th cent.

Boulogne: Library, Bibl. de la Ville, 5
Bible, St. Vaast, fol. 1ʳ
Date: 1st half 13th cent.

Cambridge: Library, St. John's College, K.26
Holland Psalter, fol. 9ʳ
Date: 1270–1280

Glasgow: Library, University, Hunter 229
Hunterian Psalter, fol. 9ᵛ
Date: c. 1170

Impruneta: Church, Sta. Maria, A.11
Antiphonary, fol. 79ʳ
Date: 14th cent.

Istanbul: Library, Topkapi Sarayi, Cod. G.I.8
Seraglio Octateuch, fol. 74ᵛ
Date: 11th cent.

Klagenfurt: Museum, Landes, VI.19
Millstatt Miscellany, fol. 24ᵛ
Date: 1180–1205

Klagenfurt: Museum, Landes, VI.19
Millstatt Miscellany, fol. 25ᵛ
Date: 1180–1205

Kraców: Library, Bibl. Czartoryskich, 3464
Antiphonary of St. Francesco Rimini, II, fol. 206ᵛ
Date: 1314

Leiden: Library, Bibl. der Universiteit, BPL 76A
St. Louis Psalter, fol. 12ᵛ
Date: 1180–1205

Lilienfeld: Library, Stiftsbibl., 151
Ulrich of Lilienfeld, *Concordantiae caritatis*, fol. 6ᵛ
Date: mid 14th cent.

London: Library, British, Cott. Claudius B.IV
Ælfric, *Paraphrase*, fol. 21ʳ
Date: 1025–1049

London: Library, British, Cott. Claudius B.IV
Ælfric, *Paraphrase*, fol. 21ᵛ
Date: 1025–1049

London: Library, British, Cott. Claudius B.IV
Ælfric, *Paraphrase*, fol. 23ʳ
Date: 1025–1049

London: Library, British, Cott. Claudius B.IV
Ælfric, *Paraphrase*, fol. 24ʳ
Date: 1025–1049

London: Library, British, Cott. Claudius B.IV
Ælfric, *Paraphrase*, fol. 26ʳ
Date: 1025–1049

London: Library, British, Cott. Claudius B.IV
Ælfric, *Paraphrase*, fol. 26ᵛ
Date: 1025–1049

London: Library, British, Cott. Claudius B.IV
Ælfric, *Paraphrase*, fol. 27ʳ
Date: 1025–1049

London: Library, British, Cott. Claudius B.IV
Ælfric, *Paraphrase*, fol. 29ʳ
Date: 1025–1049

London: Library, British, Cott. Claudius B.IV
Ælfric, *Paraphrase*, fol. 30ᵛ
Date: 1025–1049

London: Library, British, Cott. Claudius B.IV
Ælfric, *Paraphrase*, fol. 35ʳ
Date: 1025–1049

London: Library, British, Cott. Claudius B.IV
Ælfric, *Paraphrase*, fol. 35ᵛ
Date: 1025–1049

London: Library, British, Cott. Claudius B.IV
Ælfric, *Paraphrase*, fol. 37ᵛ
Date: 1025–1049

London: Library, British,
Cott. Otho B.VI
Cotton Genesis, fol. 18ʳ
Date: 400–599

London: Library, British,
Cott. Otho B.VI
Cotton Genesis, fol. 22ʳ
Date: 400–599

London: Library, British,
Cott. Otho B.VI
Cotton Genesis, fol. 36ʳ
Date: 400–599

London: Library, British,
Egerton 1894
Genesis, fol. 8ʳ
Date: 14th cent.

London: Library, British,
Egerton 1894
Genesis, fol. 9ʳ
Date: 14th cent.

London: Library, British,
Egerton 1894
Genesis, fol. 9ᵛ
Date: 14th cent.

London: Library, British,
Egerton 1894
Genesis, fol. 12ʳ
Date: 14th cent.

London: Library, British,
Harley 4381-2
Guyart des Moulins,
Bible, I, fol. 17ʳ
Date: c. 1400

London: Library, British,
Roy. 2 B.VII
Queen Mary Psalter,
fol. 8ᵛ
Date: 1310–1320

London: Library, British,
Roy. 2 B.VII
Queen Mary Psalter,
fol. 9ᵛ
Date: 1310–1320

London: Library, British,
Roy. 2 B.VII
Queen Mary Psalter,
fol. 10ᵛ
Date: 1310–1320

Maihingen: Library,
Wallerstein, I.2.qu.15
Picture Bible—*Vitae Sanc-
torum*, fol. 12ᵛ
Date: c. 1200

Moscow: Museum,
Historical, gr. 129
Chludoff Psalter, fol. 105ᵛ
Date: 800–899

Munich: Library,
Staatsbibl., gall. 16
Queen Isabella Psalter,
fol. 25ᵛ
Date: c. 1303–1308

Munich: Library,
Staatsbibl., gall. 16
Queen Isabella Psalter,
fol. 26ᵛ
Date: c. 1303–1308

Munich: Library,
Staatsbibl., gall. 16
Queen Isabella Psalter,
fol. 27ᵛ
Date: c. 1303–1308

Munich: Library,
Staatsbibl. gall. 16
Queen Isabella Psalter,
fol. 29ᵛ
Date: c. 1303–1308

New York: Library,
Morgan, M.302
Ramsey Psalter, fol. 1ᵛ
Date: c. 1300–1310
(Fig. 37)

New York: Library,
Morgan, M.322–323
Bible Historiale of Gu-
yart des Moulins, I,
fol. 28ʳ —cont.

Date: c. 1325
Attribution: Maubeuge
Master
(Fig. 38)

New York: Library,
Morgan, M.338
Psalter, fol. 200ᵛ
Date: c. 1200
Attribution: Ingeborg
Psalter Workshop
(Fig. 39)

New York: Library,
Morgan, M.394
Bible Histoirale of Gu-
yart des Moulins,
fol. 15ᵛ
Date: 1400–1425
Attribution: Boucicaut
Master Workshop
(Fig. 40)

New York: Library,
Morgan, M.677
Hours of Anne of France,
fol. 106ʳ
Date: 1470–1480
(Fig. 41)

New York: Library,
Morgan, M.739
Hedwig of Silesia Hours,
fol. 11ʳ
Date: 1204–1219
(Fig. 42)

New York: Library,
Public, Spencer 22
Miscellany, fol. 14ʳ
Date: c. 1300

New York: Library,
Public, Spencer 26
Tickhill Psalter, fol. 6ʳ
Date: early 14th cent.

Oxford: Library,
Bodleian, 270b
Bible, Moralized,
fol. 11ᵛ
Date: 1st half 13th cent.

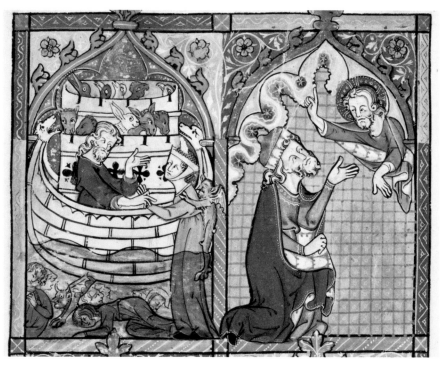

37. Noah entering the Ark (*left*) and Abraham communicating with God (*right*). Upper zone of a two-zoned full-page miniature from the Ramsey Psalter now in The Morgan Library and Museum, New York, Ms. M. 302, fol. 1ᵛ. English, Ramsey Abbey, *c*. 1300–1310 (photo: Morgan Library and Museum).

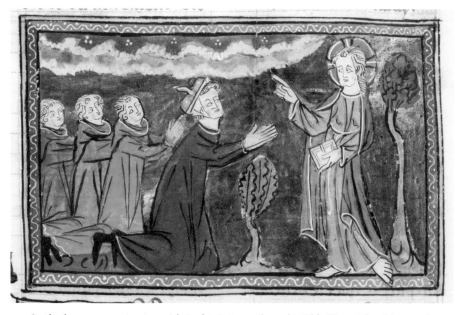

38. Abraham communicating with God. Miniature from the Bible Historiale of Guyart des Moulins now in The Morgan Library and Museum, New York, Ms. M. 322–323, 1, fol. 28ʳ. French, by the Maubeuge Master, *c*. 1325 (photo: Morgan Library and Museum).

39. Abraham communicating with God. Miniature from a Psalter now in The Morgan Library and Museum, New York, Ms. M.338, fol. 200ᵛ. French, c. 1200 (photo: Morgan Library and Museum).

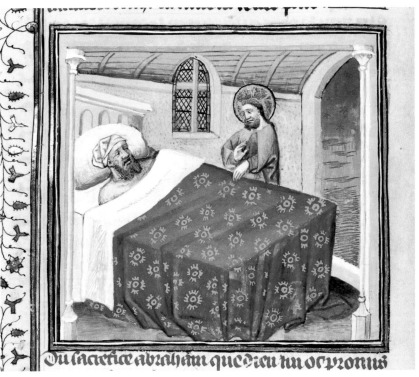

40. Abraham communicating with God. Miniature from the Bible Historiale of Guyart des Moulins now in The Morgan Library and Museum, New York, Ms. M. 394, fol. 15ᵛ. French, possibly by the Boucicaut Master workshop, 1400–1425 (photo: Morgan Library and Museum).

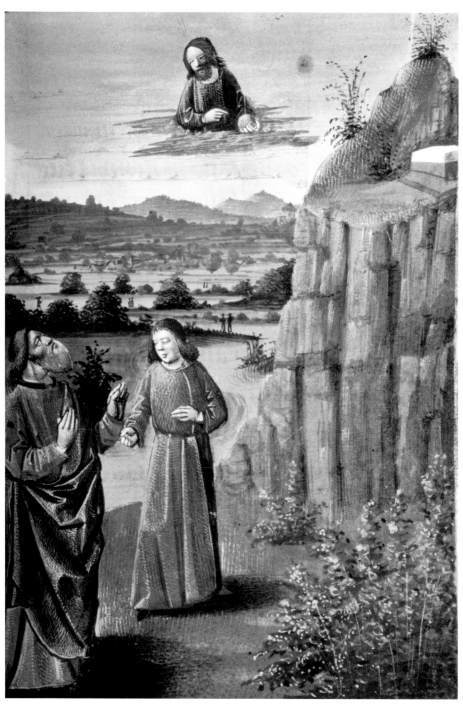

41. Abraham, communicating with God, is told to sacrifice Isaac. Full-page miniature from the Hours of Anne of France now in The Morgan Library and Museum, New York, Ms. M.677, fol. 106ʳ. French, possibly by the workshop of Jean Colombe, 1470–1480 (photo: Morgan Library and Museum).

42. Abraham communicating with God. Miniature (*detail*) from a German manuscript (Hedwig of Silesia Hours) now in The Morgan Library and Museum, New York, Ms. M. 739, fol. 11ʳ. Possibly Bohemian, 1204–1219 (photo: Morgan Library and Museum).

Oxford: Library,
Bodleian, 270b
Bible, Moralized, fol. 14ʳ
Date: 1st half 13th cent.

Oxford: Library,
Bodleian, 270b
Bible, Moralized,
fol. 15ᵛ
Date: 1st half 13th cent.

Oxford: Library,
Bodleian, Auct. D.4.4
Psalter, fol. 105ʳ
Date: 2nd half 14th cent.

Oxford: Library,
Bodleian, Auct. D.4.4
Psalter, fol. 107ᵛ
Date: 2nd half 14th cent.

Oxford: Library,
Bodleian, Junius 11
Cædmon, *Poems*, p. 84
Date: 980–1020

Oxford: Library,
Bodleian, Junius 11
Cædmon, *Poems*, p. 87
Date: 980–1020

Padua: Library,
Bibl. Capitolare
Antiphonary, 11, fol. 85ᵛ
Date: 14th cent.

Paris: Library, Bibl.
Nationale, fr. 15397
Bible, Jean de Sy, fol. 12ᵛ
Date: *c.* 1356

Paris: Library, Bibl.
Nationale, fr. 15397
Bible, Jean de Sy, fol. 35ʳ
Date: *c.* 1356

Paris: Library, Bibl.
Nationale, fr. 15397
Bible, Jean de Sy, fol. 37ᵛ
Date: *c.* 1356

Paris: Library, Bibl.
Nationale, gr. 923
John of Damascus, *Sacra
Parallela*, fol. 144ʳ
Date: 800–899

Paris: Library, Bibl.
Nationale, gr. 923
John of Damascus, *Sacra
Parallela*, fol. 248ʳ
Date: 800–899

Paris: Library, Bibl.
Nationale, gr. 923
John of Damascus, *Sacra
Parallela*, fol. 302ʳ
Date: 800–899

Paris: Library, Bibl.
Nationale, gr. 923
John of Damascus, *Sacra
Parallela*, fol. 336ʳ
Date: 800–899

Prague: Library,
University, XXIII.C.124
Velislaus Miscellany,
fol. 12ʳ
Date: 14th cent.

Prague: Library,
University, XXIII.C.124
Velislaus Miscellany,
fol. 12ᵛ
Date: 14th cent.

Prague: Library,
University, XXIII.C.124
Velislaus Miscellany,
fol. 13ᵛ
Date: 14th cent.

Prague: Library,
University, XXIII.C.124
Velislaus Miscellany,
fol. 14ᵛ
Date: 14th cent.

Prague: Library,
University, XXIII.C.124
Velislaus Miscellany,
fol. 15ᵛ
Date: 14th cent.

Prague: Library,
University, XXIII.C.124
Velislaus Miscellany,
fol. 16ʳ
Date: 14th cent.

Prague: Library,
University, XXIII.C.124
Velislaus Miscellany,
fol. 17ʳ
Date: 14th cent.

Prague: Library,
University, XXIII.C.124
Velislaus Miscellany,
fol. 18ʳ
Date: 14th cent.

Prague: Library,
University, XXIII.C.124
Velislaus Miscellany,
fol. 22ʳ
Date: 14th cent.

Rome: Library, Bibl.
Vaticana, Barb. gr. 372
Barberini Psalter,
fol. 178ʳ
Date: 1050–1099

Rome: Library, Bibl.
Vaticana, gr. 746
Octateuch, fol. 63ᵛ
Date: 1100–1099

Rome: Library, Bibl.
Vaticana, gr. 746
Octateuch, fol. 66ʳ
Date: 1100–1099

Rome: Library, Bibl.
Vaticana, gr. 746
Octateuch, fol. 68ʳ
Date: 1100–1099

Rome: Library, Bibl.
Vaticana, gr. 746
Octateuch, fol. 69ʳ
Date: 1100–1099

Rome: Library, Bibl.
Vaticana, gr.746
Octateuch, fol. 70ʳ
Date: 1100–1099

Rome: Library, Bibl.
Vaticana, gr. 746
Octateuch, fol. 70ᵛ
Date: 1100–1099

Rome: Library, Bibl.
Vaticana, gr. 746
Octateuch, fol. 73ʳ
Date: 1100–1099

Rome: Library, Bibl.
Vaticana, gr. 746
Octateuch, fol. 75ʳ
Date: 1100–1099

Rome: Library, Bibl.
Vaticana, gr. 746
Octateuch, fol. 81ᵛ
Date: 1100–1099

Rome: Library, Bibl.
Vaticana, fr. 746
Octateuch, fol. 83ᵛ
Date: 1100–1099

Rome: Library, Bibl.
Vaticana, gr. 747
Octateuch, fol. 34ᵛ
Date: 1000–1099

Rome: Library, Bibl.
Vaticana, gr. 747
Octateuch, fol. 35ᵛ
Date: 1000–1099

Rome: Library, Bibl.
Vaticana, gr. 747
Octateuch, fol. 36ᵛ
Date: 1000–1099

Rome: Library, Bibl.
Vaticana, gr. 747
Octateuch, fol. 37ʳ
Date: 1000–1099

Rome: Library, Bibl.
Vaticana, gr. 747
Octateuch, fol. 37ᵛ
Date: 1000–1099

Rome: Library, Bibl.
Vaticana, gr. 747
Octateuch, fol. 38ʳ
Date: 1000–1099

Rome: Library, Bibl.
Vaticana, gr. 747
Octateuch, fol. 38ᵛ
Date: 1000–1099

Rome: Library, Bibl.
Vaticana, gr. 747
Octateuch, fol. 39ᵛ
Date: 1000–1099

Rome: Library, Bibl.
Vaticana, gr. 747
Octateuch, fol. 43ʳ
Date: 1000–1099

Rome: Library, Bibl.
Vaticana, gr. 747
Octateuch, fol. 43ᵛ
Date: 1000–1099

Rovigo: Library,
Bibl. Academic dei
Concordi, 212
Picture Bible, fol. 7ʳ
Date: 14th cent.

Rovigo: Library,
Bibl. Academic dei
Concordi, 212
Picture Bible, fol. 8ʳ
Date: 14th cent.

Rovigo: Library,
Bibl. Academic dei
Concordi, 212
Picture Bible, fol. 9ʳ
Date: 14th cent.

Rovigo, Library,
Bibl. Academic dei
Concordi, 212
Picture Bible, fol. 9v
Date: 14th cent.

Rovigo: Library,
Bibl. Academic dei
Concordi, 212
Picture Bible, fol. 12v
Date: 14th cent.

Rovigo: Library,
Bibl. Academic dei
Concordi, 212
Picture Bible, fol. 13v
Date: 14th cent.

Smyrna: Library,
Evang. School, A.1
Octateuch, fol. 26r
Date: 12th cent.

Smyrna: Library,
Evang. School, A.1
Octateuch, fol. 26v
Date: 12th cent.

Smyrna: Library,
Evang. School, A.1
Octateuch, fol. 28r
Date: 12th cent.

Smyrna: Library,
Evang. School, A.1
Octateuch, fol. 28v
Date: 12th cent.

Smyrna: Library,
Evang. School, A.1
Octateuch, fol. 29r
Date: 12th cent.
(Fig. 43)

Smyrna: Library,
Evang. School, A.1
Octateuch, fol. 29v
Date: 12th cent.

Smyrna: Library,
Evang. School, A.1
Octateuch, fol. 30v
Date: 12th cent.

Smyrna: Library,
Evang. School, A.1
Octateuch, fol. 31r
Date: 12th cent.
(Fig. 44)

Smyrna: Library,
Evang. School, A.1
Octateuch, fol. 34v
Date: 12th cent.

Smyrna: Library,
Evang. School, A.1
Octateuch, fol. 35r
Date: 12th cent.

Strasbourg: Library,
Bibl. de la Ville
Herradis of Landsberg,
Hortus Delic., fol. 34r
Date: 12th cent.

Strasbourg: Library,
Bibl. de la Ville
Herradis of Landsberg,
Hortus Delic., fol. 80v
Date: 12th cent.

Vienna: Library,
Mechitharisten-
Kongregation, 697
Gospel Book, fol. 6v
Date: 980–1020

Vienna: Library,
Nationalbibl., 2576
Chronicon Mundi, fol. 19r
Date: late 14th cent.

Vienna: Library,
Nationalbibl., 2739
Preces, fol. 10v
Date: 2nd half 12th cent.

Vienna: Library,
Nationalbibl., Hist. gr. 6
Menologium, fol. 3v
Date: 1055–1056

Vienna: Library,
Nationalbibl., Ser. Nov.
2611
Psalter, fol. 7r
Date: 1260–1270 —*cont.*

Attribution: Douce 50
workshop or Bari work-
shop (?)

Vienna: Library,
Nationalbibl.,
Theol. gr. 31
Genesis, fol. 4v
Date: 500–599

Vienna: Library,
Nationalbibl.,
Theol. gr. 31
Genesis, fol. 6r
Date: 500–599

Zurich: Library, Zentral-
bibl., Rheinau 15
Rudolf von Ems,
Weltchronik, fol. 28r
Date: 1340–1350

IVORY

Berlin: Museum,
Staatsliche Museen
Plaque
Date: 1080–1099

Salerno: Museum,
Museo Diocesano
Altar frontal, plaque 10
Date: late 11th cent.

Salerno: Museum,
Museo Diocesano
Altar frontal, plaque 12
Date: late 11th cent.

METAL

Pistoia: Cathedral,
S. Zenone
Altar frontal
Date: 1364

Verona: Church, S. Zeno
Door (bronze)
Date: 2nd half 12th cent.
(Fig. 45)

MOSAIC

Monreale: Cathedral
Nave, north wall —*cont.*

43. Abraham communicating with God (*left*); men representing the seed of Abraham walk between the rivers of Egypt and Euphrates (*right*). Miniature from the Smyrna Octateuch, formerly in The Evangelical School, Smyrna (Ms. A.I, fol. 29ʳ). Constantinople, 12th century (photo: Index of Christian Art).

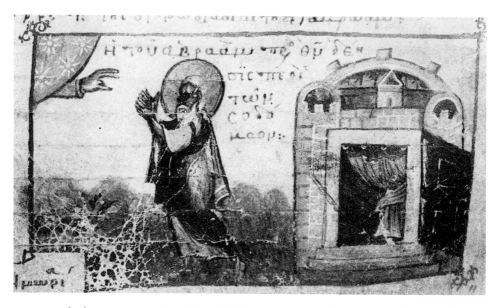

44. Abraham communicating with God. Miniature from the Smyrna Octateuch, formerly in The Evangelical School, Smyrna (Ms. A.I, fol. 31ʳ). Constantinople, 12th century (photo: Index of Christian Art).

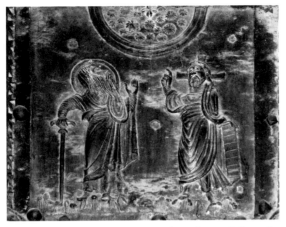

45. Abraham communicating with God. Panel from the bronze door of the west portal of San Zeno, Verona. 2nd half of the 12th century (photo: Colum Hourihane).

Date: late 12th cent.
(Fig. 46)

Palermo: Chapel,
Cappella Palatina
Nave, north wall,
zone 2
Date: 1140–1160

Venice: Church, S. Marco
Atrium, bay 5, dome
Date: 1200–1299

SCULPTURE

Malmesbury: Church,
Abbey
Exterior, south
Date: 1150–1199

Abraham: Death

ILLUMINATED MANUSCRIPT

Amiens: Library,
Bibl. de la Ville, 108
Pamplona Picture Bible,
1, fol. 5ʳ
Date: 1197

Oxford: Library, Bodleian, Auct. D.4.4 —*cont.*

Psalter, fol. 138ʳ
Date: 2nd half 14th cent.

Oxford: Library, Exeter
College, 47
Psalter, Humphrey de
Bohun, fol. 19ʳ
Date: 2nd half 14th cent.

IVORY

Rome: Museum,
Artistico Industriale
Casket (bone)
Date: 2nd half 14th cent.

Abraham: Delivered from Fire of Chaldees

ILLUMINATED MANUSCRIPT

Cambridge: Museum,
Fitzwilliam, 43-1960
Speculum Humanae Salvationis, no. 31
Date: late 14th cent.

Darmstadt: Library,
Univ.- und Landesbibl.,
2505
Speculum Humanae Salvationis, fol. 59ʳ
Date: 1350–1399

Kresmünster: Library,
Stiftsbibl., 243
Speculum Humanae Salvationis, fol. 37ʳ
Date: 1st half 14th cent.

New York: Library,
Morgan, M.140
Speculum Humanae Salvationis, fol. 34ʳ
Date: late 14th cent.
(Fig. 47)

New York: Library,
Morgan, M.158
Speculum Humanae Salvationis, fol. 42ᵛ
Date: *c.* 1476
(Fig. 48)

New York: Library,
Morgan, M.385
Speculum Humanae Salvationis, fol. 34ʳ
Date: mid 15th cent.
(Fig. 49)

New York: Library,
Morgan, M.766
Speculum Humanae Salvationis, fol. 53ʳ
Date: *c.* 1400
(Fig. 50)

New York: Library,
Morgan, M.782
Speculum Humanae Salvationis, fol. 56ᵛ
Date: 1450–1460
(Fig. 51)

Abraham: Departure from Haran

GLASS

Erfurt: Cathedral
Windows, choir
Date: 2nd half 14th–
15th cent.

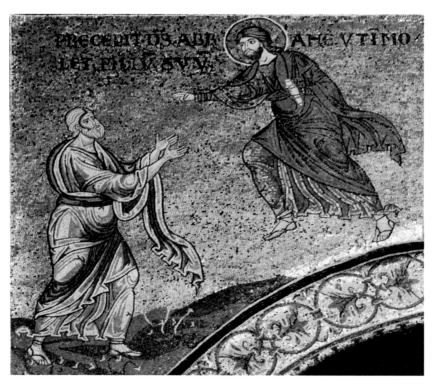

46. Abraham communicating with God. Mosaic from the north wall of the nave of Monreale Cathedral. Italian, late 12th century (photo: Colum Hourihane).

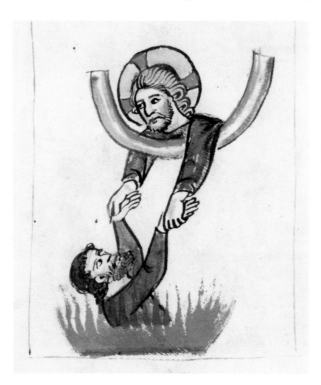

47. Abraham delivered from fire of the Chaldees. Miniature; pen drawing with colored wash from *Speculum Humanae Salvationis*, now in The Morgan Library and Museum, New York, Ms. M.140, fol. 34ʳ. German, late 14th century (photo: Morgan Library and Museum).

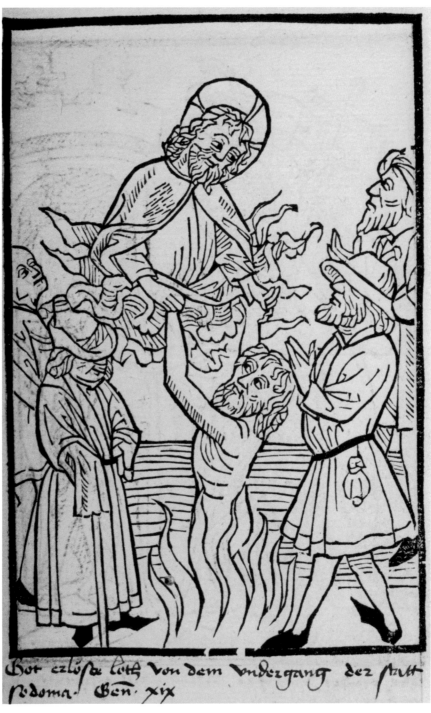

Bot erlöste loth von dem vndergang der statt
sodoma. Gen. xix

48. Abraham delivered from the fire of the Chaldees. Quarter-page woodcut from *Speculum Humanae Salvationis*, now in The Morgan Library and Museum, New York, Ms. M. 158, fol. 42ᵛ. Swiss, *c.* 1476 (photo: Morgan Library and Museum).

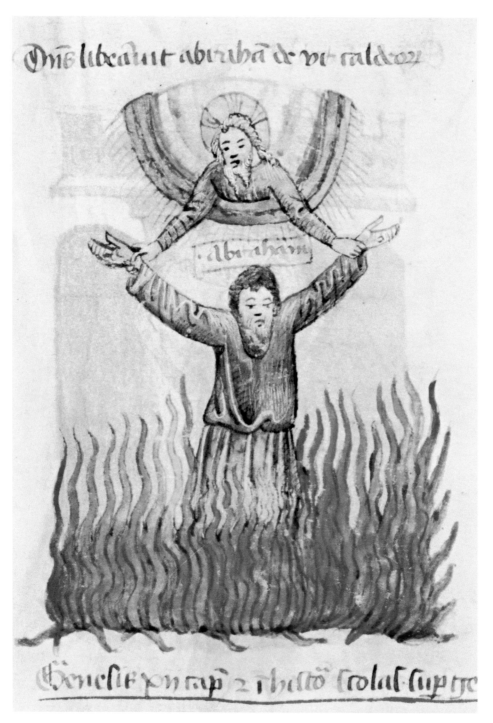

49. Abraham delivered from the fire of the Chaldees. Miniature; pen and color wash
from *Speculum Humanae Salvationis*, now in The Morgan Library and Museum, New York,
Ms. M. 385, fol. 34ʳ. Flemish, mid 15th century (photo: Morgan Library and Museum).

50. Abraham delivered from fire of the Chaldees. Pen drawing from *Speculum Humanae Salvationis*, now in The Morgan Library and Museum, New York, Ms. M . 766, fol. 53ʳ. English, possibly Yorkshire, *c.* 1400 (photo: Morgan Library and Museum).

51. Abraham delivered from fire of the Chaldees. Miniature; pen drawing with color wash from *Speculum Humanae Salvationis*, now in The Morgan Library and Museum, New York, Ms. M . 782, fol. 56ᵛ. German, possibly Augsburg, 1450–1460 (photo: Morgan Library and Museum).

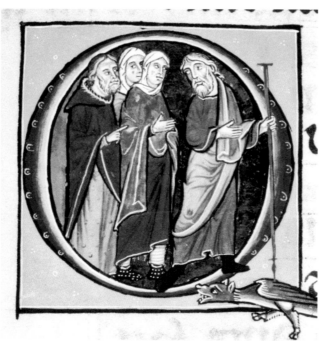

52. Abraham with staff leading Sarah and wife of Lot from Haran. Historiated initial Q from a Psalter now in The Morgan Library and Museum, New York, Ms. M. 338, fol. 172ʳ. French, *c.* 1200 (photo: Morgan Library and Museum).

ILLUMINATED
MANUSCRIPT

Berlin: Museum,
Staatliches Museen,
Kupferstichkab., 78.A.6
Psalter, fol. 1ʳ
Date: 2nd half 12th cent.

London: Library, British,
Cott. Claudius B.IV
Ælfric, *Paraphrase*,
fol. 21ʳ
Date: 1025–1049

London: Library, British,
Cott. Otho B.VI
Cotton Genesis,
fol. 18ᵛ
Date: 400–599

New York: Library,
Morgan, M. 338
Psalter, fol. 172ʳ
Date: *c.* 1200
Attribution: Ingeborg
Psalter, workshop
(Fig. 52)

Oxford: Library,
Bodleian, Auct. D.4.4
Psalter, fol. 55ᵛ
Date: 2nd half 14th cent.

Oxford: Library,
Bodleian, Auct. D.4.4
Psalter, fol. 70ʳ
Date: 2nd half 14th cent.

Oxford: Library,
Bodleian, Junius 11
Cædmon, *Poems*, p. 84
Date: 980–1020

Paris: Library, Bibl.
Nationale, fr. 15397
Bible, Jean de Sy, fol. 12ᵛ
Date: *c.* 1356

Prague: Library,
University, XXIII.C.124
Velislaus Miscellany,
fol. 12ᵛ
Date: 14th cent.

Rome: Library, Bibl.
Vaticana, gr. 746
Octateuch, fol. 64ʳ
Date: 1100–1199

Rome: Library, Bibl.
Vaticana, gr. 747
Octateuch, fol. 34ᵛ
Date: 1000–1099

Rovigo: Library,
Bibl. Accademia dei
Concordi, 212
Picture Bible, fol. 7ʳ
Date: 14th cent.

Smyrna: Library,
Evang. School, A.1
Octateuch, fol. 26ʳ
Date: 12th cent.
(Fig. 53)

Vienna: Library,
Nationalbibl.,
Ser. Nov. 2611
Psalter, fol. 7ʳ
Date: 1260–1270

MOSAIC

Venice: Church, S. Marco
Atrium, bay 5, dome
Date: 1200–1299

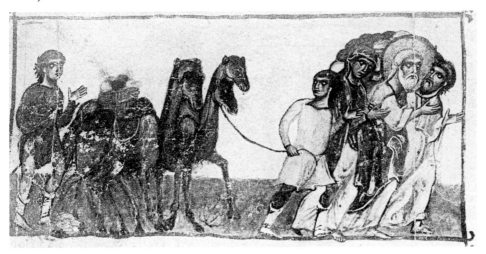

53. Departure from Haran. Miniature from the Smyrna Octateuch, formerly in The Evangelical School, Smyrna (Ms. A.1, fol. 26ʳ). Constantinople, 12th century (photo: Index of Christian Art).

Abraham: Dividing Beasts

ILLUMINATED MANUSCRIPT

Prague: Library, University, XXIII.C.124 Velislaus Miscellany, fol. 16ʳ
Date: 14th cent.

Abraham: Driving Away Fowls

ILLUMINATED MANUSCRIPT

Berlin: Museum, Staatliches Museen, Kupferstichkab., 78.A.6 Psalter, fols. 1ᵛ–2ʳ
Date: 2nd half 12th cent.

London: Library, British, Cott. Claudius B.IV Ælfric, *Paraphrase*, fol. 26ᵛ
Date: 1025–1049

Prague: Library, University, XXIII.C.124 Velislaus Miscellany, fol. 16ʳ
Date: 14th cent.

Rome: Library, Bibl. Vaticana, gr. 1162 James the Monk, Sermons, fol. 156ᵛ
Date: 1140–1159 (Fig. 54)

Abraham: Dwelling at Beersheba

ILLUMINATED MANUSCRIPT

Rome: Library, Bibl. Vaticana, gr. 746 Octateuch, fol. 83ᵛ
Date: 1100–1199

Rome: Library, Bibl. Vaticana, gr. 747 Octateuch, fol. 43ᵛ
Date: 1000–1099

Smyrna: Library, Evang. School, A.1 Octateuch, fol. 35ʳ
Date: 12th cent.

Vienna: Library, Nationalbibl., Theol. gr. 31 Genesis, fol. 6ʳ
Date: 6th cent.

Abraham: Eliezer Taking Oath

FRESCO

Bury St. Edmunds: Church, Abbey Choir
Date: 1100–1199

ILLUMINATED MANUSCRIPT

Amiens: Library, Bibl. de la Ville, 108 Pamplona Picture Bible, 1, fol. 13ᵛ
Date: 1197

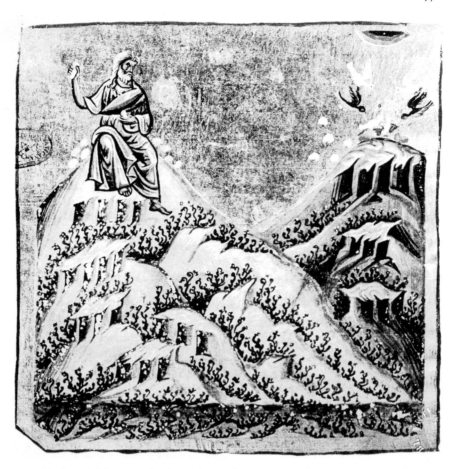

54. Abraham driving away fowls. Miniature from a manuscript of the Sermons of James the Monk, now in the Biblioteca Vaticana, Rome (Ms. gr. 1162, fol. 156ᵛ). Constantinople, 1140–1159 (photo: Index of Christian Art).

Arras: Library, Bibl.
Municipale, 561
Bible, fol. 4ᵛ
Date: 13th cent.

Istanbul: Library,
Topkapi Sarayi,
Cod. G.I.8
Seraglio Octateuch,
fol. 90ᵛ
Date: 11th cent.

Klagenfurt: Museum,
Landes, VI.19
Millstatt Miscellany,
fol. 30ʳ
Date: 1180–1220

London: Library, British,
Cott. Claudius B.IV
Ælfric, *Paraphrase*,
fol. 39ʳ
Date: 1025–1049

London: Library, British,
Egerton 1894
Genesis, fol. 12ᵛ
Date: 14th cent.

London: Library, British,
Roy.2 B.VII
Queen Mary Psalter,
fol. 12ʳ
Date: 1310–1320
(Fig. 55)

Oxford: Library,
Bodleian, 270b
Bible, Moralized,
fol. 16ʳ
Date: 1st half 13th cent.

Oxford: Library,
Bodleian,
Auct.D.4.4
Psalter, fol. 107ᵛ
Date: 2nd half 14th cent.

Paris: Library, Bibl.
Nationale, lat. 10525
St. Louis Psalter,
fol. 11ᵛ
Date: 1253–1270

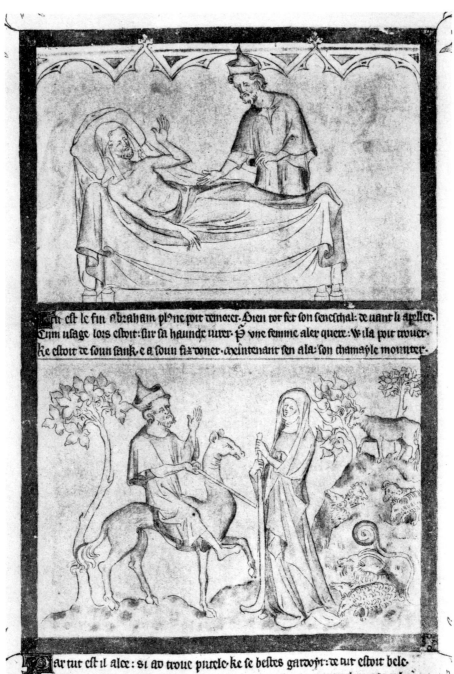

In eft le fin Abraham plone port tenorer. Dien tor fer fon feneſchal: te nant li apellet. Dun uſage lors eſtoit: ſur ſa haunde tuter. P vne femme aler quere: W ila port trouer. Ke eſtoit te ſoun ſank. e a ſoun fix toner. Orcintenant ſen ala: ſon chamayle monnter.

Par tut eſt il alee: ſi ao troue puele ke ſe beſtes garooſt: te tur eſtoit bele. Dit moi oites dimoiſele: ſi toe puiſſe aler. A cele bele fonteyne mon chamaile enbeuer. Mon uolunters ben ſire: la fonteyne e moye: Ine ya plo en co pais: mex toe la ws otrroye. Coment auex ws a noun: ele oit Rebecca. E qi eſt de toun ſank: abraham e ſarra. Tu auras yſaach: qe eſt riche ſire. voire ſyre uolunters: e te le vos uire

55. Eliezer taking an oath (*upper zone*), and Rebecca sought in marriage (*lower zone*). Full-page prefatory miniature from The Queen Mary Psalter, now in The British Library, London (Ms. Roy. 2 B.VII, fol. 12ʳ). Pen drawing with color wash. English, 1310–1320 (photo: Index of Christian Art).

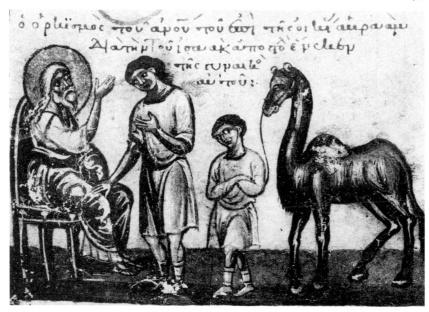

56. Eliezer taking an oath. Miniature from the Smyrna Octateuch, formerly in The Evangelical School, Smyrna (Ms. A.1, fol. 36ʳ). Constantinople, 12th century (photo: Index of Christian Art).

Prague: Library,
University, XXIII.C.124
Velislaus Miscellany,
fol. 23ᵛ
Date: 14th cent.

Rome: Library, Bibl.
Vaticana, gr. 746
Octateuch, fol. 85ʳ
Date: 1100–1199

Rome: Library, Bibl.
Vaticana, gr. 747
Octateuch, fol. 44ᵛ
Date: 1100–1199

Rovigo: Library,
Bibl. Academic dei
Concordi, 212
Picture Bible, fol. 14ᵛ
Date: 14th cent.

Smyrna: Library,
Evang. School, A.1
Octateuch, fol. 36ʳ
Date: 12th cent.
(Fig. 56)

Toledo: Library,
Bibl. del Cabildo
Bible, Moralized, I,
fol. 16ʳ
Date: 1st half 13th cent.

Vienna: Library,
Nationalbibl.,
Theol. gr. 31
Genesis, fol. 6ᵛ
Date: 500–599

*Abraham:
Entertaining the
Angels*

• — • — • — • — • — • — • — •

FRESCO

Assisi: Church,
S. Francesco, Upper
Nave, north wall,
zone 2
Date: 1280–1299

Bosra: Cathedral
Sanctuary —*cont.*

Date: 2nd half 13th–
early 14th cent.

Bury St. Edmunds:
Church, Abbey
Choir
Date: 1100–1199

Cologne: Church,
St. Maria-Lyskirchen
Nave
Date: mid 13th cent.

Čučer: Church,
St. Nicetas
Decoration
Date: 14th cent.

Ferentillo: Church,
S. Pietro in Valle, Nave
Date: 11th–12th cent.

Göreme: Church,
Elmali Kilise
Aisle, north, bay 2
Date: 1040–1060

Göreme: Church,
Karanlik Kilise —*cont.*

Narthex, west wall
Date: mid 11th cent.
(Fig. 57)

Göreme: Church,
Karanlik Kilise
Sanctuary
Date: mid 11th cent.
(Fig. 58)

Göreme: Church,
Tokali Kilise,
Sanctuary, north apse
Date: mid 10th cent.

Gračanica: Monastery,
Church
Decoration
Date: 1318–1321

Ihlara: Church,
Kokar Kilise
Nave
Date: early 10th–
11th cent.

Karan: Church,
Annunciation
Naos
Date: 1300–1349

Kiev: Cathedral,
St. Sophia
Decoration
Date: 11th cent.

Ktima: Monastery,
Agios Neophytos
Naos
Date: 1503

Lekhne: Church
Decoration
Date: 13th–14th cent.

Milan: Church,
S. Ambrogio
Date: 4th cent.

Mileševa: Monastery,
Church
Naos, east bay
Date: 1st half 13th cent.

Nereditsi: Church of
the Savior
Nave
Date: 1199

Novgorod: Cathedral,
St. Sophia
Date: 1152–1156

Novgorod: Church of
Transfiguration
Decoration
Date: 1378 and later

Ohrid: Church,
St. Sophia
Choir
Date: 11th–12th cent.

Padua: Baptistry
Decoration
Date: late 14th cent.

Parma: Baptistry
Dome, zone 4, no. 12
Date: 1250–1299

Parma: Baptistry
Dome, zone 4, no. 14
Date: mid 13th cent.

Patmos: Monastery,
St. John, Refectory
North wall, north bay
Date: 1200–1220

Patmos: Monastery,
St. John, Chapel of the
Virgin
Sanctuary
Date: 1175–1199

Peterborough: Cathedral
Decoration
Date: 12th cent.

Pomposa: Monastery,
Church
Nave, south wall, zone 1
Date: 1351

Pskov: Monastery,
Spas-Mirojski
Diaconicon
Date: 1156

Regensburg: Church,
St. Emmeram
Transept, west
Date: 12th cent.

Rome: Cemetery,
Nuova, Via Latina
Cubiculum B,
right wall
Date: 300–399

Rome: Church,
Old St. Peter's Basilica
Nave
Date: 891–896; 1277–1280

Rome: Church,
S. Giovanni a Porta
Latina
Nave
Date: 1191–1198

Rome: Church,
S. Paolo fuori le Mura
Nave
Date: 5th–6th cent.
and later

Rome: Church,
Sta. Maria Antiqua
Aisle, left
Date: 8th–9th cent.

Saint-Savin: Church,
Abbey
Nave
Date: 11th–12th cent.

Sant'Angelo in Formis:
Church
Aisle, north wall
Date: 1072–1087
(Fig. 59)

Sopoćani: Church,
Trinity
Transept, south
Date: 13th cent.

Spelies: Church,
Hodegetria
Nave, north wall, zone 1
Date: 1311

57. Abraham entertaining the angels. Fresco from the narthex of Karanlik Kilise, Göreme. Cappadocian, mid 11th century (photo: Catherine Jolivet Lévy).

58. Abraham entertaining the angels. Fresco from the sanctuary of Karanlik Kilise, Göreme. Cappadocian, mid 11th century (photo: Catherine Jolivet Lévy).

59. Abraham entertaining the angels. Fresco from Sant'An-gelo in Formis, north wall of aisle. Italian, c. 1072–1087 (photo: Colum Hourihane).

Trebizond: Church,
Hagia Sophia
Porch, north
Date: 2nd half 13th cent.

GLASS

Assisi: Church,
S. Francesco, Upper
Window, transept
Date: 13th cent.

Assisi: Church,
S. Francesco, Upper
Window, apse
Date: 13th cent.

Canterbury: Cathedral,
Christ
Window, choir,
Date: 13th cent.

Erfurt: Cathedral
Windows, choir
Date: 2nd half 14th–15th
cent.

Klosterneuburg:
Monastery
Windows
Date: late 13th–
14th cent.

ILLUMINATED
MANUSCRIPT

Amiens: Library,
Bibl. de la Ville, 108
Pamplona Picture Bible,
I, fol. 8v
Date: 1197

Augsburg: Library, Uni-
versitätsbibl., I.2 qu.15
Pamplona Picture Bible,
II, fol. 16r
Date: 1195–1205

Berlin: Library, Staats-
bibl., germ. fol. 1362
Biblia Pauperum,
fol. 5r
Date: 14th cent.

Berlin: Museum,
Staatliches Museen,
Kupferstichkab., 78.A.9
Hamilton Greek Psalter,
fol. 113v
Date: late 11th cent.

Berlin: Museum,
Staatliches Museen,
Kupferstichkab., 78.A.9
Hamilton Greek Psalter,
fol. 225r
Date: 1280–1320

Berne: Library,
Stadtbibl., 120 II
Peter of Eboli, *De Rebus
Sicilis*, fol. 143r
Date: 1195–1197

Berne: Library,
Stadtbibl., 264
Prudentius, *Psychomachia*,
fol. 33r
Date: 900–920

Brussels: Library, Bibl.
Royale, 9961-2
Psalter, fol. 40r
Date: 13th cent.

Brussels: Library, Bibl.
Royale, 9968-72
Prudentius, *Psychomania*,
fol. 76v
Date: 11th cent.

Brussels: Library, Bibl.
Royale, 9987-91
Prudentius, *Psychomachia*,
fol. 98v
Date: 900–999

Brussels: Library, Bibl.
Royale, 10066-77
Prudentius, *Psychomachia*,
fol. 114r
Date: 900–1049

Brussels: Library, Bibl.
Royale, 10175
*Histoire Ancienne Jusqu'à
César*, fol. 40r
Date: 1270–1280

Cambridge: Library, Corpus Christi College, 23
Prudentius, *Psychomachia*, fol. 5ᵛ
Date: 980–999

Cambridge: Library, St. John's College, K.26
Holland Psalter, fol. 9ᵛ
Date: 1270–1280

Cambridge: Library, Trinity College, B.11.4
Psalter, fol. 10ʳ
Date: 1220–1230

Chantilly: Museum, Condé, 1695/9
Ingeborg Psalter, fol. 10ᵛ
Date: 1195–1205

Chicago: Library, University, 125
Rotulus, section 4
Date: 1350–1399

Cologne: Library, Cathedral, 81
Prudentius, *Psychomachia*, fol. 65ᵛ
Date: 1000–1020

Constance: Museum, Rosgarten, 31
Biblia Pauperum, p. 6
Date: 14th cent.

Dijon: Library, Bibl. Communale, 562
Histoire Universalle, fol. 21ᵛ
Date: 1260–1270

Hague, The: Library, Koninklijke Bibl., 76 F 5
Picture Bible–*Vitae Sanctorum*, fol. 5ᵛ
Date: 1200–1220

Istanbul: Library, Topkapi Sarayi, Cod. G.I.8
Seraglio Octateuch, fol. 78ʳ
Date: 11th cent.

Jerusalem: Library, Greek Patriarchal, Staurou 109
Liturgy, John Chrysostom, section 15
Date: 11th–12th cent.

Klagenfurt: Museum, Landes, VI.19
Miscellany, fol. 27ʳ
Date: 12th–13th cent.

Leiden: Library, Bibl. der Universiteit, BPL 76 A
St. Louis Psalter, fol. 12ᵛ
Date: 1185–1205

Leiden: Library, Bibl. der Universiteit, Burm.Q.3
Prudentius, *Psychomachia*, fol. 121ᵛ
Date: 825–849

Leiden: Library, Bibl. der Universiteit, Voss. lat. oct. 15
Prudentius, *Psychomachia*, fol. 37ᵛ
Date: 11th cent.

Leningrad (St. Petersburg): Library, Public, Lat. Q.v.I.78
Breviary, fol. 21ᵛ
Date: 13th cent.

Lilienfeld: Library, Stiftsbibl., 151
Ulrich of Lilienfeld, *Concordantiae caritatis*, fol. 1ᵛ
Date: mid 14th cent.

Lilienfeld: Library, Stiftsbibl., 151
Ulrich of Lilienfeld, *Concordantiae caritatis*, fol. 75ᵛ
Date: mid 14th cent.

Lilienfeld: Library, Stiftsbibl., 151 —cont.

Ulrich of Lilienfeld, *Concordantiae caritatis*, fol. 122ᵛ
Date: mid 14th cent.

London: Library, British, Add. 15268
Histoire Universelle, fol. 24ᵛ
Date: 1280–1290

London: Library, British, Add. 19352
Theodore Psalter, fol. 62ᵛ
Date: 1066
Attribution: Theodore the Studite

London: Library, British, Add. 24199
Prudentius, *Psychomachia*, fol. 3ᵛ
Date: 980–1099

London: Library, British, Add. 28162
Somme le Roi, fol. 9ᵛ
Date: *c.* 1300

London: Library, British, Cott. Claudius B.IV
Ælfric, *Paraphrase*, fol. 29ᵛ
Date: 1025–1049

London: Library, British, Cott. Claudius B.IV
Ælfric, *Paraphrase*, fol. 30ʳ
Date: 1025–1049

London: Library, British, Cott. Cleo. C.VIII
Prudentius, *Psychomachia*, fol. 2ᵛ
Date: 11th cent.

London: Library, British, Cott. Otho B.VI
Cotton Genesis, fol. 25ʳ
Date: 400–599

London: Library, British, Cott. Otho B.VI
Cotton Genesis, fol. 26ᵛ
Date: 400–599

London: Library, British,
Cott. Titus D.XVI
Prudentius, *Psychomachia*,
fol. 4ʳ
Date: *c*. 1115–1120

London: Library, British,
Egerton 1894
Genesis, fol. 10ʳ
Date: 14th cent.

London: Library, British,
Roy. 2 B.VII
Queen Mary Psalter
fol. 11ʳ
Date: 1310–1320

London: Library,
Lambeth Palace, 3
Bible, 1, fol. 6ʳ
Date: 12th cent.

Lyons: Library, Palais du
commerce et des Arts, 22
Prudentius, *Psychomachia*,
fol. 5ʳ
Date: 11th cent.

Madrid: Museum,
Real Academia de la
Historia, 2, 3
Bible of S. Millán de la
Cogolla, 1,
fol. 19ᵛ
Date: 1200–1220

Manchester: Library,
University, John Ry-
lands, fr. 5
Old Testament Picture
Book, fol. 18ʳ
Date: 1225–1249

Moscow: Museum,
Historical, gr. 129
Chludoff Psalter, fol. 49ᵛ
Date: 9th cent.

Mount Athos:
Monastery, Iviron, 5
Gospel Book, fol. 457ᵛ
Date: 1200–1299

Munich: Library,
Staatsbibl., Cgm. 20
Biblia Pauperum, fol. 10ʳ
Date: 2nd half 14th cent.

Munich: Library,
Staatsbibl., Clm. 835
Psalter, fol. 11ᵛ
Date: 1200–1210

Munich: Library,
Staatsbibl., Clm. 935
Prayer Book, St. Hilde-
gardis, fol. 7ᵛ
Date: 12th cent.

Munich: Library,
Staatsbibl., gall. 16
Queen Isabella Psalter,
fol. 27ʳ
Date: *c*. 1303–1308

Munich: Library,
Staatsbibl., slav. 4
Serbian Psalter, fol. 229ʳ
Date: 1350–1420

New York: Library,
Morgan, H.5
Hours, fol. 42ʳ
Date: *c*. 1500
(Fig. 60)

New York: Library,
Morgan, M.43
Huntingfield Psalter,
fol. 10ʳ
Date: 1210–1220

New York: Library,
Morgan, M.230
Weigel-Felix Biblia
Pauperum, fol. 1ʳ
Date: *c*. 1435 & 16th cent.
(Fig. 61)

New York: Library,
Morgan, M.268
Picture Bible, fol. 4ʳ
Date: end of 14th cent.
(Fig. 62)

New York: Library,
Morgan, M.322–323
Bible Historiale of
Guyart des Moulins, 1,
fol. 28ᵛ
Date: *c*. 1325
Attribution: Maubeuge
Master
(Fig. 63)

New York: Library,
Morgan, M.338
Psalter, fol. 188ʳ
Date: 1195–1205
Attribution: Ingeborg
Psalter, workshop
(Fig. 64)

New York: Library,
Morgan, M.338
Psalter, fol. 189ᵛ
Date: 1195–1205
Attribution: Ingeborg
Psalter, workshop
(Fig. 65)

New York: Library,
Morgan, M.394
Bible Historiale of
Guyart des Moulins,
fol. 17ʳ
Date: 1400–1425
Attribution: Boucicaut
Master, workshop

New York: Library,
Morgan, M.394
Bible Historiale of
Guyart des Moulins,
fol. 17ᵛ
Date: 1400–1425
(Fig. 66)

New York: Library,
Morgan, M.485
Hours, fol. 176ʳ
Date: *c*. 1475 (Fig. 67)

New York: Library,
Morgan, M.653
Gradual, historiated
initial, no. 2
Date: 1392–1399 (Fig. 68)

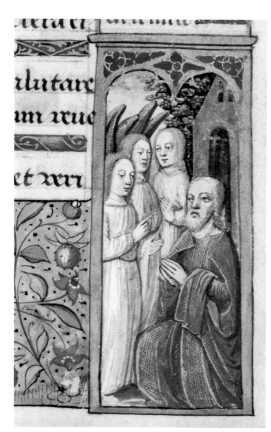

60. Abraham entertaining
the angels. Miniature from
a Book of Hours now in The
Morgan Library and Museum,
New York, Ms. H.5, fol. 42r.
French, *c.* 1500 (photo: Morgan Library and Museum).

61. Abraham entertaining the
angels. Pen drawing from the
Weigel-Felix Biblia Pauperum, now in The Morgan
Library and Museum, New
York, Ms. M.230, fol. 1r. Austrian, *c.* 1435 and 16th century
(photo: Morgan Library and
Museum).

62. Abraham entertaining the angels. Pen drawing with color wash from a Picture Bible now in The Morgan Library and Museum, New York, Ms. M. 268, fol. 4ʳ. German, end of the 14th century (photo: Morgan Library and Museum).

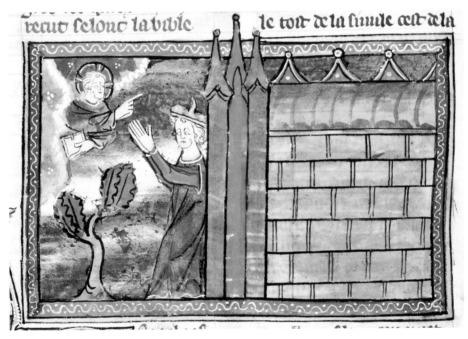

63. Abraham entertaining the angels. Christ-Logos emerges from sky and extends hand toward Abraham (angels not shown). Miniature from the Bible Historiale of Guyart des Moulins, now in The Morgan Library and Museum, New York, Ms. M. 322–323, I, fol. 28ᵛ. French, by the Maubeuge Master, *c.* 1325 (photo: Morgan Library and Museum).

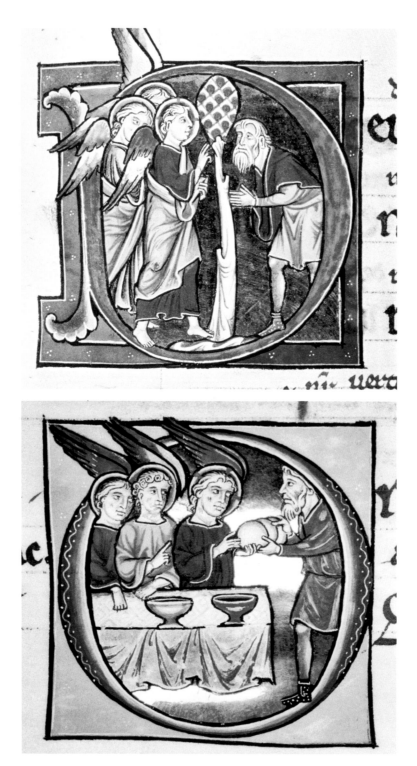

64 & 65. Abraham entertaining the angels. Historiated initials in illustration of Psalm 46 from a Psalter now in The Morgan Library and Museum, New York, Ms. M. 338, fols. 188ʳ and 189ᵛ. French, 1195–1205 (photo: Morgan Library and Museum).

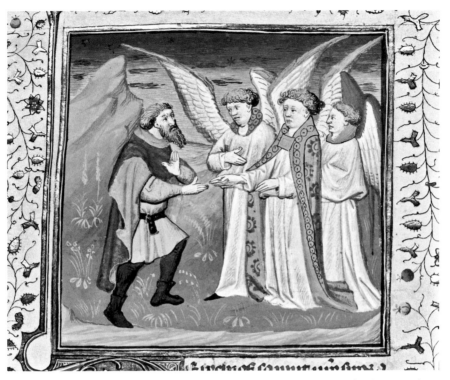

66. Abraham entertaining the angels. Miniature from the Bible Historiale of Guyart des Moulins, now in The Morgan Library and Museum, New York, Ms. M. 394, fol. 17ᵛ. French, 1400–1425 (photo: Morgan Library and Museum).

New York: Library,
Morgan, M.739
Hedwig of Silesia Hours,
fol. 10ᵛ
Date: 1204–1219
(Fig. 69)

New York: Library,
Morgan, M.742
Laudario
Date: 1335–1345

New York: Library,
Morgan, M.769
Christ-Herre Chronik,
fol. 42ʳ
Date: c. 1360
(Fig. 70)

New York: Library,
Morgan, M.877
Map of Palestine
Date: c. 1300
(Fig. 71)

Oxford: Library,
Bodleian, 270b
Bible, Moralized,
fol. 14ʳ
Date: 1st half 13th cent.

Oxford: Library,
Bodleian, Auct. D.4.4
Psalter,
fol. 88ʳ
Date: 2nd half 14th cent.

Paris: Library, Bibl.
Nationale, fr. 9682
Histoire Universelle,
fol. 24ᵛ
Date: c. 1300

Paris: Library, Bibl.
Nationale, n.a.l.3145
Hours of Jeanne of Na-
varre, fol. 23ʳ
Date: 1st half 14th cent.

Paris: Library, Bibl.
Nationale, gr. 923
John of Damascus, Sacra
Parallela, fol. 245ʳ
Date: 800–899

Paris: Library, Bibl.
Nationale, gr. 1242
John VI Cantacuzenus,
fol. 123ʳ
Date: 1371–1375

Paris: Library, Bibl.
Nationale, lat. 6
Roda Bible, 1,
fol. 12ᵛ
Date: 1000–1099

Paris: Library, Bibl.
Nationale, lat. 8085
Prudentius, Psychomachia,
fol. 56ʳ
Date: 9th cent.

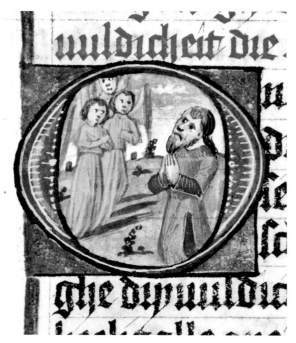

67. Abraham entertaining the angels. Historiated initial from a Book of Hours now The Morgan Library and Museum, New York, Ms. M. 485, fol. 176ʳ. Brabantine, possibly Brussels, *c.* 1475 (photo: Morgan Library and Museum).

68. Abraham entertaining the angels. Historiated initial from a Gradual (Diurno Domenicale of Santa Maria), now in The Morgan Library and Museum, New York, Ms. M. 653, no. 2. Brabantine, possibly Brussels, 1392–1399 (photo: Morgan Library and Museum).

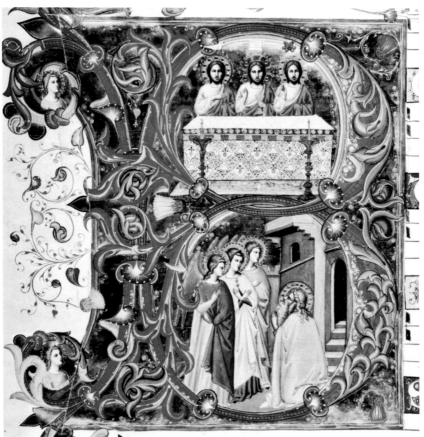

69. Abraham entertaining the angels. Miniature from a German manuscript (Hedwig of Silesia Hours), now in The Morgan Library and Museum, New York, Ms. M. 739, fol. 10ᵛ. Possibly Bohemian, 1204–1219 (photo: Morgan Library and Museum).

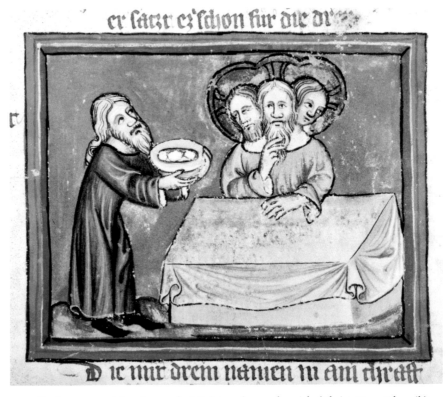

70. Abraham entertaining the angels. Miniature from a chronicle (Christ-Herre Chronik), now in The Morgan Library and Museum, New York, Ms. M. 769, fol. 42ʳ. German, possibly Bavarian, c. 1360 (photo: Morgan Library and Museum).

71. Abraham entertaining the angels. Detail from a map of Palestine now in The Morgan Library and Museum, New York, Ms. M. 877. Italian, possibly Venice, c. 1300 (photo: Morgan Library and Museum).

Paris: Library, Bibl. Nationale, lat. 8318 Prudentius, *Psychomachia*, fol. 50[r] Date: 980–999

Paris: Library, Bibl. Nationale, lat. 10525 Psalter of St. Louis, fol. 7[v] Date: 1253–1270

Paris: Library, Bibl. Nationale, lat. 18014 Duc de Berry Hours, fol. 188[r] Date: late 14th cent.

Paris: Museum, Musée Marmottan Monet Walters-Marmottan Miniatures: no. 4 Date: 1230–1240 Attribution: William de Brailles, workshop

Paris: Museum, Musée Marmottan Monet Walters-Marmottan Miniatures: nos. 113–114 Date: 1230–1240

Prague, Library, University, XXIII.C.124 Velislaus Miscellany, fol. 17[v] Date: 14th cent.

Prague: Library, University, XXIII.C.124 Velislaus Miscellany, fol. 18[r] Date: 14th cent.

Princeton: Library, University, Garrett 16 John Climacus, *Climax*, fol. 190[v] Date: 1081

Rome: Library, Bibl. Vaticana, Barb. gr. 372 Psalter, fol. 85[v] Date: 1050–1099

Rome: Library, Bibl. Vaticana, gr. 746 Octateuch, fol. 72[r] Date: 1100–1199

Rome: Library, Bibl. Vaticana, gr. 747 Octateuch, fol. 39[r] Date: 1100–1199

Rovigo: Library, Bibl. Academic dei Concordi, 212 Picture Bible, fol. 10[r] Date: 14th cent.

Saint Florian: Library, Stiftsbibl., III.207 Biblia Pauperum, fol. 4[r] Date: c. 1310

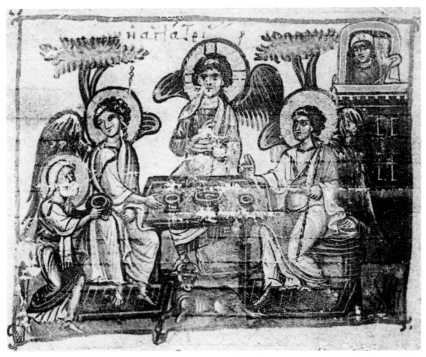

72. Abraham entertaining the angels. Miniature from the Smyrna Octateuch, formerly in The Evangelical School, Smyrna (Ms. A.I, fol. 30ʳ). Constantinople, 12th century (photo: Index of Christian Art).

Saint-Omer: Library,
Bibl. Municipale, 34
Origen, Homilies, fol. 1ᵛ
Date: 12th cent.

Salzburg: Library,
Stiftsbibl., Peter a.VII.43
Biblia Pauperum,
fol. 139ʳ
Date: late 14th cent.

Smyrna: Library,
Evang. School, A.I
Octateuch, fol. 30ʳ
Date: 12th cent.
(Fig. 72)

Strasbourg: Library,
Bibl. de la Ville
Herradis of Landsberg,
Hortus Delic., fol. 34ᵛ
Date: 12th cent.

Valenciennes: Library,
Bibl. Publique, 563 —*cont.*

Prudentius, *Psychomachia*,
fol. 3ʳ
Date: 800–899

Vienna: Library,
Nationalbibl., 1191
Bible, fol. 9ᵛ
Date: 14th cent.

Vienna: Library,
Nationalbibl., 1198
Biblia Pauperum, fol. 4ʳ
Date: 1st half 14th cent.

Vienna: Library,
Nationalbibl., 2576
Chronicon Mundi, fol. 19ʳ
Date: late 14th cent.

Vienna: Library,
Nationalbibl., 2739
Preces, fol. 5ᵛ
Date: 2nd half 12th cent.

Vienna: Library,
Nationalbibl., —*cont.*

Ser. Nov. 2611
Psalter, fol. 7ʳ
Date: 13th cent.

Weimar: Library,
Landesbibl., fol. max. 4
Biblia Pauperum, fol. 5ʳ
Date: 1st half 14th cent.

Zara: Church,
S. Francesco, MS. C
Antiphonary, fol. 19ʳ
Date: 13th cent.

IVORY

Frankfurt: Museum,
Städelsches Kunstinstitut
Plaque (on casket)
Date: 11th–12th cent.

METAL

Monreale: Cathedral
Door (bronze)
Date: *c.* 1185 (Fig. 73)

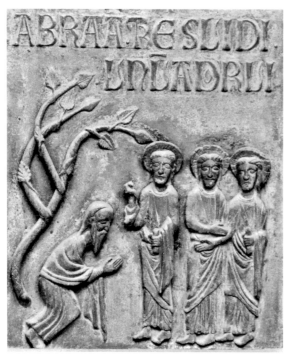

73. Abraham entertaining the angels. Monreale Cathedral, west portal doors, right valve. Italian, Pisan, by Bonanus of Pisa, c. 1185 (photo: Colum Hourihane).

Monte Sant'Angelo:
Church, S. Michele
Door (bronze)
Date: 1076

Rome: Church,
S. Giovanni in Laterano
Cross, reverse lower stem
Date: 1295–1305

Verona: Church, S. Zeno
Door (bronze)
Date: 2nd half 12th cent.
(Fig. 74)

MOSAIC

Monreale: Cathedral
Crossing
Date: 1180–1199

Monreale: Cathedral
Nave, south wall,
zone 3, no. 8
Date: late 12th cent.
(Fig. 75)

Monreale: Cathedral
Nave, south wall,
zone 3, no. 9
Date: late 12th cent.

Palermo: Chapel,
Cappella Palatina
Nave, south wall, zone 2
Date: mid 12th cent.
(Fig. 76)

Ravenna: Church,
S. Vitale
Sanctuary
Date: 2nd quarter 6th
cent. (Fig. 77)

Rome: Church,
Sta. Maria Maggiore
Nave, left wall
Date: 432–440

Venice: Church, S. Marco
Atrium
Date: 1200–1299

Zippori: Synagogue
Pavement, zones 6, 7
Date: 1st half 5th cent.

PAINTING

Athens: Museum, Benaki
Panel
Date: late 14th cent.
(Fig. 78)

Athens: Museum,
Byzantine and Christian
Panel, BXM 1544
Date: early 15th cent.
(Fig. 79)

Cambridge: Collection,
Seltman
Panel
Date: 1400–1599

Dečani: Church
Panel
Date: 1500–1599

Moscow: Gallery,
Tretjakovskaja Galereja
Panel
Date: early 16th cent.

Palermo: Museum,
Museo Diocesano
Panel
Date: 1400–1420

Patmos: Monastery,
St. John, Treasury
Vessel (wood)
Date: 14th cent.(?)

Riggisberg: Collection,
Abegg
Hanging, zone 1, no. 7
Date: 4th cent.

Riggisberg: Collection,
Abegg
Hanging, zone 2, no. 1
Date: 4th cent.

St. Petersburg:
Museum, Hermitage
Panel
Date: 1380–1420

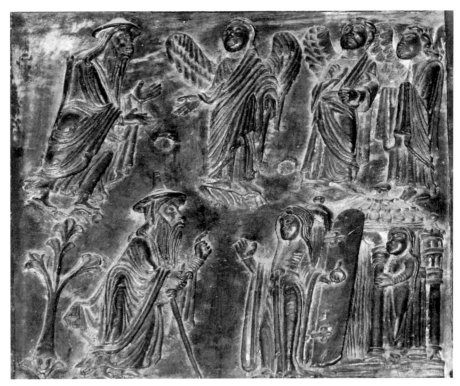

74. Abraham entertaining the angels. Panel from the bronze door of the west portal of San Zeno, Verona. 2nd half of the 12th century (photo: Colum Hourihane).

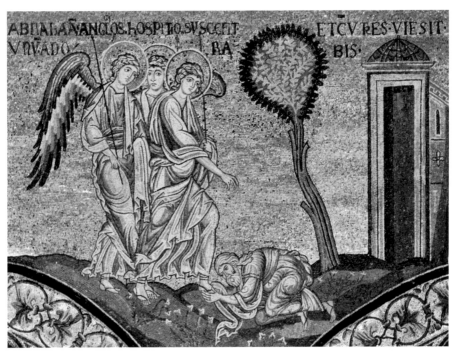

ABRAĀ ÑANGLOS. HOSPITIO. SVSCEPIT ET CV RES. VIE SIT:
VN VADO RA BIS·

75. Abraham entertaining the angels. Monreale Cathedral, mosaic, south wall. Italian, late 12th century (photo: Colum Hourihane).

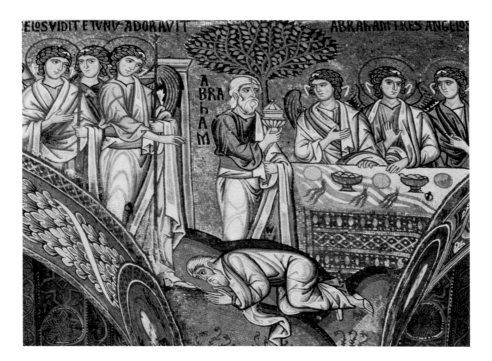

ELOS VIDIT ET TVNV ADORAVIT ABRAHAM TRES ANGELOS

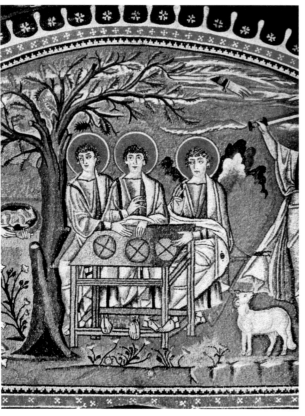

76. Abraham entertaining the angels. Mosaic from the south wall of the nave of the Cappella Palatina Chapel, Palermo. Mid 12th century (photo: Colum Hourihane).

77. Abraham entertaining the angels. Detail of a mosaic from the sanctuary (*left wall*) of San Vitale, Ravenna. 2nd quarter of the 6th century (photo: Wikimedia Commmons).

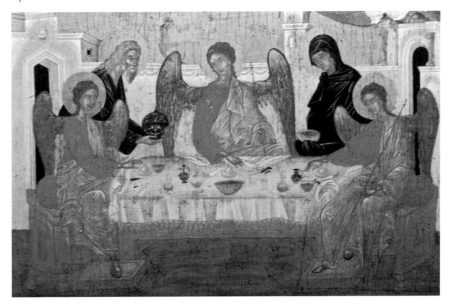

78. Abraham entertaining the angels. Icon painting from The Benaki Museum, Athens (inv. GE 2973). Late 14th century (photo: Colum Hourihane).

SCULPTURE

Arles: Church,
St.-Trophime, Cloister
Date: 1140–1155

Budapest: Museum,
Szépmüvészeti Múzeum
Relief
Date: 1100–1199

Capua: Church,
S. Marcello Maggiore
Exterior, south, portal,
archivolt
Date: 1100–1299

Cefalù: Collection,
Mâranto
Pendant (wood)
Date: 1200–1299

Gerona: Cathedral
Cloister
Date: 2nd half 12th cent.
(Fig. 80)

Issoire: Church,
St.-Austremoine
Exterior, north, relief
Date: c. 1150–1159

León: Church,
S. Isidoro
Chapel, capital 17
Date: 2nd half 11th cent.

Maestricht: Church,
Notre Dame
Capitals
Date: 12th–13th cent.

Monte Sant'Angelo:
Tower, Tomba di Rotari
Capital
Date: 1st half 12th cent.

Parma: Cathedral
Decoration
Date: 12th cent.

Piacenza: Cathedral
Nave
Date: 1122–1130

Princeton: Museum, Art
Relief (marble)
Date: 480–559

Salisbury: Cathedral,
Chapter House
Decoration, octagon
Date: 1280–1300

S. Cugat del Vallés:
Church
Cloister
Date: late 12th–
13th cent.

Soissons: Museum,
Municipal
Capital
Date: 12th cent.

Tarragona: Cathedral
Cloister
Date: 13th cent.

Toronto: Museum, Univ.
of Toronto Art Centre
Mold
Date: 5th–6th cent.

Vendôme: Church,
Trinité Abbey
Transepts
Date: 13th cent.

Zwolle: Church,
St. Michael
Relief
Date: 1200–1220

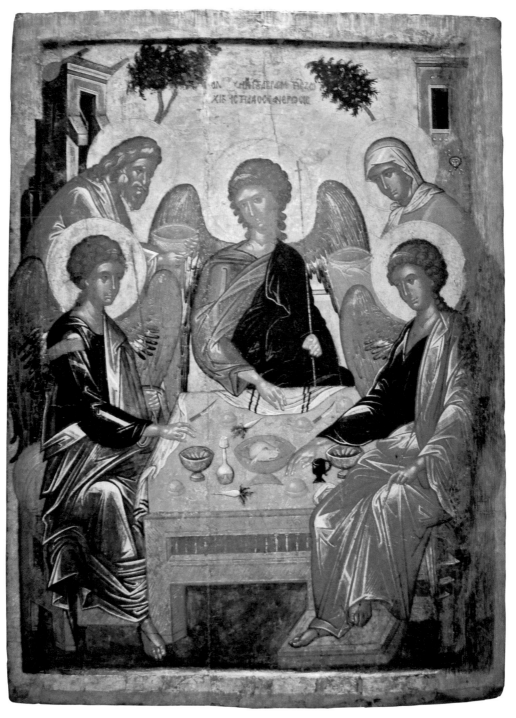

79. Abraham entertaining the angels. Icon painting from The Byzantine and Christian Museum, Athens (inv. BXM 1544). Early 15th century (photo: Colum Hourihane).

80. Abraham entertaining the angels. Carving from the cloister (southeast pier) of Gerona Cathedral. Spanish, 2nd half of the 12th century (photo: Colum Hourihane).

TERRA COTTA

Carthage: Museum,
Lavigerie
Lamp
Date: Before 700

TEXTILE

Berlin: Museum,
Staatliche Museen
Fabric, tapestry
Date: 500–699

Halberstadt: Cathedral
Hanging
Date: 1100–1199

Sankt Paul im Lavanttal:
Abbey
Vestment (chasuble;
embroidery)
Date: 12th–13th cent.

Abraham: Feast, Weaning of Isaac

ILLUMINATED MANUSCRIPT

Lilienfeld: Library,
Stiftsbibl., 151
Ulrich of Lilienfeld,
Concordantia caritatis,
fol. 168ᵛ
Date: mid 14th cent.

London: Library, British,
Cott. Claudius B.IV
Ælfric, *Paraphrase*,
fol. 35ᵛ
Date: 1025–1049

London: Library,
British, —*cont.*

Cott. Otho. B.VI
Cotton Genesis, fol. 32ᵛ
Date: 5th–6th cent.

Rome: Library, Bibl.
Vaticana, gr. 746
Octateuch, fol. 79ᵛ
Date: 1000–1099

Rome: Library, Bibl.
Vaticana, gr. 747
Ocatateuch, fol. 42ʳ
Date: 1000–1099

Rome: Library, Bibl.
Vaticana, gr. 747
Ocatateuch, fol. 79ᵛ
Date: 1000–1099

Smyrna: Library,
Evang. School, A.1
Octateuch, fol. 33ᵛ
Date: 12th cent.

Abraham: Gift to Isaac

FRESCO

Saint-Savin: Church, Abbey
Nave
Date: 11th–12th cent.

ILLUMINATED MANUSCRIPT

Lilienfeld: Library, Stiftsbibl., 151
Ulrich of Lilienfeld, *Concordatiae caritatis*, fol. 48v
Date: mid 14th cent.

Prague: Library, University, XXIII.C.124
Velislaus Miscellany, fol. 26r
Date: 14th cent.

Rovigo: Library, Bibl. Academic dei Concordi, 212
Picture Bible, fol. 16v
Date: 14th cent.

Abraham: Gifts to Sons of Concubines

ILLUMINATED MANUSCRIPT

London: Library, British, Egerton 1894
Genesis, fol. 13r
Date: 14th cent.

Prague: Library, University, XXIII.C.124
Velislaus Miscellany, fol. 26r
Date: 14th cent.

Rome: Library, Bibl. Vaticana, gr. 746
Octateuch, fol. 89r
Date: 1100–1199

Rome: Library, Bibl. Vaticana, gr. 747
Octateuch, fol. 46v
Date: 1000–1099

Rovigo: Library, Bibl. Academic dei Concordi, 212
Picture Bible, fol. 16v
Date: 14th cent.

Smyrna: Library, Evang. School, A.1
Octateuch, fol. 38r
Date: 12th cent.

Abraham: Giving Tithes to Melchisedek

ENAMEL

Klosterneuburg: Monastery
Retable
Date: 1181

FRESCO

Anagni: Cathedral, Sta. Maria
Crypt
Decoration
Date: *c.* 1173–1250

Anagni: Cathedral, Sta. Maria, Crypt
Vault
Date: 13th cent.

ILLUMINATED MANUSCRIPT

Eton: Library, Eton College, 177
Miscellany, fol. 3v
Date: 13th cent.

London: Library, British, Egerton 1894
Genesis: fol. 9r
Date: 14th cent.

Strasbourg: Library, Bibl. de la Ville —*cont.*

Herradis of Landsberg, *Hortus Delic.*, fol. 34v
Date: 12th cent.

Abraham: God Departing

ILLUMINATED MANUSCRIPT

London: Library, British, Cott. Claudius B.IV
Ælfric, *Paraphrase*, fol. 31r
Date: 1025–1049

London: Library, British, Cott. Otho. B.VI
Cotton Genesis, fol. 27r
Date: 5th–6th cent.

Abraham: Hagar Sent Away

FRESCO

Parma: Baptistry
Dome
Date: 1250–1299

Rome: Church, St. Peter's Basilica, Old Nave
Date: 891–896; 1277–1280

ILLUMINATED MANUSCRIPT

Amiens: Library, Bibl. de la Ville, 108
Pamplona Picture Bible, I, fol. 11r
Date: 1197

Cambridge: Library, Trinity College, R.17.1
Canterbury Psalter, fol. 10r
Date: mid 12th cent.

Cambridge: Library, University, Ee.4.24
Psalter, fol. 6v
Date: 2nd half 13th cent.

Istanbul: Library,
Topkapi Sarayi,
Cod. G.I.8
Seraglio Octateuch,
fol. 75r
Date: 11th cent.

London: Library, British,
Cott. Claudius B.IV
Ælfric, *Paraphrase*,
fol. 36r
Date: 1025–1049

London: Library, British,
Cott. Otho B.VI
Cotton Genesis,
fol. 34v
Date: 400–599

Munich: Library,
Staatsbibl., gall. 16
Queen Isabella Psalter,
fol. 28v
Date: *c.* 1303–1308

New York: Library,
Morgan, M.268
Picture Bible, fol. 4r
Date: end 14th cent.
(Fig. 81)

Oxford: Library,
Bodleian, Auct.D.4.4
Psalter, fol. 105r
Date: 2nd half 14th cent.

Paris: Library, Bibl. de
l'Arsenal, 5059
Jean de Papeleu, Bible,
fol. 57v
Date: 1317

Philadelphia: Library,
Free, Lewis 185
Psalter, fol. 34r
Date: 13th cent.

Prague: Library,
University, XXIII.C.124
Velislaus Miscellany,
fol. 21r
Date: 14th cent.

Rome: Library, Bibl.
Vaticana, gr. 746
Ocatateuch, fol. 71r
Date: 1100–1199

Rome: Library, Bibl.
Vaticana, gr. 746
Octateuch, fol. 80r
Date: 1100–1199

Rome: Library, Bibl.
Vaticana, gr. 747
Octateuch, fol. 42v
Date: 1000–1099

Rovigo: Library,
Bibl. Academic dei
Concordi, 212
Picture Bible, fol. 12v
Date: 14th cent.

Smyrna: Library,
Evang. School, A.1
Octateuch, fol. 29v
Date: 12th cent.

Smyrna: Library,
Evang. School, A.1
Octateuch, fol. 34r
Date: 12th cent.
(Fig. 82)

SCULPTURE

Autun: Cathedral,
St.-Lazare
Exterior, west
Date: 1120–1135

Lyons: Cathedral
Exterior, west, central
portal
Date: 1308–1332

Abraham: Hagar Taken

FRESCO

Bury St. Edmunds:
Church, Abbey
Choir
Date: 1100–1199

ILLUMINATED MANUSCRIPT

Klagenfurt: Museum,
Landes, VI.19
Millstatt Miscellany,
fol. 26r
Date: 1180–1220

London: Library, British,
Cott. Claudius B.IV
Ælfric, *Paraphrase*, fol.27v
Date: 1025–1049

London: Library, British,
Cott. Otho B.VI
Cotton Genesis, fol. 23v
Date: 400–599

London: Library, British,
Egerton 1894
Genesis, fol. 9r
Date: 14th cent.

London: Library, British,
Roy.2 B.VII
Queen Mary Psalter,
fol. 9v
Date: 1310–1320

Munich: Library,
Staatsbibl., gall. 16
Queen Isabella Psalter,
fol. 26v
Date: *c.* 1303–1308

Paris: Library, Bibl.
Nationale, fr. 1356
Bible, Jean de Sy, fol. 20v
Date: *c.* 1356

Prague: Library,
University, XXIII.C.124
Velislaus Miscellany,
fol. 16v
Date: 14th cent.

Prague: Library,
University, XXIII.C.124
Velislaus Miscellany,
fol. 20v
Date: 14th cent.

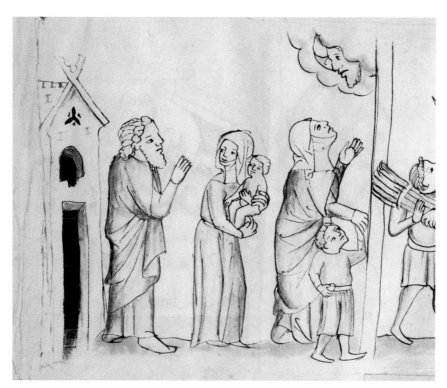

81. Hagar sent away. Detail from a Picture Bible now in The Morgan Library and Museum, New York, Ms. M. 268, fol. 4ʳ. Pen drawing with color wash. German, end of the 14th century (photo: Morgan Library and Museum).

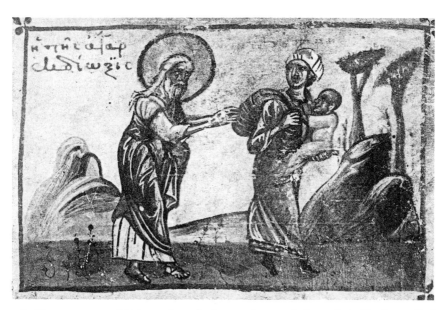

82. Hagar sent away. Miniature from the Smyrna Octateuch, formerly in The Evangelical School, Smyrna (Ms. A.1, fol. 34ʳ). Constantinople, 12th century (photo: Index of Christian Art).

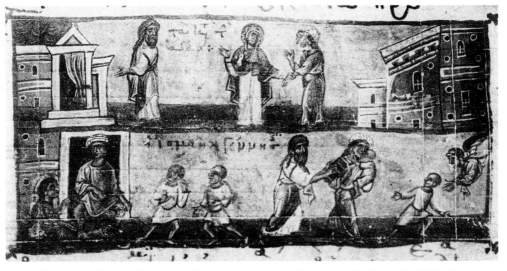

83. Hagar taken. Miniature from the Smyrna Octateuch, formerly in The Evangelical School, Smyrna (Ms. A.1, fol. 29ᵛ). Constantinople, 12th century (photo: Index of Christian Art).

Rome: Library, Bibl. Vaticana, gr. 746 Octateuch, fol. 71ʳ
Date: 1100–1199

Rome: Library, Bibl. Vaticana, gr. 747 Octateuch, fol. 37ᵛ
Date: 1000–1099

Rovigo: Library, Bibl. Academic dei Concordi, 212 Picture Bible, fol. 9ʳ
Date: 14th cent.

Smyrna: Library, Evang. School, A.1 Octateuch, fol. 29ᵛ
Date: 12th cent. (Fig. 83)

METAL

Verona: Church, S. Zeno Door (bronze)
Date: 11th–12th cent.

MOSAIC

Venice: Church, S. Marco Atrium
Date: 1200–1299

SCULPTURE

Geneva: Cathedral, St.-Pierre Nave
Date: 2nd half 12th cent.

Abraham: In Mandorla

ILLUMINATED MANUSCRIPT

Rome: Library, Bibl. Vaticana, Reg. lat. 12 Bury St. Edmunds Psalter, fol. 72ʳ
Date: 2nd quarter 11th cent.

Abraham: Infancy

ILLUMINATED MANUSCRIPT

London: Library, British, Cott. Claudius B.IV Ælfric, *Paraphrase*, fol. 19ᵛ
Date: 1025–1049

Rome: Library, Bibl. Vaticana, gr. 746 Octateuch, fol. 63ʳ
Date: 1100–1199

Rome: Library, Bibl. Vaticana, gr. 747 Octateuch, fol. 34ʳ
Date: 1000–1099

Smyrna: Library, Evang. School, A.1 Octateuch, fol. 25ʳ
Date: 12th cent. (Fig. 84)

Abraham: Instructing Sarah

ILLUMINATED MANUSCRIPT

London, Library, British, Cott. Claudius B.IV Ælfric, *Paraphrase*, fol. 22ʳ
Date: 1025–1049

Oxford: Library, Bodleian, 270b —*cont.*

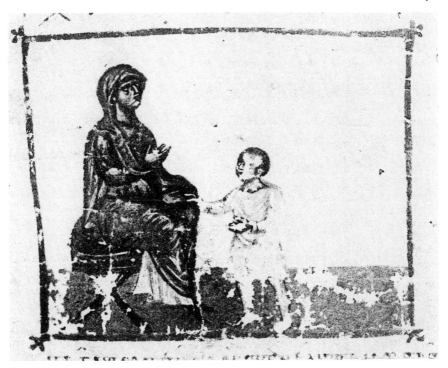

84. Abraham in infancy. Miniature from the Smyrna Octateuch, formerly in The Evangelical School, Smyrna (Ms. A.1, fol. 25r). Constantinople, 12th century (photo: Index of Christian Art).

Bible, Moralized,
fol. 11v
Date: 1st half 13th cent.

Paris: Library, Bibl.
Nationale, gr. 923
John of Damascus, *Sacra Parallela*, fol. 205v
Date: 800–899

Prague: Library,
University, XXIII.C.124
Velislaus Miscellany,
fol. 13r
Date: 14th cent.

Prague: Library,
University, XXIII.C.124
Velislaus Miscellany,
fol. 20r
Date: 14th cent.

Rovigo: Library, Bibl.
Academic dei —*cont.*

Concordi, 212
Picture Bible, fol. 7v
Date: 14th cent.

Abraham: Journey

ILLUMINATED MANUSCRIPT

London: Library, British,
Cott. Claudius B.IV
Ælfric, *Paraphrase*,
fol. 24r
Date: 1025–1049

London: Library, British,
Egerton 1894
Genesis, fol. 8r
Date: 14th cent.

Paris: Library, Bibl.
Nationale, fr. 15397
Bible, Jean de Sy, fol. 16r
Date: *c.* 1356

SCULPTURE

Toscanella: Church,
Sta. Maria Maggiore
Exterior, west
Date: early 13th cent.

Abraham: Journey to Egypt

ILLUMINATED MANUSCRIPT

Amiens: Library,
Bibl. de la Ville, 108
Pamplona Picture Bible,
I, fol. 5v
Date: 1197

Augsburg: Library, Univeritätsbibl., 1.2.qu.15
Pamplona Picture Bible,
II, fol. 13r
Date: 1195–1205

London: Library, British,
Cott. Claudius B.IV
Ælfric, *Paraphrase*, fol. 21ᵛ
Date: 1025–1049

London: Library, British,
Cott. Otho B.VI
Cotton Genesis, fol. 19ʳ
Date: 400–599

London: Library, British,
Egerton 1894
Genesis, fol. 6ᵛ
Date: 14th cent.

Oxford: Library,
Bodleian, Junius 11
Cædmon, *Poems*, p. 88
Date: 980–1020

Rovigo: Library,
Bibl. Academic dei
Concordi, 212
Picture Bible, fol. 7ᵛ
Date: 14th cent.

Vienna: Library,
Nationalbibl., 2576
Chronicon Mundi, fol. 16ᵛ
Date: late 14th cent.

Abraham: Journey to Gerar

ILLUMINATED MANUSCRIPT

London: Library, British,
Cott. Otho B.VI
Cotton Genesis, fol. 31ᵛ
Date: 400–599

Abraham: Marriage with Keturah

ILLUMINATED MANUSCRIPT

Rovigo: Library,
Bibl. Academic dei Con-
cordi, 212 —*cont.*

Picture Bible, fol. 16ʳ
Date: 14th cent.

Abraham: Met by King of Sodom

ILLUMINATED MANUSCRIPT

Amiens: Library,
Bibl. de la Ville, 108
Pamplona Picture Bible,
I, fol. 7ᵛ
Date: 1197

Augsburg: Library, Uni-
versitätsbibl., I.2.qu.15
Pamplona Picture Bible,
II, fol. 15ʳ
Date: *c.* 1200

Lilienfeld: Library,
Stiftsbibl., 151
Ulrich of Lilienfeld, *Con-
cordantiae caritatis*, fol. 35ᵛ
Date: mid 14th cent.

London: Library, British,
Cott. Claudius B.IV
Ælfric, *Paraphrase*,
fol. 25ᵛ
Date: 1000–1099

London: Library, British,
Cott. Otho B.VI
Cotton Genesis, fol. 19ᵛ
Date: 400–599

London: Library, British,
Cott. Otho. B.VI
Cotton Genesis, fol. 21ᵛ
Date: 5th–6th cent.

London: Library, British,
Egerton 1894
Genesis, fol. 9ʳ
Date: 14th cent.

Vienna: Library,
Nationalbibl., Theol.
gr. 31
Genesis, fol. 4ʳ
Date: 500–599

MOSAIC

Venice: Church, S. Marco
Atrium
Date: 1340–1360

Abraham: News of Nahor's Children

ILLUMINATED MANUSCRIPT

London: Library, British,
Cott. Otho. B.VI
Cotton Genesis, fol. 38ʳ
Date: 5th–6th cent.

Paris: Library, Bibl.
Nationale, fr. 15397
Bible, Jean de Sy, fol. 36ᵛ
Date: *c.* 1356

Prague: Library,
University, XXIII.C.124
Velislaus Miscellany,
fol. 23ʳ
Date: 14th cent.

Abraham: Planting Tree

ILLUMINATED MANUSCRIPT

London: Library, British,
Cott. Claudius B.IV
Ælfric, *Paraphrase*, fol. 37ʳ
Date: 1000–1099

Prague: Library,
University,
XXIII.C.124
Velislaus Miscellany,
fol. 21ᵛ
Date: 14th cent.

SCULPTURE

Burgos: Museum,
Museo De Burgos
Sarcophagus, 79
Date: 6th–7th cent.

Abraham: Possessions in Egypt

ILLUMINATED MANUSCRIPT

London: Library, British, Cott. Claudius B.IV
Ælfric, *Paraphrase*, fol. 22ᵛ
Date: 1000–1099

Abraham: Praying for Abimelech

ILLUMINATED MANUSCRIPT

Lilienfeld: Library, Stiftsbibl., 151
Ulrich of Lilienfeld, *Concordantiae caritatis*, fol. 152ᵛ
Date: mid 14th cent.

Abraham: Representing Paradise (Bosom of Abraham)

ENAMEL

Klosterneuburg: Monastery
Retable
Date: 1181

FRESCO

Barluenga: Church, S. Miguel, Apse
Date: 13th cent.

Civate: Church, S. Pietro
Narthex, portal, east wall
Date: 1080–1099

Cologne: Church, St. Severin
Crypt
Date: 2nd half 13th– early 14th cent.

Dädesjö: Church
Nave
Date: 13th cent.

Dečani: Church
Naos, bay 2
Date: 1333–1352

Kiev: Monastery, Church, St. Cyril
Date: 12th cent.

Maalov: Church
Decoration
Date: 1200–1225

Nabk: Mar Musa al-Habashi, Monastery, Church
Nave, west wall, zone 3
Date: 1192

Nereditsi: Church of the Savior
Nave
Date: 1199

Parma: Baptistry
Niche
Date: 14th–15th cent.

Ramersdorf: Chapel of the Teutonic Order
Decoration
Date: late 13th–early 14th cent.

Saint-Loup-de-Naud: Church
Choir
Date: 1140–1160

Sargenroth: Church, Nunkirche
Tower
Date: 13th cent.

Skiby: Church
Decoration
Date: 1175–1200

Soğanlı: Church, Canavar Kilise
Chapel
Date: 11th cent. or later
(Fig. 85)

Thessaloniki: Church, Panagia Chalkeon
Narthex, west wall, zone 1
Date: 1028

Torri in Sabina: Church, Sta. Maria in Vescovio
Nave, entrance wall
Date: 1250–1299

GLASS

Bourges: Cathedral
Window, outer ambulatory
Date: *c.* 1210–1215
(Fig. 86)

Bourges: Cathedral
Windows, Holy Cross Chapel
Date: 13th cent.

Chartres: Cathedral, Notre-Dame
Window, west wall, clerestory
Date: 13th cent. (Fig. 87)

Paris: Cathedral, Notre Dame
Window, north rose
Date: mid 13th cent.

Strasbourg: Museum, Musée Archéologique
Vessel
Date: 300–399

ILLUMINATED MANUSCRIPT

Amiens: Library, Bibl. de la Ville, 108
Pamplona Picture Bible, I, fol. 255ᵛ
Date: 1197

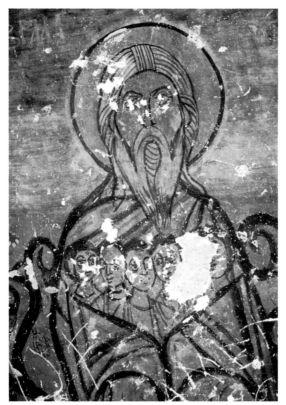

85. Abraham representing Paradise. Fresco from the nave vault of Canavar Kilise, Soğanlı. Cappadocian, 11th century or later (photo: Catherine Jolivet Lévy).

Amsterdam: Museum, Rijksmuseum, KOG 29
Book of Hours, fol. 103ᵛ
Date: c. 1480

Arras: Library, Bibl. Municipale, 38
Missal, Mont-Saint-Éloi, fol. 106ʳ
Date: 1245–1255

Augsburg: Library, Universitätsbibl., I.2.qu.15
Pamplona Picture Bible, II, fol. 271ᵛ
Date: 1195–1205

Baltimore: Museum, Walters Art, 539
Gospel Book, fol. 109ᵛ
Date: 1262 —cont.

Attribution: T'oros Roslin

Brno: Archiv, Městský
Miniature
Date: 13th cent.

Brussels: Library, Bibl. Royale, 9916-17
Gregory, Dialogi, fol. 110ʳ
Date: 2nd half 12th cent.

Cambridge: Library, University, Mm.V.31
Alexander Laicus, In Apocalipsin, fol. 75ᵛ
Date: 13th cent.

Cleveland: Museum of Art, 1933.448.1-2
Miniatures, no. 2
Date: 13th cent.

Copenhagen: Library, Universitet, E don. var. 52, 2
Necrology, fol. 43ᵛ
Date: 1st half 13th cent.

Dresden: Collection, Arnhold
Psalter, fol. 113ᵛ
Date: mid 13th cent.

Florence: Library, Bibl. Laurenziana, Plut. XXV. 3
Supplicationes Variae, fol. 382ʳ
Date: 1293–1300

Fulda: Library, Landesbibl., A.a.32
Sacramentary, fol. 163ᵛ
Date: c. 1200

Hague, The: Library, Koninklijke Bibl., 76 F 5
Picture Bible—Vitae Sanctorum, fol. 45ʳ
Date: 1200–1220

Liverpool: Library, Public, 12004
Psalter, fol. 90ᵛ
Date: 1st half 13th cent.

London: Library, British, Add. 19352
Theodore Psalter, fol. 24ᵛ
Date: 1066
Attribution: Theodore the Studite

London: Library, British, Add. 39627
Gospel Book of John Alexander, fol. 124ʳ
Date: 1356

London: Library, British, Add. 39627
Gospel Book of John Alexander, fol. 188ʳ
Date: 1356

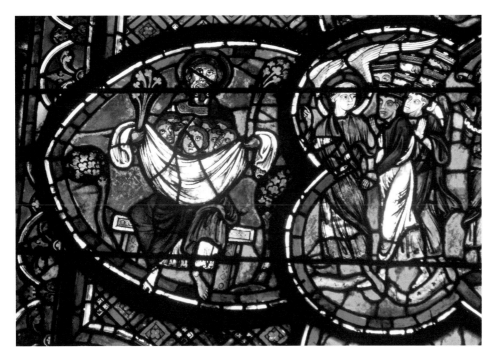

86. Abraham representing Paradise. Stained glass (window 6, detail) from the outer ambulatory of Bourges Cathedral. French, *c.* 1210–1215 (photo: Colum Hourihane).

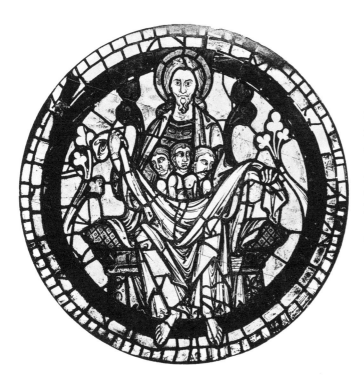

87. Abraham representing Paradise. Stained glass from the west wall of the nave (clerestory) of Chartres Cathedral. French, 13th century (photo: public domain).

Los Angeles: Museum,
Getty, Ludwig VIII.2
Würzburg Psalter,
fol. 113v
Date: 1241–1255

Milan: Library, Bibl.
Capitolo Metropolitano,
II.D.2.32
Missal, fol. 77v
Date: 14th cent.

Munich: Archive,
Hauptstaatsarchiv,
Obermünster 1
Necrology of Ober-
münster, fol. 74v
Date: 2nd half 12th cent.

Munich: Museum, Staat-
liche Graphische Samm-
lung, 39767-39770
Miniatures from Psalter
Date: 2nd half 12th cent.

New York: Library,
Morgan, M.43
Huntingfield Psalter,
fol. 21r
Date: 1210–1220
(Fig. 88)

New York: Library,
Morgan, M.92
Hours, fol. 113v
Date: 2nd quarter 13th
cent. (Fig. 89)

New York: Library,
Morgan, M.158
Speculum Humanae Salva-
tionis, fol. 53v
Date: c. 1476 (Fig. 90)

New York: Library,
Morgan, M.179
Hours, fol. 132r
Date: 1480–1500

New York: Library,
Morgan, M.280
Psalter, fol. 53v
Date: 1235–1250
(Fig. 91)

New York: Library,
Morgan, M.431
Hours, fol. 115r
Date: early 16th cent.
(Fig. 92)

New York: Library,
Morgan, M.440
Psalter-Hours, fol. 219v
Date: 1261

New York: Library,
Morgan, M.498
Bridget of Sweden,
Revelations, fol. 4v
Date: 1375–1399

New York: Library,
Morgan, M.710
Bertholdus Missal,
fol. 123r
Date: early 13th cent.

New York: Library,
Morgan, M.894
Ludolph of Saxony, Vita
Christi, fol. 94r
Date: c. 1485 (Fig. 93)

New York: Library,
Morgan, M.969
Bible, fol. 447v
Date: last quarter 13th
cent.

Oxford: Library,
Bodleian, Douce 50
Psalter, p. xvii
Date: 2nd half 13th cent.

Oxford: Library,
Bodleian, Douce 381
Miscellany, fol. 124r
Date: 13th cent.

Oxford: Library, Keble
College, 49
Legendarium, fol. 239r
Date: 2nd half 13th cent.

Palermo: Library, Bibl.
Nazionale, I.F.6-I.F.7
Bible, I, fol. 1r
Date: 13th cent.

Paris: Library, Bibl.
de l'Arsenal, 1186
Psalter of Blanche of
Castile, fol. 171r
Date: 1220–1226

Paris: Library, Bibl.
Nationale, gr. 74
Gospel Book, fol. 51v
Date: 1000–1099

Paris: Library, Bibl.
Nationale, gr. 74
Gospel Book, fol. 93v
Date: 1000–1099

Paris: Library, Bibl.
Nationale, gr. 74
Gospel Book,
fol. 145v
Date: 1000–1099

Parma: Library, Bibl.
Palatina, parm. 3285
Dante, Divina Commedia,
fol. 61r
Date: 14th cent.

Philadelphia: Library,
Free, Lewis 185
Psalter, fol. 24v
Date: 13th cent.

Princeton: Library,
University, Garrett 57
Hours, fol. 167r
Date: c. 1500
(Fig. 94)

Rome: Library, Bibl.
Vaticana, Barb. gr. 372
Psalter, fol. 39r
Date: 1050–1099

Rome: Library, Bibl.
Vaticana, gr. 394
John Climacus, Climax,
fol. 12v
Date: 1080–1099

Rome: Library, Bibl.
Vaticana, gr. 752
Psalter, fol. 42v
Date: 1059

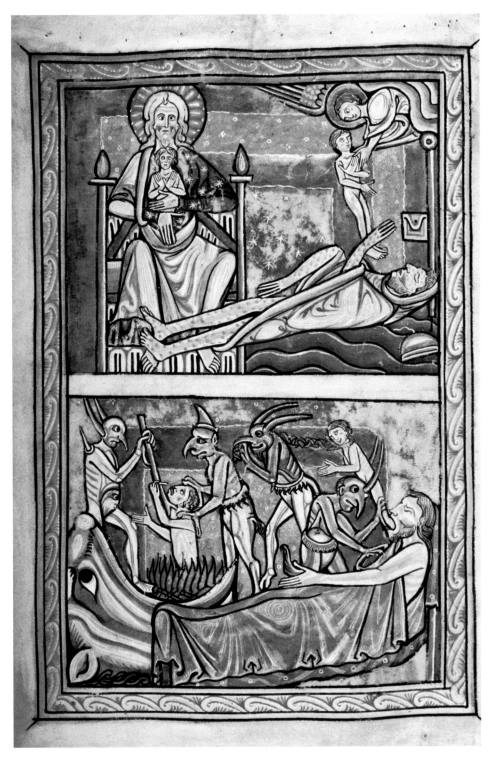

88. Abraham representing Paradise. Full-page prefatory miniature from the Huntingfield Psalter, now in The Morgan Library and Museum, New York, Ms. M. 43, fol. 21ʳ. English, possibly Oxford, 1210–1220 (photo: Morgan Library and Museum).

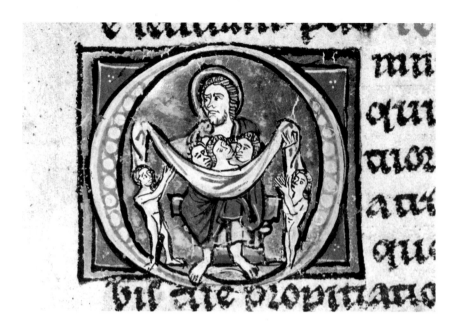

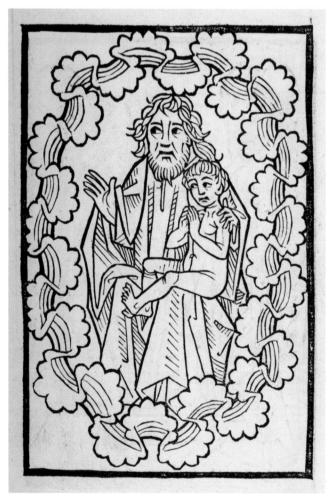

89. Abraham representing Paradise. Historiated initial from a Book of Hours now in The Morgan Library and Museum, New York, Ms. M. 92, fol. 113ᵛ. French, 2nd quarter of the 13th century (photo: Morgan Library and Museum).

90. Abraham representing Paradise. Quarter-page woodcut from *Speculum Humanae Salvationis*, now in The Morgan Library and Museum, New York, Ms. M. 158, fol. 53ᵛ. Swiss, *c.* 1476 (photo: Morgan Library and Museum).

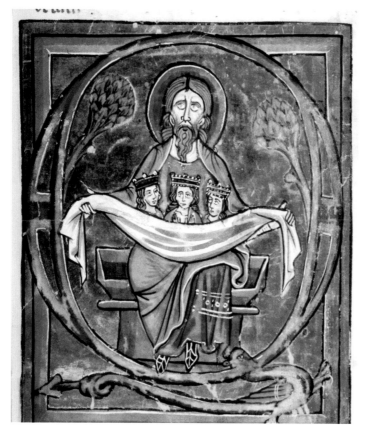

91. Abraham representing Paradise. Historiated initial from a Psalter now in The Morgan Library and Museum, New York, Ms. M. 280, fol. 53ᵛ. German, 1235–1250 (photo: Morgan Library and Museum).

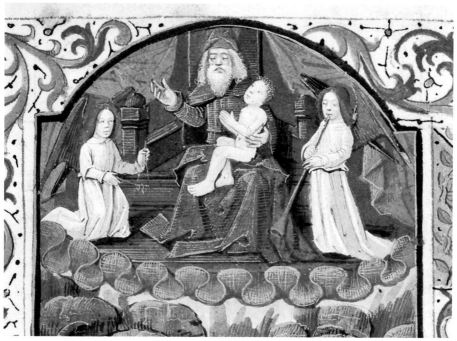

92. Abraham representing Paradise. Three-quarter-page miniature from a Book of Hours now in The Morgan Library and Museum, New York, Ms. M. 431, fol. 115ʳ. French, possibly Rouen, early 16th century (photo: Morgan Library and Museum).

plus humbles et plus parfaittes comme figure et represente

93. Abraham representing Paradise. Miniature from Ludolph of Saxony's *Vita Christi*, now in The Morgan Library and Museum, New York, Ms. M. 894, fol. 94ʳ. Flemish, Bruges, Master of Edward IV, *c.* 1485 (photo: Morgan Library and Museum).

94. Abraham representing Paradise, with Parable of Lazarus and Dives in the foreground. Historiated initial from a Book of Hours now in Princeton University Library, Ms. Garrett 57, fol. 167ʳ. Dutch, *c.* 1500 (photo: Princeton University Library).

Rome: Library, Bibl.
Vaticana, gr. 1156
Lectionary, fol. 282ᵛ
Date: 11th cent.

Rome: Library, Bibl.
Vaticana, Reg. lat. 12
Psalter, fol. 72ʳ
Date: early 11th cent.

Strasbourg: Library,
Bibl. de la Ville
Herradis of Landsberg,
Hortus Delic., fol. 263ᵛ
Date: 12th cent.

Stuttgart: Library,
Landesbibl., 24
Psalter, Hermann von
Thüringen, fol. 175ᵛ
Date: early 13th cent.

Washington: Gallery,
National, B-13, 521
Miniature from Psalter
Date: 13th cent.

Wolfenbüttel:
Library, Herzog August
Bibl., Helmst. 568 (521)
Psalter, fol. 9ʳ
Date: 13th cent.

IVORY

Copenhagen: Museum,
National
Crucifix (walrus)
Date: 1070–1080

London: Museum,
Victoria and Albert
Plaque (A.24-1926)
Date: 11th–12th cent.
(Fig. 95)

METALWORK

Copenhagen: Museum,
National
Altar (copper-gilt)
Date: 1st half 12th cent.
(Fig. 96)

King's Lynn: Church,
St. Margaret
Grave slab (brass)
Date: 1349

King's Lynn: Church,
St. Margaret
Grave slab (brass)
Date: 1364

London: Museum,
British
Grave slab (brass)
Date: *c.* 1350–1380

Lübeck: Cathedral
Grave slab (brass)
Date: 1350

North Mimms: Church,
St. Mary
Grave slab (brass)
Date: *c.* 1330–1370

Saint Albans: Cathedral,
St. Alban
Grave slab (brass)
Date: *c.* 1360–1370

Schwerin:
Cathedral, Maria and
Johannes
Grave slab of Gottfried
and Friedrich
Date: 2nd half 14th cent.

Schwerin:
Cathedral, Maria and
Johannes
Grave slab of Ludolf and
Heinrich
Date: 14th cent.

Stralsund: Church,
St. Nikolaus
Grave slab (brass)
Date: 1357

Thorn: Church,
St. Johannes
Grave slab (brass)
Date: 1361

Topcliffe: Church,
St. Columba
Grave slab (brass)
Date: 1391

Wardour: Castle
Grave slab (brass)
Date: 14th cent.

MOSAIC

Torcello: Cathedral,
Sta. Maria Assunta
Nave
Date: 1st half 12th cent.

PAINTING

Munich: Library,
Staatsbibl., Clm. 2641
Book covers
Date: *c.* 1250

SCULPTURE

Ainau: Church
Exterior, south
Date: 1200–1249

Ambronay: Church
Exterior, west
Date: 1200–1299

Amiens: Cathedral,
Notre Dame
Exterior, west,
central portal
Date: 1200–1225

Angers: Church,
St.-Serge
Decoration, keystone
Date: 1210–1225

Argenton-Château:
Church, St.-Gilles
Exterior, west, frieze
Date: 1130–1139

Autun: Cathedral, St.-
Lazare
Exterior, north
Date: 1100–1149

95. The Last Judgment
with Abraham repre-
senting Paradise (*lower
level*, *left*). Ivory plaque
now in the Victoria and
Albert Museum, Lon-
don (inv. A.24-1926).
Italian, 11th–12th
century (photo: Index
of Christian Art).

96. Abraham repre-
senting Paradise. Detail
from the Lisbjerg Altar,
now in the National
Museum, Copenhagen.
Originally from Lis-
bjerg Church, Aarhus.
Copper-gilt, Danish,
1st half of the 12th
century (photo: Index
of Christian Art).

Auxerre, Cathedral,
St.-Etienne
Exterior, south, archivolt
Date: 1300–1399

Auxerre, Cathedral,
St.-Etienne
Exterior, west
Date: 2nd half 13th cent.

Bamberg: Cathedral
Exterior, north
Date: 1215–1230

Basel: Cathedral
Relief, capital
Date: c. 1185
(Fig. 97)

Basel: Museum,
Historisches
Portal, archivolts
Date: c. 1265–1305
(Fig. 98)

Boston: Museum,
Fine Arts, inv. 27.852
Carving
Date: c. 1420–1450
(Fig. 99)

Bourges: Cathedral
Exterior, west
Date: 2nd half 13th cent.
(Fig. 100)

Châlons-en-Champagne:
Cathedral, St.-Etienne
Grave slab
Date: 1338

Chartres: Cathedral,
Notre-Dame
Exterior, south
Date: 1210–1215
(Fig. 101)

Cleobury Mortimer:
Church
Decoration
Date: 1300–1399

Colmar: Museum, Musée
d'Unterlinden
Capital
Date: mid 12th cent.
(Fig. 102)

Cologne: Cathedral
Choir stalls
Date: 1300–1349

Conques: Church,
Ste.-Foy
Exterior, west
Date: 1st half 12th cent.
(Fig. 103)

Durham: Cathedral
Keystone
Date: 1200–1299

Estella: Church,
S. Miguel
Exterior, north, wall,
zone 2
Date: late 12th–early
13th cent.
(Fig. 104)

Ferrara: Cathedral,
S. Giorgio
Exterior, west
Date: 1240–1260

Fidenza: Cathedral,
S. Donnino
Exterior, west
Date: 1170–1220

Freiberg: Cathedral
Exterior, south
Date: 1230–1245

Fribourg: Cathedral,
St.-Nicholas
Exterior, west
Date: 1380–1399

Grötlingbo: Church
Font, base
Date: 1150–1199

Ivry-la-Bataille: Church,
Abbey
Exterior, west, portal
Date: 1150–1160

Laon: Cathedral,
Notre Dame
Exterior, west, portal
right, archivolt 4
Date: c. 1180–1210

Laon: Cathedral,
Notre Dame
Exterior, west,
south window,
archivolt 4
Date: c. 1180–1210

Lincoln: Cathedral
Exterior, west
Date: 1141–1148

London: Church,
Westminster Abbey
Room, Muniment
Date: mid 13th cent.

Lund: Cathedral
Crypt
Date: 1st half 12th cent.

Messina: Church,
Sta. Maria degli
Alemanni
Exterior, north
Date: late 12th–early
13th cent.

Moissac: Church,
St.-Pierre
Porch
Date: 1115–1131
(Fig. 105)

Munich: Museum, Baye-
risches Nationalmuseum
Relief (wood; 1090)
Date: 1300–1320

Nuremberg: Church,
St. Sebaldus
Exterior, south
Date: 14th cent.
(Fig. 106)

Oplinter: Church
Cross (wood)
Date: 13th cent.

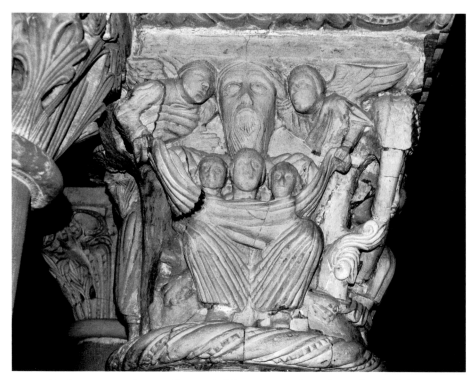

97. Abraham representing Paradise. Capital from the ambulatory in Basel Cathedral. Swiss, *c.* 1185 (photo: Colum Hourihane).

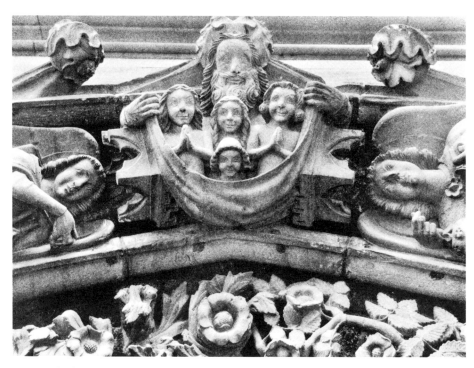

98. Abraham representing Paradise. Carved portal archivolt from Basel Cathedral, now in the Historisches Museum, Basel. Swiss, *c.* 1270–1300 (photo: Index of Christian Art).

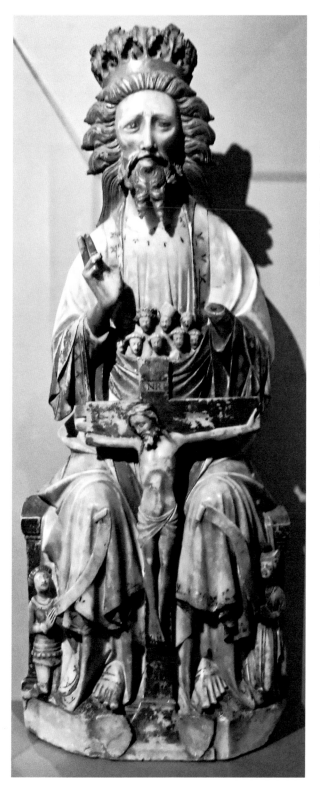

99. Abraham representing Paradise. Alabaster carving with polychrome and gilding, now in the Museum of Fine Arts, Boston (inv. 27.852). English, *c.* 1420–1450 (photo: Colum Hourihane).

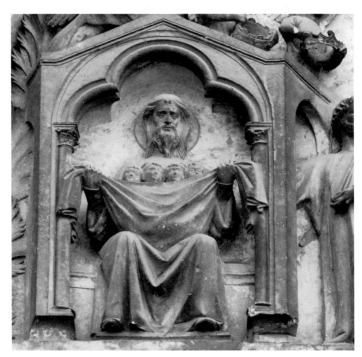

100. Abraham representing Paradise. Carving from the central portal, Bourges Cathedral. French, 2nd of the half 13th century (photo: Colum Hourihane).

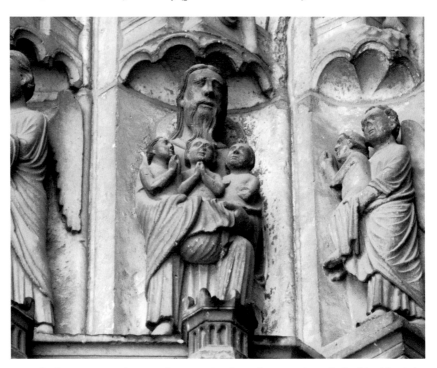

101. Abraham representing Paradise. Carving from the central porch (archivolt) of the south portal, Chartres Cathedral. French, 1210–1215 (photo: Colum Hourihane).

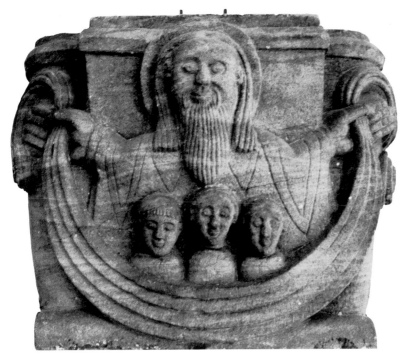

102. Abraham representing Paradise. Capital now in the Musée d'Unterlinden, Colmar. Originally from Alspach Church. French, mid 12th century (photo: Colum Hourihane).

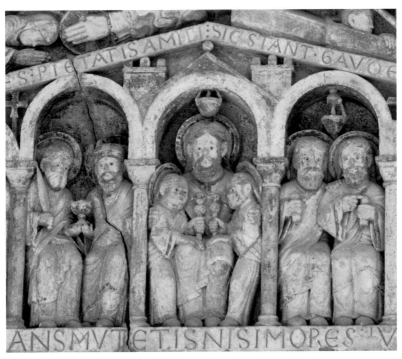

103. Abraham representing Paradise. Abraham with arms around the shoulders of two standing souls (*central panel*). Carving from the tympanum of the Church of Ste.-Foy, Conques. French, 1st half of the 12th century (photo: Colum Hourihane).

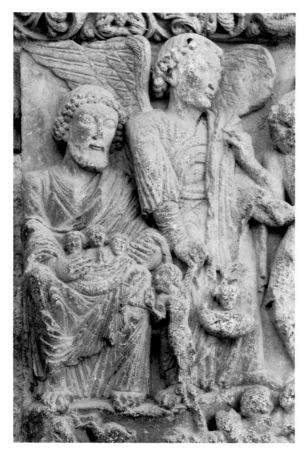

104. Abraham representing Paradise, and St. Michael weighing the souls. Carving from the exterior of the Church of San Miguel, Estella. Spanish, late 12th to early 13th century (photo: Colum Hourihane).

105. Abraham representing Paradise. Carving from the portal of the Church of St.-Pierre, Moissac, 1115–1131 (photo: Colum Hourihane).

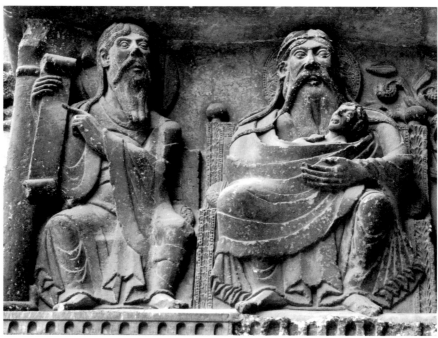

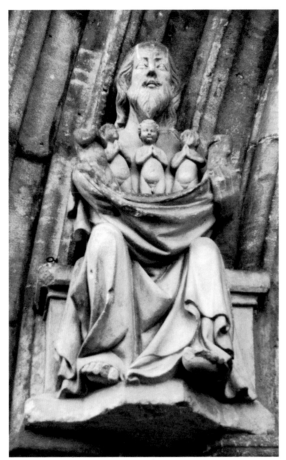

106. Abraham representing Paradise. Carving from the south portal of the Church of St. Sebaldus, Nuremberg. German, 14th century (Photo: Wikimedia Commons).

Saint-Denis: Church,
Abbey
Portal, central
Date: 1130–1140

Saint-Omer: Cathedral,
Notre Dame
Exterior, south
Date: 13th–14th cent.

Saint-Père-sous-Vézelay:
Church, St.-Pierre
Exterior, west
Date: 13th–14th cent.

Salisbury: Cathedral
Tomb of Giles of Brid-
port (Purbeck)
Date: 2nd half 13th cent.

Senlis: Cathedral,
Notre Dame
Exterior, west
Date: 1185–1190

Soria: Church,
S. Tomé
Exterior, west
Date: 12th cent.

Troyes: Church,
St.-Urbain
Exterior, west
Date: late 13th cent.

Uppsala: Cathedral
Grave slab
Date: 1328

Zwolle: Church,
St. Michael
Relief
Date: 1200–1220

TEXTILE

Rome: Church,
St. Peter's Basilica,
Sacristy
Vestment (dalmatic)
Date: 10th–16th cent.

Paris: Cathedral,
Notre Dame
Exterior, west
Date: 1210–1240

Paris: Church,
St.-Germain l'Auxerrois
Exterior, west
Date: 13th cent.

Paris: Museum, Louvre
Grave slab
Date: mid 14th cent.

Plaimpied: Church
Grave slab of Sulpicius
Date: 12th cent.

Provins: Church,
St.-Ayoul
Exterior, west
Date: 2nd half 12th cent.

Rampillon: Church
Exterior, west
Date: 13th cent.

Reims: Cathedral,
Notre Dame
Exterior, north
Date: c. 1230 (Fig. 107)

Reims: Cathedral,
Notre Dame
Grave slab
Date: 1377

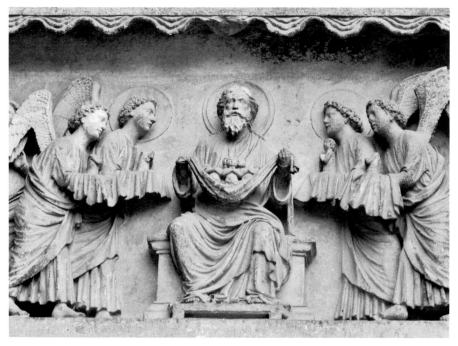

107. Abraham representing Paradise. Carving from the lintel of the left portal of the north façade, Reims Cathedral. French, *c.* 1230 (photo: Colum Hourihane).

Abraham:
Rescue of Lot

•◦•◦•◦•◦•◦•◦•◦•◦•◦•◦•◦•◦•◦•

FRESCO

Bury St. Edmunds:
Church, Abbey
Choir
Date: 1100–1199

Parma: Baptistry
Dome
Date: 1250–1299

Saint-Savin: Church,
Abbey
Nave
Date: 11th–12th cent.

GLASS

Erfurt: Cathedral
Windows, choir
Date: 2nd half 14th–
15th cent.

ILLUMINATED
MANUSCRIPT

Amiens: Library,
Bibl. de la Ville, 1, 108
Pamplona Picture Bible
1, fol. 7r
Date: 1197

Augsburg: Library, Univ-
eritätsbibl., 1.2.qu.15
Pamplona Picture Bible,
11, fol. 14v
Date: 1195–1205

Berlin: Museum,
Staatliches Museen,
Kupferstichkab., 78.A.6
Psalter, fols. 1v–2r
Date: 2nd half 12th cent.

Berne: Library,
Stadtbibl., 264
Prudentius, *Psychomachia*,
fol. 31v
Date: 9th–10th cent.

Berne: Library,
Stadtbibl., 264
Prudentius, *Psychomachia*,
fol. 32r
Date: 900–920

Berne: Library,
Stadtbibl., 264
Prudentius, *Psychomachia*,
fol. 32v
Date: 900–920

Brussels: Library, Bibl.
Royale, 9987-91
Prudentius, *Psychomachia*,
fol. 97v
Date: 900–999

Brussels: Library, Bibl.
Royale, 9987-91
Prudentius, *Psychomachia*,
fol. 98r
Date: 900–999

Brussels: Library, Bibl.
Royale, 10066-77 —*cont.*

Prudentius, *Psychomachia*,
fol. 112v
Date: 900–1049

Brussels: Library, Bibl.
Royale, 10066-77
Prudentius, *Psychomachia*,
fol. 113r
Date: 900–1049

Cambridge: Library, Corpus Christi College, 23
Prudentius, *Psychomachia*,
fol. 4v
Date: 980–999

Cambridge: Library, Corpus Christi College, 23
Prudentius, *Psychomachia*,
fol. 5r
Date: 980–999

Cologne: Library,
Cathedral, 81
Prudentius, *Psychomachia*,
fol. 66v
Date: 980–999

Cologne: Library,
Cathedral, 81
Prudentius, *Psychomachia*,
fol. 67r
Date: 980–999

Leiden: Library,
Bibl. der Universiteit,
Burm. Q.3
Prudentius, *Psychomachia*,
fol. 120v
Date: 825–849

Leiden: Library, Bibl. der
Universiteit, Burm. Q.3
Prudentius, *Psychomachia*,
fol. 121r
Date: 825–849

Leiden: Library, Bibl. der
Universiteit,
Voss. lat. oct. 15
Prudentius, *Psychomachia*,
fol. 37r
Date: 9th cent.

Lilienfeld: Library,
Stiftsbibl., 151
Ulrich of Lilienfeld,
Concordantiae caritatis,
fol. 100v
Date: mid 14th cent.

London: Library, British,
Add. 24199
Prudentius, *Psychomachia*,
fol. 2v
Date: 980–1099

London: Library, British,
Add. 24199
Prudentius, *Psychomachia*,
fol. 3r
Date: 980–1099

London: Library, British,
Cott. Claudius B.IV
Ælfric, *Paraphrase*,
fol. 25r
Date: 1025–1049

London: Library, British,
Cott. Claudius B.IV
Ælfric, *Paraphrase*,
fol. 25v
Date: 1025–1049

London: Library, British,
Cott. Cleo. C.VIII
Prudentius, *Psychomachia*,
fol. 1v
Date: 980–999

London: Library, British,
Cott. Cleo. C.VIII
Prudentius, *Psychomachia*,
fol. 2r
Date: 980–999

London: Library, British,
Cott. Otho B.VI
Cotton Genesis, fol. 19v
Date: 400–599

London: Library, British,
Cott. Titus D.XVI
Prudentius, *Psychomachia*,
fol. 2v
Date: 1115–1120

London: Library, British,
Cott. Titus D.XVI
Prudentius, *Psychomachia*,
fol. 3r
Date: 1115–1120

London: Library, British,
Egerton 1894
Genesis, fol. 8v
Date: 14th cent.

Lyons: Library, Palais du
commerce et des Arts, 22
Prudentius, *Psychomachia*,
fol. 3r
Date: 11th cent.

Lyons: Library, Palais du
commerce et des Arts, 22
Prudentius, *Psychomachia*,
fol. 3v
Date: 11th cent.

Munich: Library, Staatsbibl., Clm. 835
Munich Psalter, fol. 11r
Date: 1200–1220

New York: Library,
Morgan, M.43
Huntingfield Psalter,
fol. 9v
Date: 1210–1220
(Fig. 108)

New York: Library,
Morgan, M.43
Huntingfield Psalter,
fol. 10v
Date: 1210–1220

New York: Library,
Morgan, M.638
Morgan Picture Bible,
fol. 3v
Date: *c.* 1250
(Fig. 109)

New York: Library,
Morgan, M.739
Hedwig of Silesia Hours,
fol. 10r
Date: 1204–1219
(Fig. 110)

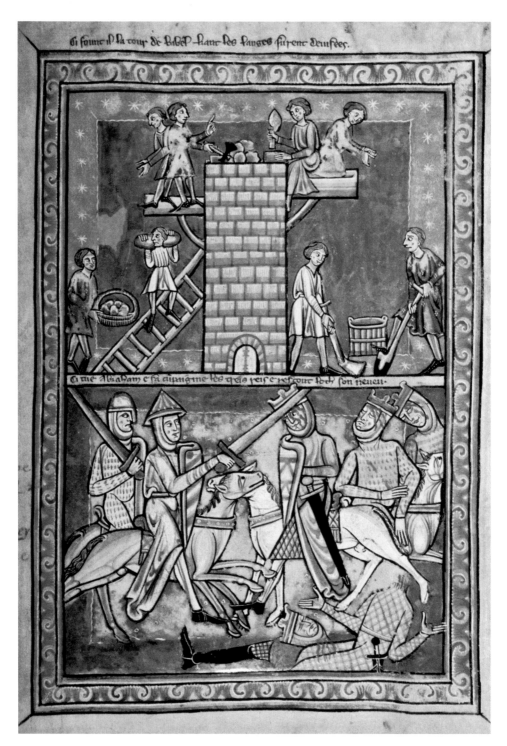

108. Tower of Babel (*upper zone*) and Abraham rescued of Lot (*lower zone*). Full-page prefatory miniature from the Huntingfield Psalter, now in The Morgan Library and Museum, New York, Ms. M. 43, fol. 9ᵛ. English, possibly Oxford, 1210–1220 (photo: Morgan Library and Museum).

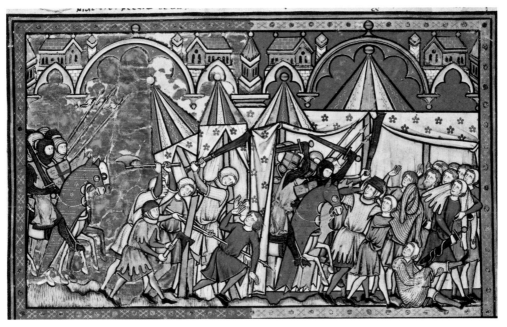

109. Abraham rescued of Lot. Upper register of a full-page miniature from The Morgan Picture Bible, now in The Morgan Library and Museum, New York, Ms. M. 638, fol. 3ᵛ. French, c. 1250 (photo: Morgan Library and Museum).

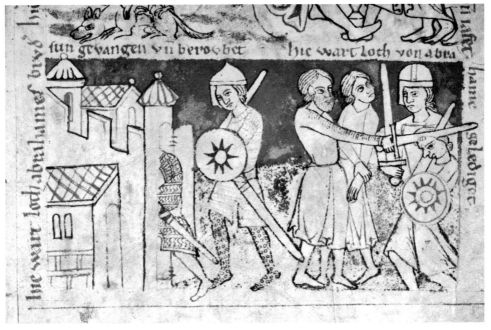

110. Abraham rescued of Lot. Miniature from a German manuscript (Hedwig of Silesia Hours) now in The Morgan Library and Museum, New York, Ms. M. 739, fol. 10ʳ. Possibly Bohemian, 1204–1219 (photo: Morgan Library and Museum).

Oxford: Library,
Bodleian, 270b
Bible, Moralized, fol. 13ᵛ
Date: 1st half 13th cent.

Oxford: Library,
Bodleian, Junius 11
Cædmon, *Poems*, p. 96
Date: 980–1020

Paris: Library, Bibl.
Nationale, lat. 8085
Prudentius, *Psychomachia*,
fol. 55ᵛ
Date: 9th cent.

Paris: Library, Bibl.
Nationale, lat. 8085
Prudentius, *Psychomachia*,
fol. 56ʳ
Date: 9th cent.

Paris: Library, Bibl.
Nationale, lat. 10525
St. Louis Psalter, fol. 5ᵛ
Date: 1253–1270

Prague: Library,
University, XXIII.C.124
Velislaus Miscellany,
fol. 14ʳ
Date: 14th cent.

Rome: Library, Bibl.
Vaticana, gr. 746
Octateuch, fol. 67ʳ
Date: 1100–1199

Rome: Library, Bibl.
Vaticana, gr. 746
Octateuch, fol. 67ᵛ
Date: 1100–1199

Rome: Library, Bibl.
Vaticana, gr. 747
Octateuch, fol. 36ʳ
Date: 1000–1099

Rovigo: Library,
Bibl. Academic dei
Concordi, 212
Picture Bible, fol. 8ᵛ
Date: 14th cent.

Smyrna: Library,
Evang. School, A.1
Octateuch, fol. 27ᵛ
Date: 12th cent.

Smyrna: Library,
Evang. School, A.1
Octateuch, fol. 28ʳ
Date: 12th cent.

Strasbourg: Library,
Bibl. de la Ville
Herradis of Landsberg,
Hortus Delic., fol. 34ʳ
Date: 12th–13th cent.

Valenciennes: Library,
Bibl. Publique, 563
Prudentius, *Psychomachia*,
fol. 1ᵛ
Date: 800–899

Valenciennes: Library,
Bibl. Publique, 563
Prudentius, *Psychomachia*,
fol. 2ʳ
Date: 800–899

Vienna: Library,
Nationalbibl.,
Ser. Nov. 2611
Psalter, fol. 7ʳ
Date: 1260–1270

Vienna: Library, Na-
tionalbibl., Theol. gr. 31
Vienna Genesis, fol. 4ʳ
Date: 500–599

MOSAIC

Venice: Church, S. Marco
Atrium, bay 5, dome
Date: 1200–1299

Abraham: Returning to Young Men

••••••••••••••••••••••••••

ILLUMINATED MANUSCRIPT

London: Library,
British, Cott. Claudius
B.IV —*cont.*

Ælfric, *Paraphrase*, fol. 38ᵛ
Date: 1025–1049

London: Library, British,
Cott. Otho. B.VI
Cotton Genesis,
fol. 38ʳ
Date: 400–599 cent.

Prague: Library,
University, XXIII.C.124
Velislaus Miscellany,
fol. 23ʳ
Date: 14th cent.

Rovigo: Library,
Bibl. Academic dei
Concordi, 212
Picture Bible,
fol. 14ʳ
Date: 14th cent.

Vienna: Library, Na-
tionalbibl., Theol. gr. 31
Genesis, fol. 6ʳ
Date: 500–599

Abraham: Sacrificing Isaac

••••••••••••••••••••••••••

ENAMEL

Berlin: Museum,
Kunstgewerbemuseum
Altar, portable
Date: 1157–1167

Brussels: Museum,
Musée Royaux d'Art et
d'Histoire
Altar (portable)
Date: 1150–1160

Chantilly: Museum,
Condé
Plaque
Date: late 12th cent.

Cleveland: Museum,
of Art
Pyx (1949.431)
Date: *c.* 1175

Florence: Museum,
Museo Nazionale del
Bargello
Plaque
Date: 1180–1199

Huy: Church,
Notre Dame
Casket (reliquary)
Date: 13th cent.

Klosterneuburg:
Monastery
Retable
Date: 1181

London: Museum, British
Plaques
Date: 12th cent.

London: Museum,
Victoria and Albert
Pyxis (Kennet)
Date: 12th cent.

London: Museum,
Victoria and Albert
Pyxis (Warwick)
Date: 2nd half 12th cent.

London: Museum,
Victoria and Albert
Alton Towers Triptych
Date: 1145–1155

München-Gladbach:
Church, Klosterkirche
Altar (portable)
Date: 12th cent.

New York: Museum,
Morgan
Malmesbury Pyxis
Date: 1160–1175

Paris: Museum, Louvre
Cross (reliquary)
Date: 1174–1205

Paris: Museum, Louvre
Plaque
Date: 1100–1199

Saint-Denis, Church,
Abbey
Cross
Date: 1145–1147

Saint-Omer: Museum,
Musée de l'Hôtel
Sandelin
Base (for cross)
Date: 1165–1175

Toledo (Ohio): Museum,
of Art
Plaque, 50.288
Date: 1100–1199

Vienna: Cathedral, St.
Stephan, Treasury
Plaques
Date: 1165–1175

Vienna: Museum,
Kunsthistorisches
Chalice
Date: 2nd half 12th cent.

Xanten: Cathedral,
St. Victor
Altar (portable)
Date: 1175–1185

FRESCO

Althofen: Church
Decoration
Date: 13th cent.

Arilye: Monastery,
Church of St. Achillius
Narthex, inner
Date: late 13th–
14th cent.

Asinou: Church, Panagia
Choir
Date: 12th–13th cent.

Assisi: Church,
S. Francesco, Upper
Nave, north wall,
zone 2
Date: 1280–1299

Augsburg: Church,
Sts. Ulrich and Afra
Decoration
Date: 12th cent.

Al-Bagawat: Necropolis
Building, Great
Date: 4th cent.

Al-Bagawat: Necropolis
Chapel with Moses
Date: early 4th cent. or
later

Al-Bagawat: Necropolis
Chapel with Personifica-
tions
Date: 4th cent.

Bahdeidat: Church,
Mar Tadros
Sanctuary, east wall
Date: mid 13th cent.

Bergamo: Church,
Sta. Maria Maggiore
Transept, north
Date: 1347

Berghausen: Church
Apse
Date: early 13th cent.

Brauweiler: Abbey
Chapter House
Date: 1150–1170

Brioude: Church,
St.-Julien
Nave
Date: 13th cent.

Bury St. Edmunds:
Church, Abbey
Choir
Date: 1100–1199

Cairo: Church, Abu
Sefein, Upper
Chapel of Mar Girgis,
Haykal, dome
Date: 1150–1199

Cairo: Museum, Coptic
Fragment (inv. 8411)
Date: 6th–7th cent.

Ceri: Church, Sta. Maria
Immacolata
Nave, north wall
Date: early 12th cent.

Concordia: Baptistry
Decoration, sanctuary
Date: 1080–1099

Damascus: Museum,
National
Dura-Europos Synagogue
Decoration, west wall,
arch of niche
Date: 245–256

Ferentillo: Church,
S. Pietro in Valle
Nave
Date: 11th–12th cent.

Florence: Church,
Sta. Croce
Sacristy
Date: late 14th cent.

Gračanica: Monastery,
Church
Decoration
Date: 1318–1321

Grissiano: Church,
S. Giacomo
Triumphal arch
Date: 1180–1220

Gurk: Cathedral, Mariä
Himmelfahrt
Porch
Date: 1st half 14th cent.

Kiev: Cathedral,
St. Sophia
Decoration
Date: 11th cent.

Lekhne: Church
Decoration
Date: 13th–14th cent.

Meldorf: Church
Transept, north
Date: mid 13th cent.

Milan: Church,
S. Ambrogio
Wall
Date: 380–399

Nabk: Mar Musa al-
Habashi, Monastery,
Church
Aisle, north, south wall
Date: 1192

Nereditsi: Church, of
the Savior
Nave
Date: 1199

Ohrid: Church,
St. Sophia
Choir
Date: 11th–13th cent.

Padua: Baptistry
Decoration
Date: late 14th cent.

Parma: Baptistry
Dome
Date: 1250–1299

Peterborough: Cathedral
Decoration (on choir
screen)
Date: 12th cent.

Pskov: Monastery,
Spas-Mirojski
Diaconicon
Date: 1156

Qara: Monastery,
Deir Mar Yakub
Church, lower (formerly)
Date: 1st half 13th cent.

Raskida: Church,
Mar Girgius
Chapel
Date: 12th cent.

Reims: Hypogeum
Decoration
Date: 4th cent.

Rhäzüns: Church,
St. George
Nave
Date: 2nd half 14th cent.

Rome: Cemetery,
Anonymous,
Via Anapo
Niche
Date: 315–330

Rome: Cemetery,
Callixtus
Arch with Abraham
Date: 2nd half 4th cent.

Rome: Cemetery,
Callixtus
Chapel of Sacraments, A3
Date: 4th cent.

Rome: Cemetery,
Domitilla
Cubiculum II
Date: 1st half 4th cent.

Rome: Cemetery,
Domitilla
Cubiculum X
Date: 1st half 4th cent.

Rome: Cemetery,
Domitilla
Gallery with two loculi
Date: mid 4th cent.

Rome: Cemetery,
Generosa
Arch with shepherd
Date: 6th–7th cent.

Rome: Cemetery,
Hermes
Cubiculum with fishes
Date: late 3rd cent.

Rome: Cemetery, Jordani
Niche
Date: 3rd cent.

Rome: Cemetery,
Marcus and Marcellianus
Cubiculum of Marcus
and Marcellianus
Date: 2nd half 4th cent.

Rome: Cemetery,
Nuova, Via Latina
Cubiculum C
Date: 300–399

Rome: Cemetery,
Nuova, Via Latina
Cubiculum L
Date: 300–399

Rome: Cemetery,
Ostrianum
Arch I with Magi
Date: 2nd half 4th cent.

Rome: Cemetery,
Ostrianum
Cubiculum with Susanna
Date: 2nd half 4th cent.

Rome: Cemetery,
Pamphilus
Cubiculum
Date: 380–399

Rome: Cemetery,
Petrus and Marcellinus
Cubiculum III
Date: 320–340

Rome: Cemetery,
Petrus and Marcellinus
Cubiculum VIII
Date: 295–320

Rome: Cemetery,
Petrus and Marcellinus
Cubiculum XXXIII
Date: 320–340

Rome: Cemetery,
Petrus and Marcellinus
Cubiculum 37A
Date: 340–360

Rome: Cemetery,
Petrus and Marcellinus
Cubiculum with
Abraham
Date: 320–340

Rome: Cemetery,
Priscilla
Chapel, Greek
Date: early 2nd cent.

Rome: Cemetery,
Priscilla
Cubiculum V
Date: 2nd half 3rd cent.

Rome: Cemetery, Thekla
Cubiculum, double
Date: 2nd half 4th cent.

Rome: Cemetery,
Thraso
Arch with orants
Date: 1st half 9th cent.

Rome: Cemetery, Vigna
Massimi
Arch with Good Shep-
herd
Date: 1st half 4th cent.

Rome: Church,
Old Basilica of St. Peter,
Nave
Date: 891–896;
1277–1280

Rome: Church,
S. Clemente, lower
aisle, right
Date: 700–799

Rome: Church,
S. Giovanni a Porta
Latina
Nave, north wall
Date: late 12th cent.
(Fig. 111)

Rome: Church,
S. Paolo fuori le Mura
Nave
Date: 5th–6th cent. and
later

Rome: Church,
Sta. Maria Antiqua
Aisle, left
Date: 8th–9th cent.

Saint-Savin: Church,
Abbey
Nave
Date: 11th–12th cent.

Sant'Angelo in Formis:
Church
Aisle, north,
zone 1, no. 6
Date: 1072–1087

Sant'Angelo in Formis:
Church
Aisle, north,
zone 1, no. 7
Date: 1072–1087
(Fig. 112)

Schaffhausen: Museum,
zu Allerheiligen
Chapel, Erhard
Date: 1200–1220

Sigena: Monastery
Chapter House
Date: 12th–13th cent.

Soğanlı: Church,
Ballık Kilise
Nave, north
Date: before 2nd half
11th cent.

Sopoćani: Church,
Trinity
Narthex, inner
Date: 1250–1299

Spoleto: Church,
S. Ansano
Crypt
Date: 12th cent.

Strägnäs: Cathedral
Nave
Date: c. 1300

Summaga: Church,
Sta. Maria Assunta
Decoration
Date: 1080–1099

Summaga: Church,
Sta. Maria Assunta
Chapel,
west wall
Date: 1080–1099

111. Sacrifice of Isaac. Fresco from the nave (north wall) of San Giovanni a Porta Latina, Rome. Italian, late 12th century (photo: Colum Hourihane).

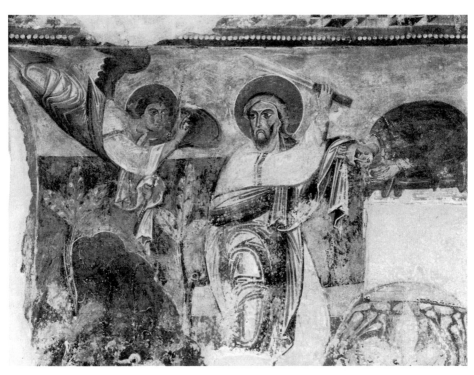

112. Sacrifice of Isaac. Fresco from the aisle (north wall) of Sant'Angelo in Formis. Italian, Campania, 1072–1087 (photo: Colum Hourihane).

Syracuse: Cemetery,
Vigna Cassia
Arch in section M
Date: 4th cent.

Thessaloniki: Cemetery,
Hypogeum
Old and New Testaments
Date: 280–359

Thessaloniki: Cemetery,
Hypogeum
Old Testament
Date: 300–349

Toitenwinkel: Church
Choir
Date: early 14th cent.

Torri in Sabina: Church,
Sta. Maria in Vescovio
Nave, right wall, zone 2
Date: 1250–1299

Třebíč: Church,
Prokopa Chapel,
south wall, west bay
Date: mid 13th cent.

Vertemate: Monastery,
Church
Choir
Date: 2nd half 14th cent.

Wadi al-Natrun: Monas-
tery, Deir Anba An-
tonius, Church of St.
Anthony
Haykal of St. Anthony
Date: 1232–1235

Wadi al-Natrun: Mon-
astery, Deir Abu Maqar,
Church, St. Macarius
Haykal, north
Date: 1100–1199

Wadi al-Natrun: Mon-
astery, Deir al-Baramus,
Al-'Adra Church
Haykal, central, east wall
Date: 1200–1299

Westgröningen: Convent
Room, under organ
gallery
Date: 13th cent.

Wienhausen: Convent,
Church
Nuns' choir
Date: c. 1300–1400

GLASS

Assisi: Church,
S. Francesco, Upper
Window, apse (rest)
Date: 13th cent.

Bourges: Cathedral
Window 5, outer
ambulatory
Date: c. 1210–1215
(Fig. 113)

Canterbury: Cathedral,
Christ Church
Window, east, corona
Date: c. 1200

Canterbury: Cathedral,
Christ Church
Windows, choir
Date: 1180–1185

Châlons-en-Champagne:
Cathedral, St.-Etienne
Window
Date: 12th cent.

Chartres: Cathedral,
Notre-Dame
Window, north wall,
bay 6
Date: 13th cent.
(Fig. 114)

Chartres: Cathedral,
Notre-Dame
Window, nave, north wall
Date: 13th cent.

Chartres: Cathedral,
Notre-Dame
Window, nave, north
wall, clerestory
Date: 13th cent.

Cologne: Cathedral
Windows, Magi Chapel
Date: late 13th cent.

Cologne: Church,
St. Kunibert
Windows
Date: 13th cent.

Erbach im Odenwald:
Castle
Window 3
Date: early 14th cent.

Erfut: Cathedral
Windows, choir
Date: 2nd half 14th–
15th cent.

Esslingen: Church,
Franziskanerkirche
Window, choir
Date: 14th cent.

Esslingen: Church, Frau-
enkirche
Window, choir
Date: 14th cent.

Esslingen: Church,
St. Dionys
Windows, choir
Date: 13th–14th cent.

Glasgow: Museum,
Burrell Collection
Panel (from window; 341)
Date: mid 13th cent.

Kappenberg: Castle
Windows
Date: mid 14th cent.

Lyons: Cathedral
Window, apse
Date: 13th cent.

Meissen: Cathedral
Window, east
Date: 13th–14th cent.

Munich: Museum,
Archäologische Staats-
sammlung
Vessel
Date: 380–399

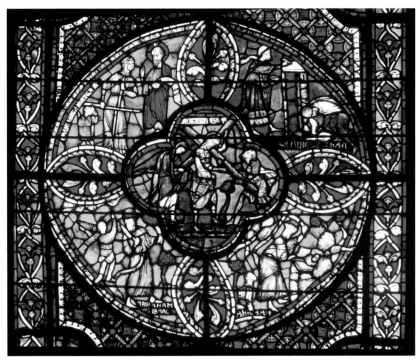

113. Sacrifice of Isaac. Stained glass from the outer ambulatory (window 5), Bourges Cathedral. French, Master of the New Alliance, *c.* 1210–1215 (photo: Colum Hourihane).

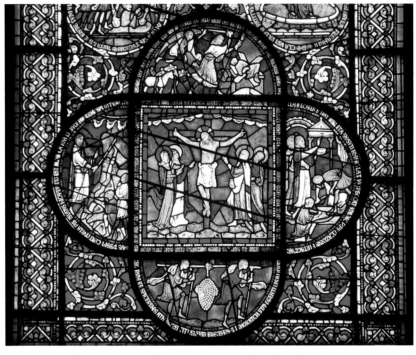

114. Sacrifice of Isaac (*above crucifixion scene*). Stained glass from Chartres Cathedral, north wall of nave (bay 6). French, 13th century (photo: Colum Hourihane).

Munich: Museum, Bayerisches Nationalmuseum
Windows
Date: 1360–1370

Munich: Museum, Staatliche Münzsammlung
Pendant
Date: 3rd–4th cent.

Orbais l'Abbaye: Church
Window, choir
Date: 13th cent.

Paris: Church,
Ste.-Chapelle
Windows, north , bay 1
Date: 1242–1248

Rome: Museum,
Antiquarium Comunale
Vessel
Date: 1st half 4th cent.

Rouen: Cathedral,
Notre Dame
Window, ambulatory
Date: 13th cent.

Rouen: Collection, Bellon
Vessel
Date: 5th cent.

Saint-Germain-en-Laye:
Museum, Musée des Antiquités Nationales
Vessel
Date: 340–360

St. Petersburg: Museum,
Hermitage
Vessel
Date: 4th cent.

Schwerin: Museum,
Staatliches Museum
Plaque
Date: late 13th–14th
cent.

Strasbourg: Museum,
Archéologique
Vessel
Date: 300–399

Strasbourg: Museum,
Œuvre Notre-Dame
Windows
Date: 1325; 15th cent.

Tours: Cathedral,
St.-Gatien
Window, choir
Date: 13th cent.

Tours: Cathedral,
St.-Gatien
Windows, Virgin Mary
Chapel
Date: 13th cent.

Trier: Museum, Rheinisches Landesmusem
Vessel
Date: 300–349

Troyes: Cathedral,
St.-Pierre
Window, Pierre et Paul
Chapel (lost)
Date: 13th cent.

Würzburg: Museum, der
Universität
Vessel
Date: 200–499

GLYPTIC

Gotha: Museum,
Schlossmuseum
Cameo (carnelian)
Date: before 700

Paris: Library, Bibl.
Nationale, Cabinet des
Médailles
Gem (sard; 1130)
Date: before 320

Philadelphia: Museum,
University of
Pennsylvania
Cameo (marble)
Date: 4th cent.

GOLD GLASS

Anagni: Monastery,
della Carità —cont.

Vessel
Date: 3rd–5th cent.

Grosseto: Museum,
Museo Archeologico e
d'Arte della Maremma
Vessel
Date: 300–399

London: Museum,
British
Vessel
Date: 200–499

London: Museum,
British
Vessel
Date: 350–399

Oxford: Collection,
Pusey House
Vessel [1]
Date: 200–499

Oxford: Collection,
Pusey House
Vessel [2]
Date: 200–499

Rome: Museum,
Antiquarium Comunale
Vessel
Date: 300–349

Rome: Museum,
Camposanto Tedesco
Medallion
Date: 200–499

Rome: Museum,
Camposanto Tedesco
Medallion (DR 378; 180)
Date: 3rd–5th cent.

Rome: Museum, Musei
Vaticani, Museo Pio
Cristiano
Vessel
Date: 3rd–5th cent.

Rome: Museum, Musei
Vaticani, Museo Pio
Cristiano
Medallion (DR 375; 177)
Date: 3rd–5th cent.

Rome: Museum, Musei
Vaticani, Museo Pio
Cristiano
Medallion (DR 376; 178)
Date: 3rd–5th cent.

St. Petersburg: Museum,
Hermitage
Vessel
Date: 300–399

St. Petersburg: Museum,
Hermitage
Vessel
Date: 3rd–5th cent.

Würzburg: Museum,
Universität
Vessel, H.1492
Date: 3rd–5th cent.

ILLUMINATED
MANUSCRIPT

Aberystwyth: Library,
National, of Wales,
15536E
Sherbrooke Missal,
fol. 230ʳ
Date: 1310–1320

Admont: Library, Stifts-
bibl., lat. 58
Godfrey I of Admont,
Homiliae, fol. 64ʳ
Date: 1155–1165

Admont: Library, Stifts-
bibl., lat. 128
Peter of Poiters, *Compen-
dium Veteris Testamenti*
Date: 1225–1249

Alnwick: Collection,
Duke of Northumberland
Missal, Sherborne, p. 380
Date: *c.* 1400

Amiens: Library,
Bibl. de la Ville, 108
Pamplona Picture Bible,
I, fol. 11ᵛ
Date: 1197

Amiens: Library,
Bibl. de la Ville, 108
Pamplona Picture Bible,
I, fol. 12ʳ
Date: 1197

Antwerp: Museum,
Plantin-Moretus, M.17.4
Sedulius, *Carmen Paschale*,
fol. 8ʳ
Date: 800–899

Arras: Library, Bibl.
Municipale, 38
Missal of Mont-Saint-
Éloi, fol. 104ᵛ
Date: 1245–1255

Arras: Library, Bibl.
Municipale, 49
Missal of Arras,
Mont-Saint-Éloi,
fol. 81ʳ
Date: 1225–1249

Arras: Library, Bibl.
Municipale, 297
Missal of Arras, fol. 44ʳ
Date: 1290–1299

Arras: Library, Bibl.
Municipale, 561
Bible of Mont-Saint-Éloi,
fol. 106ᵛ
Date: 1245–1255

Augsburg: Library, Uni-
versitätsbibl., 1.2.qu.15
Pamplona Picture Bible,
II, fol. 20ᵛ
Date: 1195–1205

Augsburg: Library, Uni-
versitätsbibl., 1.2.qu.15
Pamplona Picture Bible,
II, fol. 21ʳ
Date: 1195–1205

Avranches: Library,
Bibl. de la Ville, 42
Missal, fol. 140ᵛ
Date: early 13th cent.

Baltimore: Museum,
Walters Art, W.174
Missal of Eberhard von
Greiffenklau, fol. 113ʳ
Date: 2nd quarter 15th
cent. (Fig. 115)

Bamberg: Library, Staats-
bibl., Lit. 1
Fulda Sacramentary,
fol. 13ʳ
Date: 997–1011

Basel: Library, Univer-
sitätsbibl., A. II.1
Nicholas of Lyra,
Postillae, fol. 53ʳ
Date: 1396

Berlin: Museum,
Staatliche Museen
Fragments (papyrus;
1.6119)
Date: 5th–6th cent.

Berlin: Museum,
Staatliches Museen,
Kupferstichkab., 78.A.9
Hamilton Greek Psalter,
fol. 186ʳ
Date: 1280–1320

Berlin: Museum,
Staatliches Museen,
Kupferstichkab., 78.E.3
Hamilton Bible, fol. 4ʳ
Date: 2nd half 14th cent.

Brussels: Library, Bibl.
Royale, 9961-2
Psalter, fol. 48ʳ
Date: 13th cent.

Brussels: Library, Bibl.
Royale, 9968-72
Prudentius, *Psychomachia*,
fol. 74ʳ
Date: 11th cent.

Brussels: Library, Bibl.
Royale, 9987-91
Prudentius, *Psychomachia*,
fol. 97ʳ
Date: 900–999

115. Sacrifice of Isaac. Miniature from the Missal of Eberhard von Greiffenklau, now in the Walters Art Museum, W. 174, fol. 113ʳ. Dutch, possibly Utrecht, by the Masters of Zweder van Culemborg or the Master of Catherine of Cleves, 2nd quarter of the 15th century (© 2011 Walters Art Museum, used under a Creative Commons Attribution-Non Commercial-Share Alike 3.0 license. http://creativecommons.org/licenses/by-nc-sa/3.0/).

Brussels: Library, Bibl.
Royale, 10066-77
Prudentius, *Psychomachia*,
fol. 112ʳ
Date: 900–1049

Brussels: Library, Bibl.
Royale, 10175
*Histoire Ancienne Jusqu'à
César*, fol. 45ʳ
Date: 1270–1280

Brussels: Library, Bibl.
Royale, 10730
Bible, fol. 5ᵛ
Date: 13th–15th cent.

Budapest: Library,
Hungarian Academy of
Sciences, A 77/III, Kaufmann *Mishneh Torah*
Date: 1296

Cambridge: Library, Corpus Christi College, 23
Prudentius, *Psychomachia*,
fol. 3ᵛ
Date: 980–999

Cambridge: Library,
St. John's College, K.26
Holland Psalter,
fol. 10ʳ
Date: 1270–1280

Cambridge: Library,
Trinity College, B.10.1
Bible, fol. 3ʳ
Date: 13th cent.

Cambridge: Library,
Trinity College, B.11.4
Psalter, fol. 10ʳ
Date: 1220–1230

Cambridge: Library,
University, Ee.4.24
Psalter, fol. 28ᵛ
Date: 2nd half 13th cent.

Cambridge (Mass.):
Library, Harvard,
Typ 216H
Peter of Poitiers, *Compendium Veteris Testamenti*
Date: 13th cent.

Cava dei Tirreni:
Library, Bibl. Abbazia,
Trinità 33
Bible, fol. 5ʳ
Date: 13th–14th cent.

Chantilly: Museum,
Condé, 1632-1633
Josephus, *Antiquitates
Judaicae*, fol. 3ʳ
Date: 12th cent.

Chantilly: Museum,
Condé, 1695/9
Ingeborg Psalter, fol. 11ʳ
Date: 1195–1205

Chantmarle: Collection,
Hornby
Missal, fol. 163ʳ
Date: 1st half 13th cent.

Cleveland: Museum of
Art, 1954.388
Miniature
Date: 1st half 13th cent.

Cologne: Museum,
Wallraf-Richartz, 148
Miniature
Date: early 13th cent.

Constance: Museum,
Rosgarten, 31
Biblia Pauperum, p. 11
Date: 14th cent.

Constance: Museum,
Rosgarten, 31
Biblia Pauperum, p. 12
Date: 14th cent.

Darmstadt: Library,
Univ.- und Landesbibl.,
2505
Speculum Humanae Salva-tionis, fol. 40ᵛ
Date: 1350–1399

Dijon: Library,
Bibl. Communale, 562
Histoire Universelle, fol. 26ʳ
Date: 1260–1270

Douai: Library,
Bibl. Municipale, 90
Missal, Anchin, 1, fol.59ʳ
Date: late 12th cent.

Douai: Library,
Bibl. Municipale, 152
Breviary-Missal of
Anchin, fol. 118ʳ
Date: *c.* 1299

Erlangen: Library,
Universitätsbibl., 121
Gumpert Bible, fol. 129ᵛ
Date: before 1195

Eton: Library,
Eton College, 177
Miscellany, fol. 4ᵛ
Date: 13th cent.

Eton: Library,
Eton College, 177
Miscellany, fol. 5ʳ
Date: 13th cent.

Etschmiadzin:
Library, Monastery, 229
Gospel Book, fol. 8ʳ
Date: 989

Gerona: Cathedral,
Archives, 7
Gerona Beatus of 975,
fol. 11ʳ
Date: 975

Glasgow: Library,
University, Hunter 229
Hunterian Psalter, fol. 9ᵛ
Date: *c.* 1170

Göttingen: Library, Uni-versitätsbibl., Theol. 231
Sacramentary of Fulda,
fol. 1ᵛ
Date: 970–980

Grenoble: Library,
Bibl. de la Ville, 12-15
Bible, 1, fol. 5ᵛ
Date: 2nd half 12th cent.

Hague, The: Museum,
Meermanno-Westreenia-num, 10.B.21
Maerlant, *Rijmbijbel*,
fol. 13ʳ
Date: 1332

Halberstadt: Library,
Domgymnasium, 114
Missal, fol. 21ᵛ
Date: 1st half 13th cent.

Istanbul: Library,
Topkapi Sarayi,
Cod. G.I.8
Seraglio Octateuch,
fol. 87ᵛ
Date: 11th cent.

Jerusalem: Library,
Jewish National,
Schocken Collection
Pentateuch, Hebrew
Date: 13th–14th cent.

Jerusalem: Library,
Armenian Patriarchal,
Armenian Patr. 2555
2nd Etchmiadzin Gos-pels, fol. 8ᵛ
Date: 980–1020

Klagenfurt: Museum,
Landes, VI.19
Millstatt Miscellany,
fol. 29ʳ
Date: 1180–1220

Kremsmünster: Library,
Stiftsbibl., 243
Speculum Humanae Salva-tionis, fol. 27ʳ
Date: 1st half 14 cent.

Kremsmünster: Library,
Stiftsbibl., 328
Biblia Pauperum, fol. 6ᵛ
Date: late 14th cent.

Leiden: Library, Bibl. der
Universiteit, BPL 76 A
St. Louis Psalter, fol. 13ʳ
Date: 1185–1205

Leiden: Library, Bibl. der
Universiteit, Burm. Q. 3
Prudentius, *Psychomachia*,
fol. 120ʳ
Date: 825–849

Leiden: Library, Bibl. der
Universiteit, Voss. Lat.
Oct. 15
Prudentius, *Psychomachia*,
fol. 37ʳ
Date: 11th cent.

Leipzig: Library,
Universitätsbibl., 1676
Biblia Pauperum, verso
Date: early 14th cent.

Leningrad (St. Peters-burg): Library,
Public, Fr.F.1.
Guyart des Moulins,
Bible, 1, fol. 1ʳ
Date: 14th cent.

Leningrad (St. Peters-burg): Library,
Public, Lat. Q.v.I.78
Breviary, fol. 25ᵛ
Date: 13th cent.

León: Church,
S. Isidoro, 2
León Bible of 960, fol. 7ʳ
Date: 960

León: Church,
S. Isidoro, 2
León Bible of 960, fol. 21ᵛ
Date: 960

León: Church,
S. Isidoro, 3
Bible, 1, fol. 3ʳ
Date: 1162

León: Church,
S. Isidoro, 3
Bible, I, fol. 18ᵛ
Date: 1162

Liège: Library, Bibl. de
l'Université, 2613 c
Wittert Leaf, recto
Date: 1150

Liège: Library, Bibl. de
l'Université, lat. 363
Averbode Gospels,
fol. 86ʳ
Date: 2nd half 12th cent.

Lilienfeld: Library,
Stiftsbibl., 151
Ulrich of Lilienfeld,
Concordantiae caritatis,
fol. 82ᵛ
Date: mid 14th cent.

Lilienfeld: Library,
Stiftsbibl., 151
Ulrich of Lilienfeld,
Concordantiae caritatis,
fol. 89ᵛ
Date: mid 14th cent.

London: Collection,
Beatty, 69
Chronicle, sect. 3
Date: *c.* 1300

London: Library, British,
Add. 15268
Histoire Universelle, fol. 30ᵛ
Date: 1280–1290

London: Library, British,
Add. 16975
Lyre Abbey Psalter,
fol. 25ʳ
Date: 1290–1300

London: Library, British,
Add. 19352
Theodore Psalter,
fol. 140ᵛ
Date: 1066
Attribution: Theodore
the Studite

London: Library, British,
Add. 24199
Prudentius, *Psychomachia*,
fol. 2ʳ
Date: 980–1099

London: Library, British,
Add. 28106-7
Bible, Stavelot, I, fol. 6ʳ
Date: 1097

London: Library, British,
Add. 50000
Oscott Psalter, fol. 17ʳ
Date: 2nd half 13th cent.

London: Library, British,
Burney 3
Bible, Robert of Battle,
fol. 5ᵛ
Date: 13th cent.

London: Library, British,
Cott. Claudius B.IV
Ælfric, *Paraphrase*, fol. 38ʳ
Date: 1025–1049

London: Library, British,
Cott. Cleo. C.VIII
Prudentius, *Psychomachia*,
fol. 1ʳ
Date: 980–999

London: Library, British,
Cott. Nero C.IV
Winchester Psalter, fol. 3ʳ
Date: 1150–1160

London: Library, British,
Cott. Otho. B.VI
Cotton Genesis, fol. 36ᵛ
Date: 5th–6th cent.

London: Library, British,
Cott. Titus D.XVI
Prudentius, *Psychomachia*,
fol. 1ᵛ
Date: 1115–1125

London: Library, British,
Egerton 1894
Genesis, fol. 12ʳ
Date: 14th cent.

London: Library, British,
Harley 5102
Psalter, fol. 68ʳ
Date: 1180–1199

London: Library, British,
King's 5
Biblia Pauperum, fol. 16ʳ
Date: *c.* 1400

London: Library, British,
Roy. 2 B.VII
Queen Mary Psalter,
fol. 11ᵛ
Date: 1310–1320

London: Library, British,
Roy. 16 G.VII
Fleurs des Histoires,
fol. 28ʳ
Date: 14th cent.

London: Museum,
Victoria and Albert,
L. 1346-1891
St. Denis Missale,
fol. 236ʳ
Date: 1350

London: Library,
Lambeth Palace, 3
Bible, I, fol. 6ʳ
Date: 12th cent.

Lyons: Library, Palais du
commerce et des Arts, 22
Prudentius, *Psychomachia*,
fol. 2ʳ
Date: 11th cent.

Madrid: Archive, Ar-
chivo Histórico Nacional,
1097B
Tábara Beatus, fol. 1ʳ
Date: 970

Madrid: Library, Bibl.
Nacional, Vit. 14-2
Facundus Beatus, fol. 13ʳ
Date: 1047

Madrid: Library, Bibl.
Nacional, Vit. 20-7
Pontifical, fol. 82ʳ
Date: 12th–13th cent.

Madrid: Museum,
Arqueológico Nacional
Beatus, *In Apocalipsin*,
fol. 1ʳ
Date: 12th–13th cent.

Madrid: Museum, Real
Academia de la Historia,
2, 3
Bible of S. Millián de la
Cogolla, I, fol. 21ʳ
Date: 1200–1220

Madrid: Museum,
Real Academia de la
Historia, 22
Lectionary
Date: 1073

Manchester: Library,
John Rylands, Univer-
sity, fr. 5
Old Testament Picture
Book, fol. 21ᵛ
Date: 1225–1249

Milan: Library, Bibl.
Ambrosiana, B.30 inf.
Pentateuch, Hebrew,
fol. 102ʳ
Date: 13th cent.

Moscow: Museum,
Historical, gr. 129
Chludoff Psalter, fol. 105ᵛ
Date: 800–899

Mount Athos: Monas-
tery, Pantokrator, 61
Pantocrator Marginal
Psalter, fol. 151ᵛ
Date: 800–899

Mount Athos: Monas-
tery, Rossikon, 6
Gregory Nazianzen,
Homilies, fol. 152ʳ
Date: 1000–1099

Mount Sinai: Library,
Monastery, 1186
Cosmas Indicopleustes,
fol. 100ʳ
Date: 10th–11th cent.

Munich: Library,
Staatabibl., Cgm. 20
Biblia Pauperum, fol. 14ʳ
Date: 2nd half 14th cent.

Munich: Library,
Staatabibl., Clm. 146
*Speculum Humanae Salva-
tionis*, fol. 24ᵛ
Date: 14th cent.

Munich: Library,
Staatabibl., Clm. 835
Psalter, fol. 12ʳ
Date: 1200–1210

Munich: Library,
Staatabibl., Clm. 935
Prayer Book, St. Hilde-
gardis, fol. 8ᵛ
Date: 12th cent.

Munich: Library,
Staatabibl., Clm. 14159
Dialogus Cruce Christi,
fol. 1ᵛ
Date: 1170–1175

Munich: Library,
Staatabibl., Clm. 19414
Biblia Pauperum, fol. 165ʳ
Date: mid 14th cent.

Munich: Library,
Staatabibl., Clm. 23425
Biblia Pauperum, fol. 5ʳ
Date: *c.* 1300

Munich: Library,
Staatabibl., Clm. 23425
Biblia Pauperum, fol. 5ᵛ
Date: *c.* 1300

Munich: Library,
Staatabibl., Clm. 23426
Biblia Pauperum, fol. 7ʳ
Date: mid 14th cent.

Munich: Library,
Staatabibl., gall. 16
Queen Isabella Psalter,
fol. 29ᵛ
Date: *c.* 1303–1306

Munich: Library,
Staatabibl., slav. 4
Serbian Psalter, fol. 134ᵛ
Date: 1350–1420

New York: Library,
Morgan, G.64
Minatures from Bible,
fol. 6ᵛ
Date: 2nd half 13th cent.

New York: Library,
Morgan, H.1
Hours, fol. 41ʳ
Date: *c.* 1500
(Fig. 116)

New York: Library,
Morgan, H.5
Hours, fol. 58ʳ
Date: *c.* 1500
(Fig. 117)

New York: Library,
Morgan, M.8
Breviary, fol. 61ʳ
Date: *c.* 1511
(Fig. 118)

New York: Library,
Morgan, M.32
Hours, fol. 6ᵛ
Date: *c.* 1470
(Fig. 119)

New York: Library,
Morgan, M.43
Huntingfield Psalter,
fol. 11ʳ
Date: 1210–1220
(Fig. 120)

New York: Library,
Morgan, M.47
Sheldon Missal, fol. 110ʳ
Date: *c.* 1430
(Fig. 121)

New York: Library,
Morgan, M.107
Titptoft Missal, fol. 141ᵛ
Date: *c.* 1320
(Fig. 122)

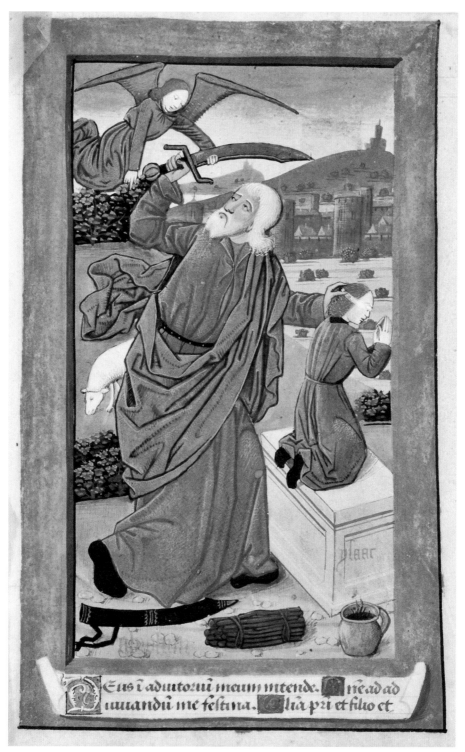

116. Sacrifice of Isaac. Miniature from a Book of Hours now in The Morgan Library and Museum, New York, Ms. H. I, fol. 41ʳ. French, possibly by Robert Boyvin or a follower of the Master of the Rouen Échevinage, *c.* 1500 (photo: Morgan Library and Museum).

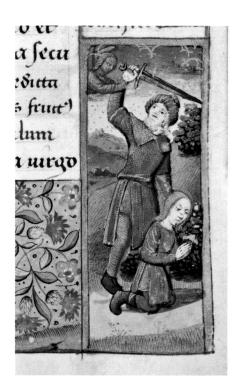

117. Sacrifice of Isaac. Miniature from a Book of Hours now in The Morgan Library and Museum, New York, Ms. H.5, fol. 58ʳ. French, possibly by Robert Boyvin or a follower of the Master of the Rouen Échevinage, *c.* 1500 (photo: Morgan Library and Museum).

118. Sacrifice of Isaac. Miniature from a Breviary now in The Morgan Library and Museum, New York, Ms. M.8, fol. 61ʳ. French, *c.* 1511 (photo: Morgan Library and Museum).

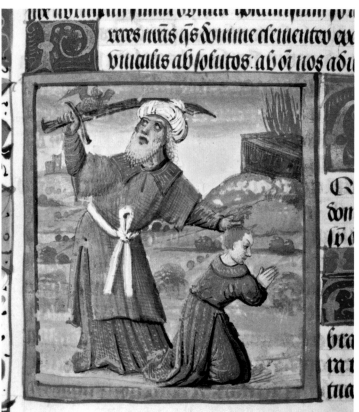

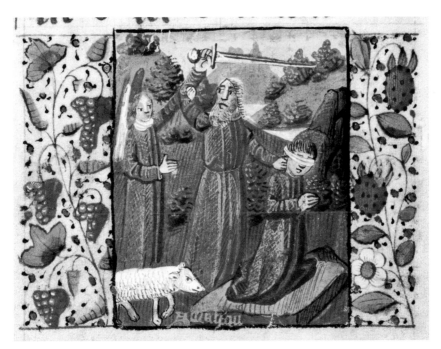

119. Sacrifice of Isaac. Miniature from a Book of Hours now in The Morgan Library and Museum, New York, Ms. M. 32, fol. 6ᵛ. French, possibly Rouen, *c.* 1470 (photo: Morgan Library and Museum).

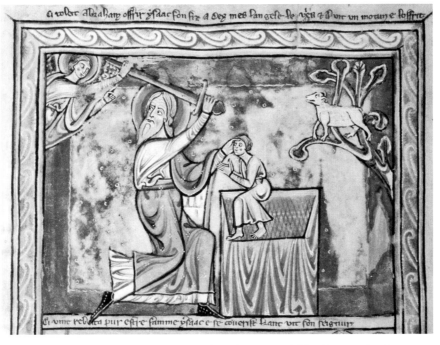

120. Sacrifice of Isaac. Prefatory miniature from the Huntingfield Psalter, now in The Morgan Library and Museum, New York, Ms. M. 43, fol. 11ʳ. English, possibly Oxford, 1210–1220 (photo: Morgan Library and Museum).

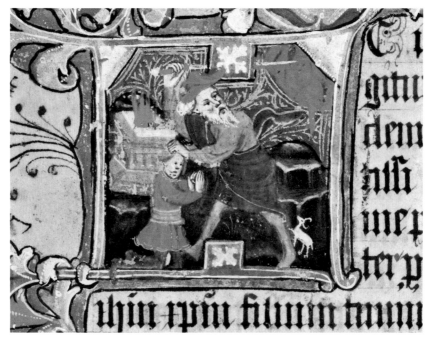

121. Sacrifice of Isaac. Historiated initial from the Sheldon Missal now in The Morgan Library and Museum, New York, Ms. M.47, fol. 110ʳ. English, *c.* 1430 (photo: Morgan Library and Museum).

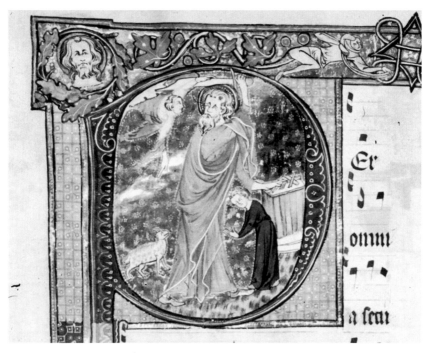

122. Sacrifice of Isaac. Historiated initial from the Titptoft Missal, now in The Morgan Library and Museum, New York, Ms. M. 107, fol. 141ᵛ. English, possibly Cambridge, *c.* 1320 (photo: Morgan Library and Museum).

New York: Library,
Morgan, M.131
Hours, fol. 13r
Date: 1475–1475

New York: Library,
Morgan, M.140
*Speculum Humanae Salva-
tionis*, fol. 24v
Date: late 14th cent.
(Fig. 123)

New York: Library,
Morgan, M.158
*Speculum Humanae Salva-
tionis*, fol. 37v
Date: *c.* 1476
(Fig. 124)

New York: Library,
Morgan, M.212–213
*Histoire Ancienne Jusqu'à
César*, fol. 20v
Date: *c.* 1460
(Fig. 125)

New York: Library,
Morgan, M.230
Weigel-Felix Biblia
Pauperum, fol. 15r
Date: *c.* 1435 & 16th cent.
(Fig. 126)

New York: Library,
Morgan, M.230
Weigel-Felix Biblia
Pauperum, fol. 17r
Date: *c.* 1435 & 16th cent.
(Fig. 127)

New York: Library,
Morgan, M.285
Hours, fol. 150v
Date: 1465–1475

New York: Library,
Morgan, M.304
Hours, fol. 17r
Date: *c.* 1445
(Fig. 128)

New York: Library,
Morgan, M.322-323 —*cont.*

Bible Historiale of Guy-
art des Moulins, I, fol. 32r
Date: *c.* 1325
Attribution: Maubeuge
Master
(Fig. 129)

New York: Library,
Morgan, M.338
Psalter, fol. 200v
Date: *c.* 1200
(Fig. 130)

New York: Library,
Morgan, M.367
Peter of Poitiers, *Compen-
dium Historiae in Genealo-
gia Christi*, recto
Date: late 13th cent.
(Fig. 131)

New York: Library,
Morgan, M.385
*Speculum Humanae
Salvationis*,
fol. 24v
Date: mid 15th cent.
(Fig. 132)

New York: Library,
Morgan, M.394
Bible Historiale of Gu-
yart des Moulins,
fol. 20r
Date: 1400–1425
Attribution: Boucicaut
Master, workshop
(Fol. 133)

New York: Library,
Morgan, M.485
Hours, fol. 61r
Date: *c.* 1475

New York: Library,
Morgan, M.628
Peter of Poitiers, *Compen-
dium Historiae in Genea-
logia Christi*, single leaf,
recto, section 5
Date: 1250–1299
(Fig. 134)

New York: Library,
Morgan, M.638
Morgan Picture Bible,
fol. 3r
Date: *c.* 1250
(Fig. 135)

New York: Library,
Morgan, M.644
Morgan Beatus, fol. 6r
Date: *c.* 940–945
(Fig. 136)

New York: Library,
Morgan, M.739
Hedwig of Silesia Hours,
fol. 11v
Date: 1204–1219
(Fig. 137)

New York: Library,
Morgan, M.766
*Speculum Humanae
Salvationis*, fol. 43v
Date: *c.* 1400
(Fig. 138)

New York: Library,
Morgan, M.769
Christ-Herre Chronik,
fol. 47v
Date: *c.* 1360
(Fig. 139)

New York: Library,
Morgan, M.769
Christ-Herre Chronik,
fol. 48r
Date: *c.* 1360
(Fig. 140)

New York: Library,
Morgan, M.782
*Speculum Humanae Salva-
tionis*, fol. 38v
Date: 1450–1460
(Fig. 141)

New York: Library,
Morgan, M.803
Lectionary, fol. 130r
Date: 1334

·pſaac porat ligna· ad pœndū cor̄⁹ ꝓū·

Gen̄. 22·

Abraḥā·

yſaac·

Sic oli̅ paā̃ ꝯ̃ eū̃ feē̃ n̅az̃ campina coṁ·
Dya⁹·n̅· uideñſ ſcōſ p̅eſ ī lymbo exultare
Cōiciebat ꝙ xꝑ ſuā paſſione̅ uelł eos lib̅are·

123. Sacrifice of Isaac. Pen-and-color wash drawing from *Speculum Humanae Salvationis*, now in The Morgan Library and Museum, New York, Ms. M. 140, fol. 24ᵛ. German, late 14th century (photo: Morgan Library and Museum).

124. Sacrifice of Isaac. Quarter-page woodcut from *Speculum Humanae Salvationis*, now in The Morgan Library and Museum, New York, Ms. M. 158, fol. 37ᵛ. Swiss, *c.* 1476 (photo: Morgan Library and Museum).

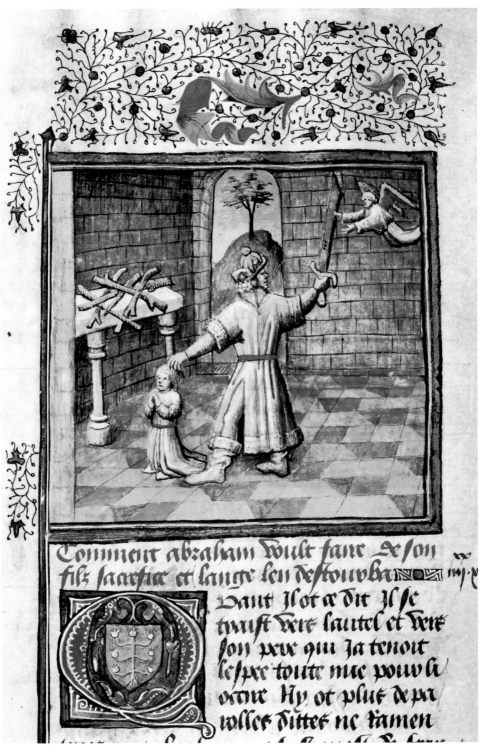

Comment abraham voult fane de son
fils sacrifice et lange sen destourba

vaut Ilot ce dit Ilse
truist vers lautiel et vers
son pere qui la tenoit
lespee toute mue pour li
ocrre Hy ot plus de pa
roller dittes ne tamen

125. Sacrifice of Isaac. Miniature from a manuscript of the *Histoire Ancienne Jusqu'à César*,
now in The Morgan Library and Museum, New York, Ms. M. 212, fol. 20ᵛ. French, possibly
by the Master of Amiens 200, c. 1460 (photo: Morgan Library and Museum).

126 & 127. Sacrifice of Isaac. Pen drawings from the Weigel-Felix Biblia Pauperum, now in The Morgan Library and Museum, New York, Ms. M. 230, fol. 15ʳ (*above*), and fol. 17ʳ (*below*). Austrian, *c*. 1435 and 16th century (photo: Morgan Library and Museum).

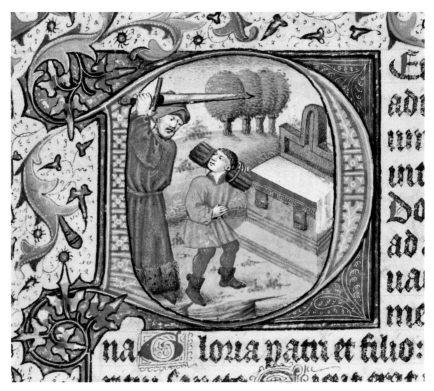

128. Sacrifice of Isaac. Historiated initial from a Book of Hours now in The Morgan Library and Museum, New York, Ms. M. 304, fol. 17r. French, *c.* 1445 (photo: Morgan Library and Museum).

129. Sacrifice of Isaac. Miniature from the Bible Historiale of Guyart des Moulins, now in The Morgan Library and Museum, New York, Ms. M. 322–323, I, fol. 32r. French, by the Maubeuge Master, *c.* 1325 (photo: Morgan Library and Museum).

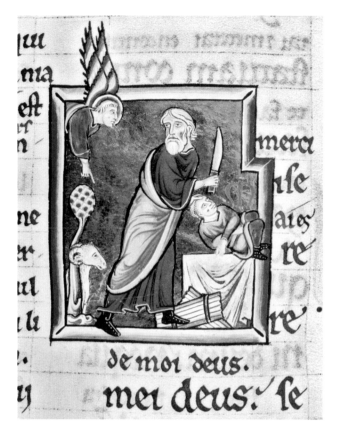

130. Sacrifice of Isaac. Miniature from a Psalter now in The Morgan Library and Museum, New York, Ms. M. 338, fol. 200ᵛ. French, possibly the northeast, *c.* 1200 (photo: Morgan Library and Museum).

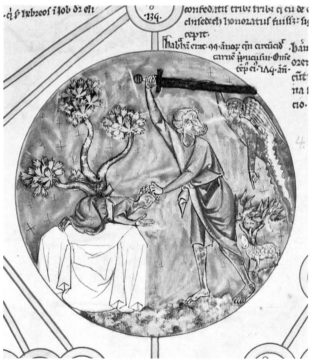

131. Sacrifice of Isaac. Pen drawing from Peter of Poitiers, *Compendium Historiae in Genealogia Christi*, now in The Morgan Library and Museum, New York, Ms. M. 367, recto. French, Picardy, late 13th century (photo: Morgan Library and Museum).

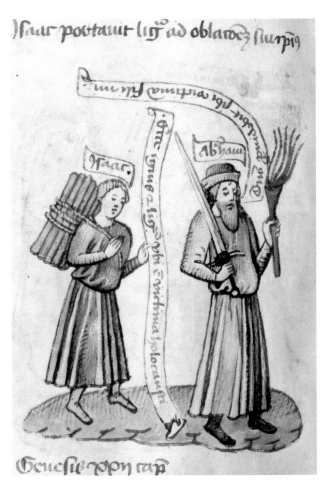

Isaac portauit ligna ad oblacioné suirpig

Isaac.

Abrahã.

Genesis xxij cap.

132. Sacrifice of Isaac. Pen drawing with color wash from *Speculum Humanae Salvationis*, now in The Morgan Library and Museum, New York, Ms. M. 385, fol. 24ᵛ. Flemish, mid 15th century (photo: Morgan Library and Museum).

133. Sacrifice of Isaac. Miniature from the Bible Historiale of Guyart des Moulins, now in The Morgan Library and Museum, New York, Ms. M. 394, fol. 20ʳ. French, possibly by the Boucicaut Master workshop, 1400–1425 (photo: Morgan Library and Museum).

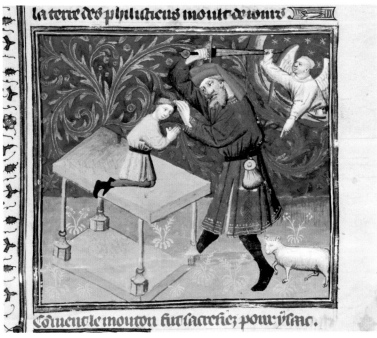

la terre des phulicheus mout de loiur

Comuent le mouton fut sacrifiez pour ysaac.

134. Sacrifice of Isaac. Pen drawing with color wash from Peter of Poitiers, *Compendium Historiae in Genealogia Christi*, now in The Morgan Library and Museum, New York, Ms. M. 628, recto. English, 1250–1299 (photo: Morgan Library and Museum).

135. Sacrifice of Isaac. Lower register of a full-page miniature from The Morgan Picture Bible, now in The Morgan Library and Museum, New York, Ms. M. 638, fol. 3ʳ. French, *c*. 1250 (photo: Morgan Library and Museum).

136. Sacrifice of Isaac. Miniature from the Morgan Beatus, now in The Morgan Library and Museum, New York, Ms. M. 644, fol. 6ʳ. Spanish, by Maius, *c.* 940–945 (photo: Morgan Library and Museum).

137. Sacrifice of Isaac. Miniature (*detail*) from a German manuscript (Hedwig of Silesia Hours), now in The Morgan Library and Museum, New York, Ms. M. 739, fol. 11ᵛ. Possibly Bohemian, 1204–1219 (photo: Morgan Library and Museum).

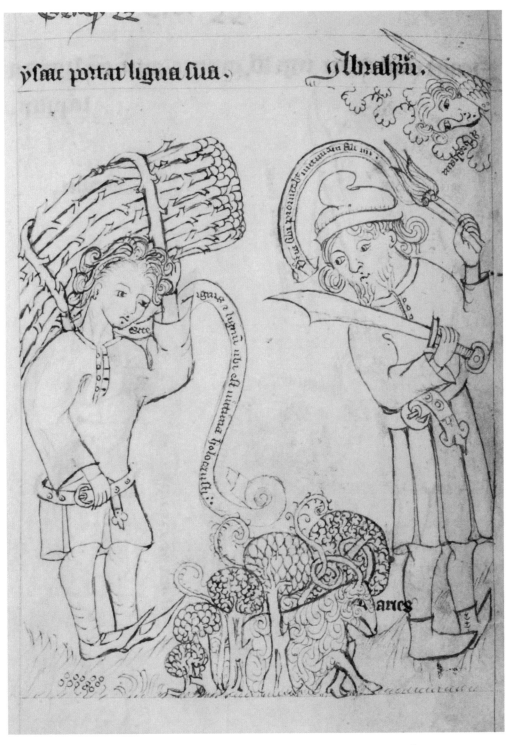

ysaac portat ligna sua. abraham.

138. Sacrifice of Isaac. Pen drawing from *Speculum Humanae Salvationis*, now in The Morgan Library and Museum, New York, Ms. M. 766, fol. 43ᵛ. English, possibly Yorkshire, *c.* 1400 (photo: Morgan Library and Museum).

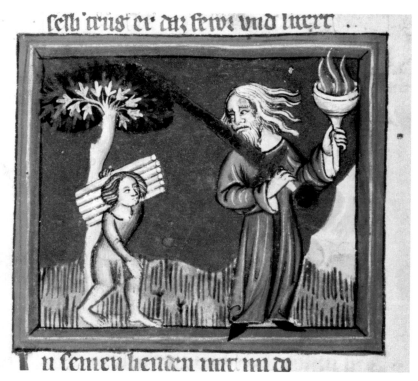

139. Sacrifice of Isaac. Miniature from a chronicle (Christ-Herre Chronik) now in The Morgan Library and Museum, New York, Ms. M. 769, fol. 47ᵛ. German, possibly Bavarian, c. 1360 (photo: Morgan Library and Museum).

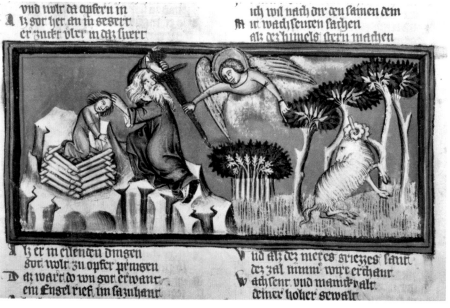

140. Sacrifice of Isaac. Miniature from a chronicle (Christ-Herre Chronik) now in The Morgan Library and Museum, New York, Ms. M. 769, fol. 48ʳ. German, possibly Bavarian, c. 1360 (photo: Morgan Library and Museum).

141. Sacrifice of Isaac. Pen drawing with color wash from *Speculum Humanae Salvationis*, now in The Morgan Library and Museum, New York, Ms. M. 782, fol. 38ᵛ. German, possibly by Hector and Georg Mülich, 1450–1460 (photo: Morgan Library and Museum).

New York: Library,
Morgan, M.914
Missal, fragment
Date: 1220–1225
(Fig. 142)

New York: Library,
Morgan, M.917
Hours of Catherine of
Cleves, no. 146, p. 97
Date: c. 1440
(Fig. 143)

New York: Library,
Morgan, M.969
Bible, fol. 173ʳ
Date: last quarter 13th
cent.

New York: Library,
Morgan, M.983
Tongerloo Missal,
fol. 116ʳ
Date: 1552
(Fig. 144)

New York: Library,
Morgan, M.1078
Croesinck Hours, fol. 53ʳ
Date: c. 1494
(Fig. 145)

New York: Library,
Morgan, M.1157
Genealogical Chronicle
of France, section 9
Date: c. 1470–1475

New York: Library,
Public, Spencer 26
Tickhill Psalter, fol. 6ʳ
Date: early 14th cent.

Oxford: Library, All Souls
College, 6
Amesbury Psalter, fol. 13ʳ
Date: 1250–1260

Oxford: Library,
Bodleian, 270b
Bible, Moralized, fol. 15ᵛ
Date: 1st half 13th cent.

Oxford: Library,
Bodleian, 270b
Bible, Moralized, fol. 16ʳ
Date: 1st half 13th cent.

Oxford: Library,
Bodleian, Auct. D.4.4
Psalter, fol. 105ʳ
Date: 2nd half 13th cent.

Oxford: Library,
Bodleian, Auct. D.4.4
Psalter, fol. 107ᵛ
Date: 2nd half 14th cent.

Oxford: Library,
Bodleian, Douce 366
Ormesby Psalter,
fol. 30ʳ
Date: c. 1320

Palermo: Library, Bibl.
Nazionale, I.F.6–I.F.7
Bible, I, fol. 1ʳ
Date: 13th cent.

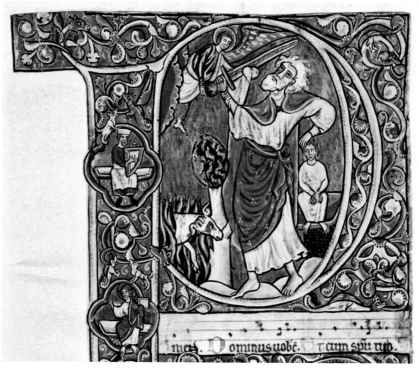

142. Sacrifice of Isaac. Historiated initial from a Missal fragment now in The Morgan Library and Museum, New York, Ms. M. 914. English, 1220–1225 (photo: Morgan Library and Museum).

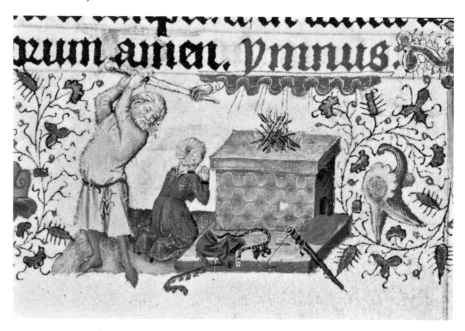

143. Sacrifice of Isaac. Marginalia from the Hours of Catherine of Cleves, now in The Morgan Library and Museum, New York, Ms. M. 917, no. 146, p. 97. Dutch, Utrecht, by the Master of Catherine of Cleves, c. 1440 (photo: Morgan Library and Museum).

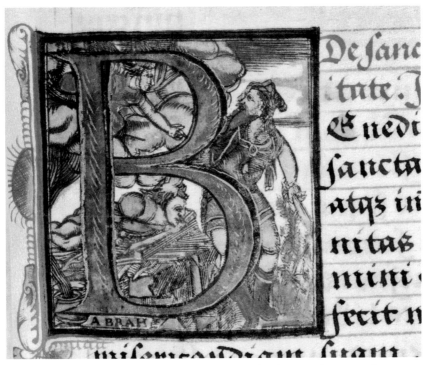

144. Sacrifice of Isaac. Historiated initial from the Tongerloo Missal, now in The Morgan Library and Museum, New York, Ms. M. 983, fol. 116ʳ. Flemish, 1552 (photo: Morgan Library and Museum).

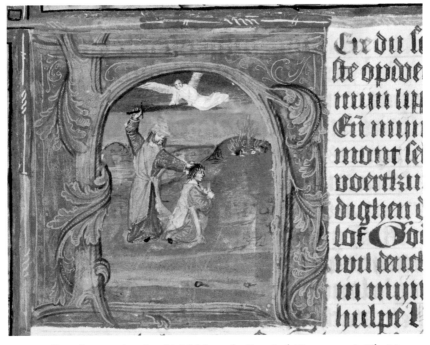

145. Sacrifice of Isaac. Historiated initial from the Croesinck Hours, now in The Morgan Library and Museum, New York, Ms. M. 1078, fol. 53ʳ. Dutch, by the Master of Cornelis Croesinck, c. 1494 (photo: Morgan Library and Museum).

Paris: Library, Bibl. de
l'Arsenal, 1186
Psalter of Blanche of
Castile, fol. 13ᵛ
Date: 1220–1226

Paris: Library, Bibl. de
l'Arsenal, 5212
Bible Historiale, fol. 30ᵛ
Date: late 14th cent.

Paris: Library, Bibl.
Nationale, fr. 15397
Bible, Jean de Sy, fol. 35ʳ
Date: c. 1356

Paris: Library, Bibl.
Nationale, fr. 15397
Bible, Jean de Sy, fol. 35ᵛ
Date: c. 1356

Paris: Library, Bibl.
Nationale, fr. 20125
Histoire Universelle, fol. 35ʳ
Date: c. 1300

Paris: Library, Bibl.
Nationale, gr. 20
Psalter, fol. 13ʳ
Date: 800–899

Paris: Library, Bibl.
Nationale, gr. 510
Gregory Nazianzen,
Homilies, fol. 174ᵛ
Date: 879–883

Paris: Library, Bibl.
Nationale, lat. 6
Roda Bible, I, fol. 1ᵛ
Date: 1000–1099

Paris: Library, Bibl.
Nationale, lat. 17.311
Cambrai Missal,
fol. 174ʳ
Date: 1st half 14th cent.

Paris: Library, Bibl. Na-
tionale, lat. 8085
Prudentius, *Psychomachia*,
fol. 55ᵛ
Date: 9th cent.

Paris: Library, Bibl.
Nationale, lat. 8318
Prudentius, *Psychomachia*,
fol. 49ᵛ
Date: 10th cent.

Paris: Library, Bibl.
Nationale, lat. 8846
Psalter, fol. 1ᵛ
Date: 12th–13th cent.

Paris: Library, Bibl.
Nationale, lat. 8878
St. Sever Apocalypse,
fol. 8ʳ
Date: 1028–1072

Paris: Library, Bibl.
Nationale, lat. 9428
Sacramentary of Drogo,
fol. 15ᵛ
Date: 844–855

Paris: Library, Bibl.
Nationale, lat. 10431
Bible, fol. 348ʳ
Date: 13th cent.

Paris: Library, Bibl.
Nationale, lat. 10434
Psalter of St.-Germaine-
en-Laye, fol. 11ᵛ
Date: 1240–1250

Paris: Library, Bibl.
Nationale, lat. 10525
Psalter of St. Louis,
fol. 10ʳ
Date: 1253–1270

Philadelphia: Library,
Free, Lewis 185
Psalter, fol. 163ᵛ
Date: 13th cent.

Prague: Library,
University, XIII.E.14b
Psalter, fol. (?)
Date: 12th cent.

Prague: Library, Univer-
sity, XXIII.C.124 —*cont.*

Velislaus Miscellany,
fol. 22ʳ
Date: 14th cent.

Prague: Library,
University, XXIII.C.124
Velislaus Miscellany,
fol. 22ᵛ
Date: 14th cent.

Rome: Library, Bibl.
Vaticana, Barb. gr. 372
Barberini Psalter,
fol. 178ᵛ
Date: 1050–1099

Rome: Library, Bibl.
Vaticana, gr. 699
Cosmas Indicopleustes,
fol. 59ʳ
Date: 850–899

Rome: Library, Bibl.
Vaticana, gr. 746
Octateuch, fol. 82ʳ
Date: 1100–1199

Rome: Library, Bibl.
Vaticana, gr. 746
Octateuch, fol. 83ʳ
Date: 1100–1199

Rome: Library, Bibl.
Vaticana, gr. 747
Octateuch, fol. 43ʳ
Date: 1000–1099

Rome: Library, Bibl.
Vaticana, gr. 747
Octateuch, fol. 43ᵛ
Date: 1000–1099

Rome: Library, Bibl.
Vaticana, lat. 5729
Farfa Bible, fol. 6ʳ
Date: 1000–1099

Rovigo: Library,
Bibl. Academic dei
Concordia, 212
Picture Bible, fol. 13ᵛ
Date: 14th cent.

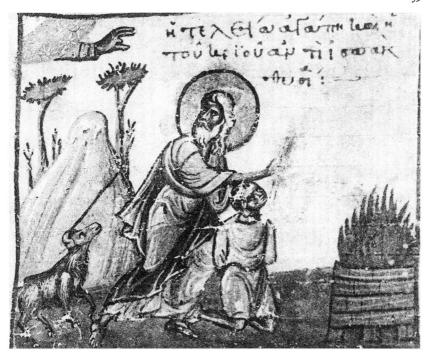

146. Sacrifice of Isaac. Miniature from the Smyrna Octateuch, formerly in The Evangelical School, Smyrna (Ms. A.1, fol. 35r). Constantinople, 12th century (photo: Index of Christian Art).

Rovigo: Library, Bibl. Academic dei Concordia, 212 Picture Bible, fol. 14r Date: 14th cent.

Saint Florian: Library, Stiftsbibl., III.207 Biblia Pauperum, fol. 6v Date: c. 1310

Saint Florian: Library, Stiftsbibl., III.207 Biblia Pauperum, fol. 7r Date: c. 1310

Saint-Omer: Library, Bibl. Municipale, 34 Origen, *Homilies*, fol. 1v Date: 12th cent.

Salzburg: Library, Stiftsbibl., Peter a.VII.43 Biblia Pauperum, fol. 141r Date: late 14th cent.

Salzburg: Library, Stiftsbibl., Peter a.VII.43 Biblia Pauperum, fol. 141v Date: late 14th cent.

Salzburg: Library, Stiftsbibl., Peter a.IX.12 Biblia Pauperum, fol. 6v Date: c. 1400

Sarajevo: Museum, National Museum of Bosnia and Herzegovina *Haggadah*, fol. 7v Date: 14th cent.

Sarajevo: Museum National Museum of Bosnia and Herzegovina *Haggadah*, fol. 8r Date: 14th cent.

Schaffhausen: Library, Stadtbibl., Min. 6 Bible, fol. 2r Date: 1st half 14th cent.

Schulpforta: Library, Bibl. der Landesschule, A.10 Augustine, *De Civitate Dei*, fol. 2v Date: c. 1180

Smyrna: Library, Evang. School, A.1 Octateuch, fol. 34v Date: 12th cent.

Smyrna: Library, Evang. School, A.1 Octateuch, fol.35r Date: 12th cent. (Fig. 146)

Smyrna: Library, Evang. School, B.8 *Physiologus*-Cosmas Indicopleustes Date: 11th–12th cent.

Strasbourg: Library, Bibl. de la Ville —*cont.*

Herradis of Landsberg,
Hortus Delic., fol. 36[r]
Date: 12th cent.

Stuttgart: Library,
Landesbibl.,
Hist. Fol. 418
Josephus, *Antiquitates
Judaicae*, fol. 3[r]
Date: 1st half 12th cent.

Toledo: Library, Bibl.
del Cabildo, 10.8
Speculum Humanae Salvationis, fol. 24[v]
Date: 1320–1340

Toledo (Ohio): Museum,
of Art, 1923.3204
Buckland Missal, recto
Date: 1360–1380

Trier: Cathedral, Treasury, 141.A.126
Gospel Book, fol. 15[r]
Date: 12th–13th cent.

Turin: Library, Bibl.
Nazionale, I.II.1
Beatus, *In Apocalipsin*,
fol. 11[r]
Date: 1100–1124

Valenciennes: Library,
Bibl. Publique, 563
Prudentius, *Psychomachia*,
fol. 1[r]
Date: 800–899

Vienna: Library, Mechitharisten-
Kongregation, 697
Gospel Book, fol. 6[v]
Date: 980–1020

Vienna: Library,
Nationalbibl., 1198
Biblia Pauperum, fol. 6[v]
Date: 1st half 14th cent.

Vienna: Library,
Nationalbibl., 1198
Biblia Pauperum, fol. 7[r]
Date: 1st half 14th cent.

Vienna: Library,
Nationalbibl., 2576
Chronicon Mundi, fol. 21[r]
Date: late 14th cent.

Vienna: Library,
Nationalbibl., 2583
Matfre Ermengaud,
Brev. d'Amor, fol. 55[v]
Date: 14th cent.

Vienna: Library,
Nationalbibl., 2739
Preces, fol. 6[v]
Date: 2nd half 12th cent.

Vienna: Library,
Nationalbibl.,
Ser. Nov. 2611
Psalter, fol. 7[r]
Date: 1260–1270

Weimar: Library, Landesbibl., Fol. max. 4
Biblia Pauperum, fol. 6[v]
Date: 1st half 14th cent.

Weimar: Library, Landesbibl., Fol. max. 4
Biblia Pauperum, fol. 7[r]
Date: 1st half 14th cent.

Winchester: Library,
Cathedral
Bible, I, fol. 5[r]
Date: 2nd half 12th cent.

Wolfenbüttel: Library,
Herzog August Bibl.,
3662
Sketchbook, fol. 93[v]
Date: 1st half 13th cent.

Wolfenbüttel: Library,
Herzog August Bibl.,
Guelf. 521 Helmst.
Psalter, fol. 8[v]
Date: *c.* 1220

Wolfenbüttel: Library,
Herzog August Bibl.,
Helmst. 35a
Miscellany, fol. 7[v]
Date: 2nd half 14th cent.

Wolfenbüttel: Library,
Herzog August Bibl.,
Helmst. 569 (522)
Missal, endsheet (front)
Date: 13th cent.

Zurich: Library, Zentralbibl., Rheinau 15
Rudolf von Ems,
Weltchronik, fol. 32[v]
Date: 1340–1350

IVORY

Berlin: Museum,
Staatliche Museen
Plaque (I.3775)
Date: 300–499

Berlin: Museum,
Staatliche Museen
Pyxis (563)
Date: 395–404

Bologna: Museum, Civico
Pyxis
Date: 400–499

Darmstadt: Museum,
Hessisches Landesmuseum
Altar (portable)
Date: late 11th–12th
cent.

Liverpool: Museum,
Public Library
Plaque (walrus; from
book cover)
Date: 1150–1199

London: Museum, British
Pyxis
Date: 500–599

Osnabrück: Cathedral,
Treasury
Altar (portable)
Date: 2nd half 11th
cent.

Rome: Museum, Terme
Pyxis
Date: 6th cent.

Salerno: Museum,
Museo Diocesano
Altar frontal
Date: late 11th cent.

St. Petersburg: Museum,
Hermitage
Plaque
Date: 1000–1099

St. Petersburg: Museum,
Hermitage
Plaque
Date: mid 11th cent.

Trier: Museum, Rhei-
nisches Landesmuseum
Pyxis
Date: 400–499

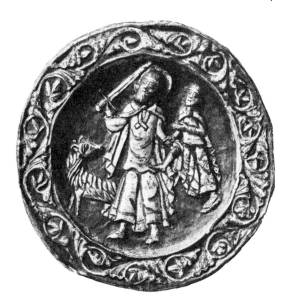

147. Sacrifice of Isaac. Detail from the Lisbjerg Altar, now in the National Museum, Copenhagen. Originally from Lisbjerg Church, Aarhus. Copper-gilt, Danish, 12th century (photo: Index of Christian Art).

METAL

Aquileia: Cathedral,
Treasury
Spoon
Date: mid 4th cent.

Berlin: Museum,
Staatliche
Pendant (bronze; 1751)
Date: 14th – 15th cent.

Bonn: Museum,
Rheinisches Landesmu-
seum
Plaque
Date: 300–399

Borga: Cathedral
Chalice (silver-gilt)
Date: late 12th – 13th
cent.

Cologne: Church,
St. Maria-Lyskirchen
Crucifix (processional)
Date: 11th – 13th cent.

Copenhagen: Museum,
National
Altar (copper-gilt)
Date: 12th cent.
(Fig. 147)

Geneva: Museum, Musée
d'Art et d'Histoire
Vessel (silver; AD 2383)
Date: 600–699

Gniezno: Museum,
Muzeum Archidiezjalne
Paten
Date: 1150–1199

Hannover: Museum,
Provinzial
Plaque (copper; XXI.a.45)
Date: 11th – 12th cent.

London: Museum, British
Plaque
Date: 1st half 4th cent.

London: Museum, British
Ring (bronze)
Date: 3rd – 4th cent.

Mainz: Cathedral,
St. Martin, Treasury
Cross (processional;
copper-gilt)
Date: 12th cent.

Marienstern: Convent,
Cistercian
Paten (gold)
Date: 1240–1260

Milan: Cathedral
Candelabrum (bronze-
gilt)
Date: c. 1180

Monreale: Cathedral
Door (bronze)
Date: 1185 (Fig. 148)

Monte Sant'Angelo:
Church, S. Michele
Door (bronze)
Date: 1076

Munich: Museum,
Residenz
Reliquary
Date: 11th cent.

Paris: Museum,
Musée de Cluny
Altar (portable)
Date: 1000–1033

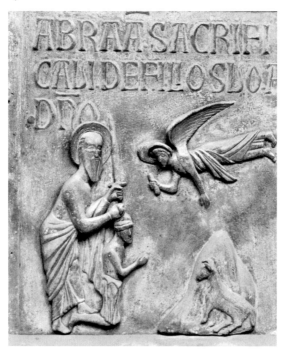

148. Sacrifice of Isaac. Monreale Cathedral, west portal doors, left valve. Italian, Pisan, by Bonanus of Pisa, *c.* 1185 (photo: Colum Hourihane).

Pistoia: Cathedral,
S. Zenone
Altar frontal
Date: 1364

Rome: Church,
S. Giovanni in Laterano
Cross (of Constantine)
Date: 12th cent.

Rome: Church,
S. Giovanni in Laternao,
Treasury
Casket (copper-gilt)
Date: 9th–12th cent.

Rome: Museum,
Musei Vaticani,
Museo Pio Cristiano
Plaque
Date: 4th cent.

Rome: Museum, Musei
Vaticani, *—cont.*

Museo Pio Cristiano
Plaque (bronze)
Date: before 700

Rome: Studio di Canova
Sarcophagus
Date: 300–324

Sahl: Church
Altar (copper-gilt)
Date: 1200–1220

Tongres: Church,
Notre Dame
Reliquary (True Cross)
Date: 12th–13th cent.

Trier: Cathedral,
Treasury
Censer (Gozbert)
Date: *c.* 1100

Trzemeszno: Church,
Augustinian Abbey
Paten
Date: 12th cent.

Verona: Church,
S. Zeno
Door (bronze)
Date: 11th–12th cent.

Vienna: Museum,
Kunsthistorisches
Chalice
Date: 1160–1170

Werben: Church,
St. Johannes der Täufer
Chalice (silver-gilt)
Date: 1200–1299

MOSAIC

Beit Alpha: Synagogue
Pavement
Date: 500–524

Hildesheim: Cathedral
Pavement
Date: 1153–1161

Istanbul: Church,
Kahrie-Djami
Narthex, inner
Date: 400–499

Jerusalem: Church, Holy
Sepulcher
Chapels, calvary
Date: 12th cent.

Monreale: Cathedral
Nave, north wall,
zone 3, no. 8
Date: late 12th cent.
(Fig. 149)

Palermo: Chapel,
Cappella Palatina
Nave, north wall,
zone 2, nos. 03–04
Date: 1140–1160

Ravenna: Church,
Sant'Apollinare in Classe
Apse
Date: 673–679

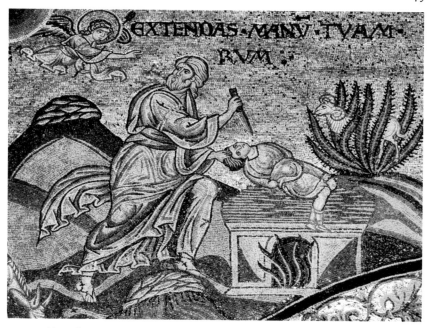

149. Sacrifice of Isaac. Monreale Cathedral, Mosaic from the nave (north wall). Italian, late 12th century (photo: Colum Hourihane).

Ravenna: Church,
S. Vitale
Sanctuary
Date: 525–549

Reims: Church, St.-Remi
Choir
Date: after 1090

Reims: Museum,
Musée St.-Remi
Pavement
Date: late 12th cent.

Rome: Cemetery,
Hermes
Arch 1
Date: 4th cent.

Rome: Church,
Sta. Costanza
Dome, zone 1
Date: mid 4th cent.

Rome: Church,
S. Giovanni in Laterano
Nave
Date: 4th cent.

Tigzirt: Basilica
Nave
Date: 5th–6th cent.

Tunis: Museum, Bardo
National
Grave slab of Calendionis
and Fortunatas
Date: 1st half 5th cent.

Zippori: Synagogue
Pavement
Date: 400–499

PAINTING

Bury St. Edmunds:
Church, Abbey
Hanging, choir
Date: 13th cent.

Hamburg: Gallery,
Kunsthalle
Retable
Date: 1375–1383
(Fig. 150)

Mount Sinai: Monastery,
Church of the —cont.

Transfiguration
Panels
Date: 600–699

Rome: Museum,
Pinacoteca Vaticana
Triptych
Date: 1300–1349

Southampton: Gallery,
City Art
Triptych
Date: 1355–1375

SCULPTURE

Aire-sur-l'Adour:
Church,
Ste.-Quitterie du Mas
d'Aire
Sarcophagus
Date: 400–499

Aix-en-Provence: Mu-
seum, Musée Granet
Sarcophagus
Date: 380–399

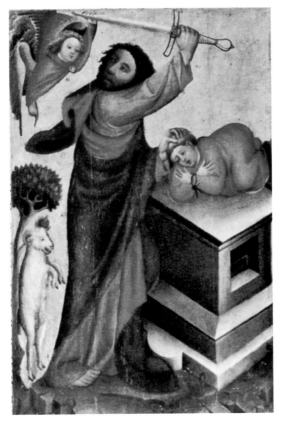

150. Sacrifice of Isaac. Detail from the High Altar of St. Peter's in Hamburg (The Grabower Altar), now in the Hamburger Kunsthalle, Hamburg. German, by Meister Bertram, 1375–1383 (photo: Wikimedia Commons).

Akhtamar: Monastery, Church, Holy Cross Exterior, south Date: 915–921

Alfeld: Church, Nikolaikirche Cross Date: 1225–1245

Amiens: Cathedral, Notre Dame Exterior, south, portal, archivolts Date: 1259–1269

Ancona: Museum, Museo Diocesano —cont.

Sarcophagus of Gorgonius Date: 380–399

Arboe: Cemetery Cross Date: 800–899

Arles: Church, St.-Trophime Cloister Date: 1140–1155

Arles: Museum, Musée de l'Arles Antique Sarcophagus (Repertorium III, 35) Date: 4th cent. (Fig. 151)

Arles: Museum, Musée de l'Arles Antique Sarcophagus (Repertorium III, 38) Date: 2nd quarter 4th cent.

Arles: Museum, Musée de l'Arles Antique Sarcophagus (Repertorium III, 40) Date: late 4th cent. (Fig. 152)

Arles: Museum, Musée de l'Arles Antique Sarcophagus (Repertorium III, 41) Date: 2nd quarter 4th cent.

Arles: Museum, Musée de l'Arles Antique Sarcophagus (Repertorium III, 52) Date: 4th cent.

Arles: Museum, Musée de l'Arles Antique Sarcophagus (Repertorium III, 61) Date: 2nd third of the 4th cent. (Fig. 153)

Arles: Museum, Musée de l'Arles Antique Sarcophagus (Repertorium III, 84) Date: 4th cent. (Fig. 154)

Armagh: Cathedral Cross Date: 10th cent.

Armentia: Church, S. Prudencio Relief Date: 1100–1199

Auch: Museum, Musée des Jacobins Sarcophagus Date: 2nd quarter 4th cent.

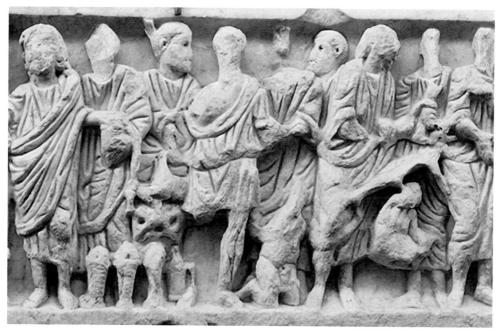

151. Sacrifice of Isaac. Detail of a sarcophagus now in the Musée de l'Arles Antique (Repertorium III, no. 35). Italian, early Christian, 4th century (photo: Colum Hourihane).

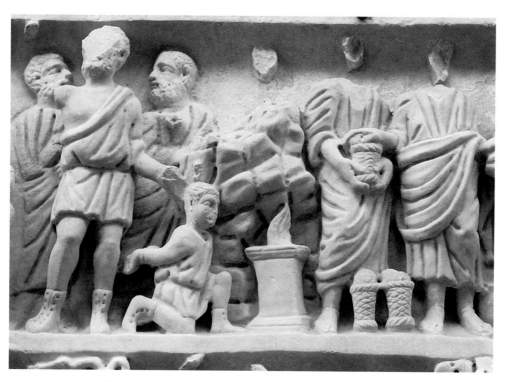

152. Sacrifice of Isaac. Detail of a sarcophagus now in the Musée de l'Arles Antique (Repertorium III, no. 40). Italian, early Christian, late 4th century (photo: Colum Hourihane).

153. Abraham, holding knife and standing next to ram (*left panel*). Sarcophagus now in the Musée de l'Arles Antique (Repertorium III, no. 61). Italian, early Christian, 2nd third of the 4th century (photo: Colum Hourihane).

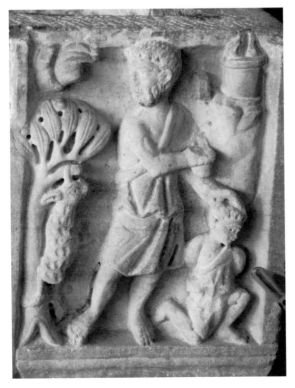

154. Sacrifice of Isaac. Detail of a sarcophagus now in the Musée de l'Arles Antique (Repertorium III, no. 84). Italian, early Christian, 4th century (photo: Colum Hourihane).

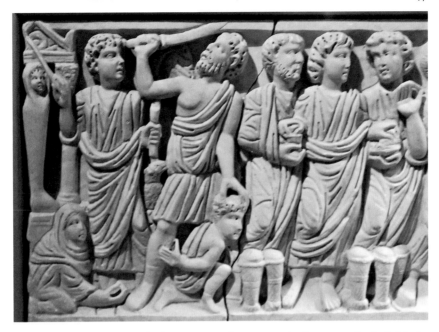

155. Sacrifice of Isaac. Detail of Layos Sarcophagus, now in the Museu Frederic Marès, Barcelona. Marble, Italian, 4th century (photo: Colum Hourihane).

Autun: Cathedral,
St.-Lazare
Nave, west pier, capital
Date: 1120–1135

Bad Doberan: Church,
Cistercian
Cross, double-sided
Date: 1300–1399

Bad Doberan: Church,
Cistercian
Retable (triptych)
Date: 1305–1315

Bad Gögging: Church
Exterior, north, relief
Date: 1200–1249

Barcelona: Museum,
Museu Frederic Marès
Sarcophagus
Date: 4th cent.
(Fig. 155)

Basel: Cathedral
Ambulatory, capital
Date: 1185–2000

Berlin: Museum,
Staatliche Museen
Relief
Date: 400–599

Berlin: Museum,
Staatliche Museen
Sarcophagus
Date: 300–320

Berteaucourt-les-Dames:
Church, Notre Dame
Exterior, west
Date: 1140–1159

Bommiers: Church
Crossing, capital
Date: 1100–1199

Bordeaux: Museum,
Musée d'Aquitaine
Keystone
Date: 1200–1249
(Fig. 156)

Bourges: Cathedral
Exterior, south
Date: 1100–1199

Bryn Athyn: Museum,
Glencairn
Capital
Date: early 12th cent.
(Fig. 157)

Burgos: Cathedral,
Cloister
Statue
Date: 1265–1270
(Fig. 158)

Burgos: Museum,
Museo de Burgos
Sarcophagus, 79
Date: 6th–7th cent.

Camus-Macosquin:
Cemetery
Cross
Date: 10th cent.

Capua: Church,
S. Marcello Maggiore
Sarcophagus
Date: 300–320

Capua: Church, S. Marcello Maggiore —cont.

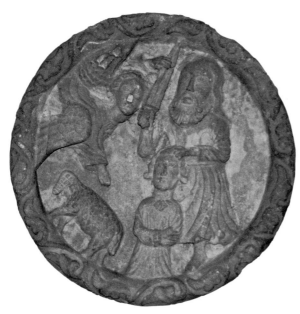

156. Sacrifice of Isaac. Carved keystone (*detail*), now in the Musée d'Aquitaine, Bordeaux. French, 1200–1249 (photo: Colum Hourihane).

Exterior, south, portal, archivolt
Date: 1100–1299

Carcassonne: Museum, Château Comtal
Sarcophagus
Date: 300–399

Castillo de Loarre: Church
Portal
Date: 11th cent.

Castledermot: Cemetery
Cross, north
Date: 800–899

Castledermot: Cemetery
Cross, south
Date: 800–899

Châlons-en-Champagne: Church, Notre Dame
Statue
Date: 1100–1199

Chartres: Cathedral, Notre-Dame
Exterior, north
Date: 1205–1210

Châteauneuf-sur-Charente: Church, St.-Pierre
Capital
Date: 1130–1150

Cismar: Church, Benedictine
Retable
Date: 1300–1320

Ciudad Rodrigo: Cathedral
Statue
Date: 1100–1299

Cívita Castellana: Cathedral, Sta. Maria
Sarcophagus
Date: 350–399

Clermont-Ferrand: Church, Notre-Dame du Port
Exterior, south
Date: 1180–1199

Clermont-Ferrand: Museum, Musée Bargoin
Sarcophagus
Date: 300–499

Cleveland: Museum of Art
Altar
Date: 1170–1180

Clones: Marketplace
Cross, obverse
Date: 900–999

Cognac: Church, St. Léger
Exterior, west
Date: 1150–1199

Cologne: Cathedral
Choir stall
Date: 1300–1349

Conques: Church, St.-Foy
Choir, arcade capital of crossing pier
Date: 1st half 12th cent. (Fig. 159)

Die: Cathedral
Capital
Date: 1100–1199

Donaghmore (Tyrone): Cemetery
Cross
Date: 900–999

Durrow: Cemetery
Cross, reverse
Date: 900–999

Écija: Church, Sta. Cruz
Sarcophagus
Date: 300–399

157. Sacrifice of Isaac. Capital from Glencairn Museum, Bryn Athyn, inv. 9.SP.239 (*three views*). Marble, Italian, possibly from Modena or Milan, early 12th century (photo: Colum Hourihane).

158. Sacrifice of Isaac. Carving from the cloisters of Burgos Cathedral. Spanish, 1265–1270 (photo: Colum Hourihane).

Ephesus: Museum,
Archaeological
Ambo
Date: 500–699

Florence: Cathedral,
Sta. Maria del Fiore
Bell Tower
Date: 1416–1421

Freiburg: Cathedral
Narthex
Date: 1280–1320

Galloon Island: Cemetery
Cross
Date: 800–899

Galloon Island: Cemetery
Cross
Date: 900–999

Geneva: Cathedral,
St.-Pierre
Nave
Date: 1150–1199

Genoa: Museum,
Museo di Sant'Agostino
Relief
Date: 1300–1320

Gensac-la-Pallue:
Church, St.-Martin
Exterior, west
Date: 1100–1199

Gerona: Cathedral
Cloister, southeast pier
Date: 2nd half 12th cent.
(Fig. 160)

Gerona: Church, S. Feliú
Sarcophagus
Date: 4th cent.
(Fig. 161)

Glennes: Church
Capitals
Date: 12th cent.

Gloucester: Cathedral
Choir stalls
Date: 1340–1360

159. Sacrifice of Isaac. Church of Ste.-Foy, Conques, arcade capital from the crossing pier. French, 1st half of the 12th century (photo: Colum Hourihane).

Graiguenamanagh: Cemetery
Cross
Date: 9th cent.

Gurk: Cathedral, Mariä Himmelfahrt
Door
Date: 1195–1205

Hannover: Museum, Provinzial
Cross (wood)
Date: mid 13th cent.

Inishkeel: Cemetery
Stele
Date: 900–999

Iona: Cemetery
Cross
Date: 750–799

Issoire: Church, St.-Austremoine
Exterior, north
Date: c. 1150–1159

Istanbul: Museum, Archaeology
Relief
Date: 380–499

Istanbul: Museum, Archaeology
Relief
Date: 480–599

Istanbul: Museum, Archaeology
Table
Date: 380–459

Jaca: Cathedral
Exterior, south portal, Capital
Date: late 11th–early 12th cent. (Fig. 162)

Kells: Cemetery
Cross (of SS. Patrick & Columba)
Date: 9th–10th cent.

Kells: Market Square
Cross
Date: 10th cent.

Kildalton, Islay Island: Cemetery
Cross
Date: 750–799

Killary: Cemetery
Cross
Date: 10th cent.

La Sauve-Majeure: Church, Abbey
Capitals
Date: 12th cent.

La Sauve-Majeure: Church, Abbey
Keystones
Date: 12th cent.

Le Teil: Church, St.-Etienne de Mélas
Capitals
Date: before 11th cent.

Leernes: Church, Martin
Relief
Date: 1100–1199

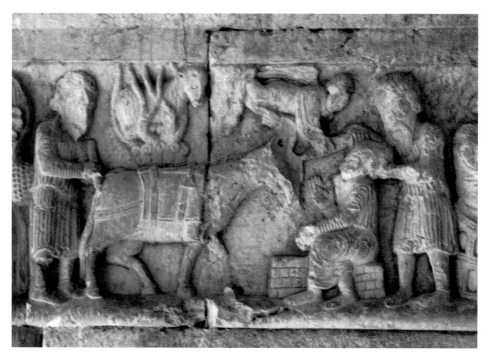

160. Sacrifice of Isaac. Carving from the southeastern pier of the cloisters at Gerona Cathedral. Spanish, 2nd half of the 12th century (photo: Colum Hourihane).

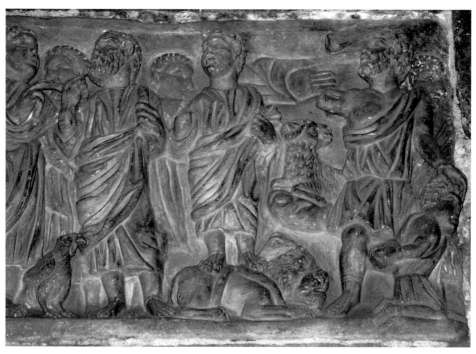

161. Sacrifice of Isaac. Detail of a sarcophagus now in the Church of San Feliú, Gerona. 4th century (photo: Colum Hourihane).

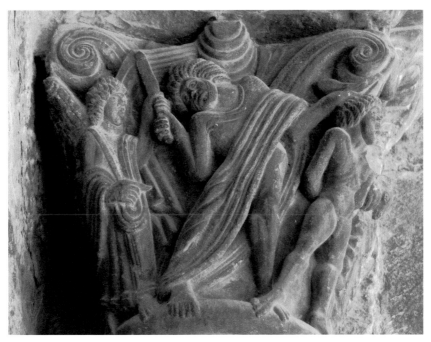

162. Sacrifice of Isaac. Capital on the south portal of Jaca Cathedral. Spanish, late 11th to early 12th centuries (photo: Colum Hourihane).

León: Church, S. Isidoro Chapel, Panteon de los Reyes, capital
Date: 2nd half 11th cent. (Fig. 163)

León: Church, S. Isidoro Exterior, south
Date: late 11th–early 12th cent. (Fig. 164)

Limassol: Museum, District Archaeological Table
Date: 380–459

London: Museum, Victoria and Albert Capital
Date: 1140–1159

Lübeck: Cathedral Relief
Date: 1335–1336

Lucca: Museum, Civico Capitals
Date: 12th cent.

Lucq-de-Béarn: Church Sarcophagus
Date: 300–399

Lund: Cathedral Crypt
Date: 1st half 12th cent.

Lyons: Cathedral Exterior, west
Date: 1308–1332

Madrid: Museum, Arqueológico Nacional San Justo de la Vega Sarcophagus
Date: 300–399

Madrid: Museum, Real Academia de la Historia Hellin Sarcophagus
Date: 300–399

Madrid: Museum, Real Academia de la Historia Layos Sarcophagus
Date: 300–399

Maestricht: Cathedral, St. Servatius Exterior, south, embrasures, left 4
Date: early 13th cent. (Fig. 165)

Maestricht: Church, Notre Dame Capitals
Date: 12th–13th cent.

Malines: Building, Schepenhuis Council Room, console 1
Date: 1377–1378

Malines: Building, Schepenhuis Council Room, beam 3
Date: 1375–1376

Malmesbury: Church, Abbey Exterior, south
Date: 1150–1199

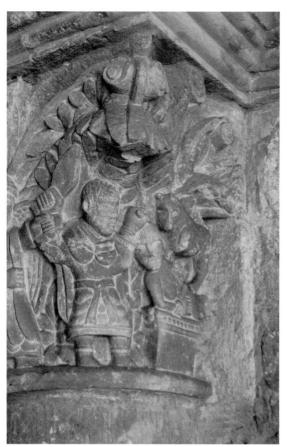

163. Sacrifice of Isaac. Capital from the Church of San Isidoro, Panteón de los Reyes Chapel (no. 17). Spanish, 2nd half of the 11th century (photo: Colum Hourihane).

164. Sacrifice of Isaac. Carved from the south tympanum of the Church of San Isidoro in León. Spanish, late 11th to early 12th centuries (photo: Colum Hourihane).

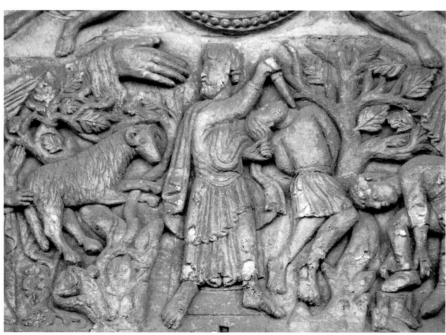

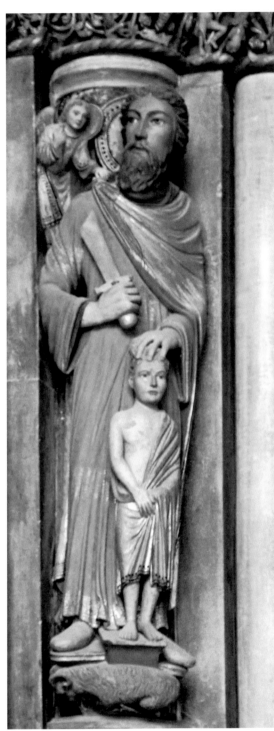

165. Sacrifice of Isaac. Portal figure from the Bergportal in the Cathedral of St. Servatius, Maestricht. Mosan, early 13th century (photo: Colum Hourihane).

Marburg: Museum,
Universitätsmuseum
Statues (from choir
screen)
Date: 13th–14th cent.

Marseilles: Church,
St.-Victor
Sarcophagus
Date: 400–499

Marseilles: Museum,
d'Archéologie Méditer-
ranéene
Sarcophagus [1]
Date: 350–399

Marseilles: Museum,
d'Archéologie Méditer-
ranéene
Sarcophagus [2]
Date: 350–399

Milan: Church,
S. Ambrogio
Sarcophagus
Date: 380–399

Modena: Cathedral
Choir screen, capital 10
Date: c. 1184 (Fig. 166)

Modena: Cathedral
Pulpit
Date: 12th–13th cent.

Moissac: Church,
St.-Pierre
Cloister
Date: 1095–1105

Mont-devant-Sassey:
Church
Exterior, south
Date: 13th cent.

Monte Sant'Angelo:
Tower, Tomba di Rotari
Capital 1
Date: 1st half 12th cent.

Montivilliers: Church
Transept, south
Date: late 10th cent.

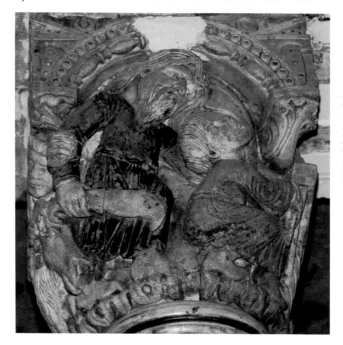

166. Sacrifice of Isaac. Capital from the choir screen of Modena Cathedral. Italian, *c.* 1184 (Photo: Colum Hourihane).

Moone: Cemetery
Cross
Date: 800–899

Moscow: Museum,
Historical
Reliefs
Date: 12th – 13th cent.

Mount Sinai:
Monastery,
Church of the Transfig-
uration
Door (wood)
Date: *c.* 700

Narbonne: Museum,
Musée Lapidaire
Sarcophagus
Date: 400–599

Nicosia: Museum,
Cyprus
Table
Date: 380–459

Nîmes: Museum,
Musée Archéologique
Capital
Date: 12th cent.

Oxford: Cathedral,
Christ Church
Jews' Cross
Date: late 12th cent.

Paris: Cathedral,
Notre Dame
Exterior, west
Date: *c.* 1220–1230

Paris: Museum, Louvre
Capitals (1848–1849)
Date: 12th cent.

Paris: Museum, Louvre
Sarcophagus
Date: 380–399

Parma: Cathedral
Decoration
Date: 12th cent.

Pavia: Church, S. Michele
Decoration
Date: 12th cent.

Perros-Guirec: Church
Capital
Date: 12th cent.

Piacenza: Cathedral
Nave
Date: 1122–1130

Pisa: Cemetery,
Camposanto
Sarcophagus
Date: 310–330

Princeton: Museum,
Art Museum
Relief
Date: 480–559

Reims: Cathedral,
Notre Dame
Exterior, west,
right portal
Date: 1245–1255

Reims: Cathedral,
Notre Dame
Nave
Date: 1255–1275

Rochester (England):
Cathedral
Chapter House
Date: 12th cent.

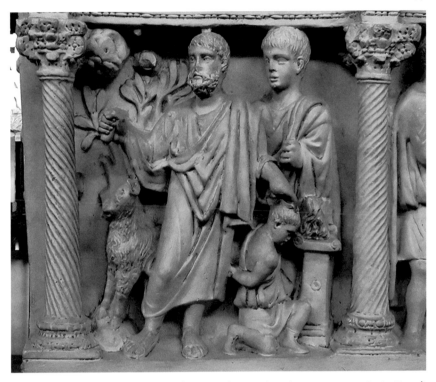

167. Sacrifice of Isaac. Detail from the Sarcophagus of Junius Bassus, now in St. Peter's Basilica, Rome (Repertorium 1, no. 680). Marble, Italian, 359 (photo: Colum Hourihane).

Rome: Cemetery,
Callixtus
Sarcophagus (cover)
Date: 4th cent.

Rome: Cemetery,
Callixtus
Sarcophagus (front)
Date: 2nd quarter 4th
cent.

Rome: Cemetery,
Callixtus
Sarcophagus (front frag.)
2nd half 4th cent.

Rome: Cemetery,
Cyriaca
Sarcophagus [1]
Date: 300–399

Rome: Cemetery,
Cyriaca
Sarcophagus [2]
Date: 300–399

Rome: Cemetery,
Marcus and Marcellianus
Sarcophagus [1]
Date: 4th cent.

Rome: Cemetery, Marcus
and Marcellianus
Sarcophagus [2]
Date: 4th cent.

Rome: Cemetery, Marcus
and Marcellianus
Sarcophagus
Date: 2nd third 4th cent.

Rome: Cemetery,
Pretextatus
Sarcophagus (frag.)
Date: 4th cent.

Rome: Cemetery,
Sebastian
Sarcophagus
Date: 333–365

Rome: Church,
S. Lorenzo fuori le Mura
Sarcophagus
Date: 300–332

Rome: Church,
St. Peter's Basilica
Sarcophagus
Date: 380–399

Rome: Church,
St. Peter's Basilica,
Crypt
Sarcophagus of Junius
Bassus
Date: 359
(Fig. 167)

Rome: Church, S. Se-
bastiano fuori le mura,
Museum
Sarcophagus [1]
Date: 300–399

Rome: Church, S. Sebastiano fuori le Mura, Museum
Sarcophagus [2]
Date: 300–399

Rome: Church, S. Sebastiano fuori le Mura, Museum
Sarcophagus [3]
Date: 300–399

Rome: Church, S. Sisto Vecchio
Sarcophagus
Date: 4th cent.

Rome: House, Piazza del Paradiso, 68
Sarcophagus
Date: 4th cent.

Rome: Museum, Camposanto Tedesco
Sarcophagus
Date: 1st quarter 4th cent.

Rome: Museum, Camposanto Tedesco
Sarcophagus
Date: 4th cent.

Rome: Museum, Capitolino
Sarcophagus of Sixtus Acerra Lupus
Date: 4th cent.

Rome: Museum, Nazionale Romano
Sarcophagus
Date: 1st third 4th cent.

Rome: Museum, Musei Vaticani, Museo Pio Cristiano
Sarcophagus, 55
Date: 300–324

Rome: Museum, Musei Vaticani, Museo Pio Cristiano
Sarcophagus, 64
Date: 4th cent.

Rome: Museum, Musei Vaticani, Museo Pio Cristiano
Sarcophagus, 116
Date: 325–349

Rome: Museum, Musei Vaticani, Museo Pio Cristiano
Sarcophagus, 133
Date: 300–324

Rome: Museum, Musei Vaticani, Museo Pio Cristiano
Sarcophagus, 135
Date: 325–349

Rome: Museum, Musei Vaticani, Museo Pio Cristiano
Sarcophagus, 137
Date: 300–399

Rome: Museum, Musei Vaticani, Museo Pio Cristiano
Sarcophagus, 147
Date: 1st quarter 4th cent.

Rome: Museum, Musei Vaticani, Museo Pio Cristiano
Sarcophagus, 152 (rest.)
Date: 333–365

Rome: Museum, Musei Vaticani, Museo Pio Cristiano
Sarcophagus, 175
Date: 300–399

Rome: Museum, Musei Vaticani, Museo Pio Cristiano
Sarcophagus, 178
Date: 325–349

Rome: Museum, Musei Vaticani, Museo Pio Cristiano
Sarcophagus, 184
Date: 300–332

Rome: Museum, Musei Vaticani, Museo Pio Cristiano
Sarcophagus, 189
Date: 300–332

Rome: Museum, Musei Vaticani, Museo Pio Cristiano
Sarcophagus, 191
Date: 300–332

Rome: Museum, Musei Vaticani, Museo Pio Cristiano
Sarcophagus, 210
Date: 333–365

Rome: Museum, Musei Vaticani, Museo Pio Cristiano
Sarcophagus, 212
325–349

Rome: Museum, Musei Vaticani, Museo Pio Cristiano
Sarcophagus, 222; 227
Date: 4th cent.

Rome: Museum, Terme
Sarcophagus of Claudianus
Date: 4th cent.

Rome: Museum, Terme
Sarcophagus of Claudianus
Date: 4th cent.

Rome: Museum, Terme
Sarcophagus
Date: 4th cent.

Rome: Studio di Canova
Sarcophagus
Date: 300–324

Rome: Vineyard near Baths of Caracalla
Sarcophagus
Date: 4th cent.

Saint-Aignan-sur-Cher: Church, Choir
Date: 12th cent.

Trani: Cathedral,
S. Nicola
Exterior, west
Date: 12th–13th cent.

Trier: Museum,
Diözesanmuseum
Statue
Date: 1240–1250

Tudela: Church,
Collegiate
Exterior, west, embra-
sures, capital 16
Date: 1180–1220

Ullard: Cemetery
Cross
Date: 9th cent.

Vendôme: Church,
Trinité Abbey
Transepts
Date: 13th cent.

Venice: Church,
S. Marco
Relief
Date: 14th cent.

Vereaux: Church,
St.-Martin
Relief (set in west wall)
Date: 12th cent.

Vézelay: Church,
Ste.-Marie-Madeleine
Narthex, upper
Date: 1st half 12th cent.

Vézelay: Church,
Ste.-Marie-Madeleine
Nave
Date: 1st half 12th cent.

Vienne: Cathedral,
St.-Maurice
Capital
Date: 12th cent.

Volterra: Cathedral
Pulpit
Date: 1175–1185

Washington, D.C.: Mu-
seum, Dumbarton Oaks
—cont.

Relief
Date: 1300–1320

Wells: Cathedral,
St. Andrew
Exterior, west
Date: 13th cent.

Winchester: Museum,
City Museum
Capital (Arch. 836)
Date: 12th cent.

Worcester, England:
Cathedral
Choir stalls
Date: late 14th cent.

Worms: Cathedral,
Sts. Peter and Paul
Exterior, south
Date: 1300–1320

Zamora: Church,
S. Cipriano
Exterior
Date: 11th–12th cent.

TERRA COTTA

Carthage: Museum,
Musée national de
Carthage
Lamp
Date: before 700

Constantine: Museum,
Musée Cirta Constantine
Tile
Date: 5th–7th cent.

Lausanne: Museum,
Cantonal Archaeological
Lamp
Date: before 700

Mainz: Museum,
Römisch-Germanisches
Zentralmuseum
Vessel
Date: 300–399

Paris: Museum, Louvre
Tile
Date: 5th cent.

Rome: Museum,
Camposanto Tedesco
Lamp
Date: 4th–5th cent.

Rome: Museum, Musei
Vaticani, Museo Pio
Cristiano
Lamp
Date: 3rd–4th cent.

Toronto: University,
Malcove Collection
Vessel
Date: 340–520

Tunis: Museum,
Bardo National
Tile
Date: 500–599

Valetta: Collection,
Bonavita
Lamp
Date: before 700

TEXTILE

Brakel: Church
Hanging (embroidery)
Date: 1345–1405

Drübeck: Monastery
Altar cloth (embroidery)
Date: 1315–1335

Halberstadt: Cathedral,
Treasury
Hanging (embroidery)
Date: 1270–1280

Krefeld: Museum,
Deutsches Textilmuseum
Fabric (linen; 00109)
Date: 4th–5th cent.

Lyons: Museum,
Musée des Tissus
Fabric
Date: 7th–8th cent.

New York: Museum,
Cooper Union
Fabric
Date: 600–799

New York: Museum,
Metropolitan, Cloisters
Hanging
Date: 1395–1405

Riggisberg: Collection,
Abegg
Hanging
Date: 400–599

Sankt Paul im Lavanttal:
Abbey
Vestment (chasuble;
embroidery)
Date: 12th–13th cent.

Strasbourg: Collection,
Forrer
Fabric (tapestry)
Date: 3rd–4th cent.

Abraham:
Scene, Unidentified

FRESCO

Novgorod: Cathedral,
St. Sophia
Decoration
Date: 12th cent. and
later

ILLUMINATED
MANUSCRIPT

Berlin: Museum,
Staatliches Museen,
Kupferstichkab., 78.A.5
Hamilton Psalter, fol. 63r
Date: late 11th cent.

London: Library, British,
Add. 19352
Theodore Psalter,
fol. 109v
Date: 1066

London: Library, British,
Cott. Claudius B.IV
Ælfric, *Paraphrase*,
fol. 19v
Date: 1025–1049

London: Library, British,
Cott. Claudius B.IV
Ælfric, *Paraphrase*, fol. 20r
Date: 1025–1049

London: Library, British,
Cott. Claudius B.IV
Ælfric, *Paraphrase*,
fol. 20v
Date: 1025–1049

London: Library, British,
Cott. Claudius B.IV
Ælfric, *Paraphrase*, fol. 28r
Date: 1025–1049

London: Library, British,
Roy. 2 B.VII
Queen Mary Psalter,
fol. 10v
Date: 1310–1320

New York: Library,
Morgan, M.7
Hours, fol. 20r
Date: 1490–1501
(Fig. 168)

New York: Library,
Morgan, M.748
Gospel Book, fol. 132r
Date: 1000–1099

Oxford: Library,
Bodleian, Auct.D.4.4
Psalter, fol. 70r
Date: 2nd half 14th cent.

Oxford: Library,
Bodleian, Auct.D.4.4
Psalter, fol. 88r
Date: 2nd half 14th cent.

Rome: Library, Bibl.
Vaticana, gr.394
John Climacus, *Climax*,
fol. 12v
Date: 1080–1099

Rome: Library, Bibl.
Vaticana, gr.746
Octateuch, fol. 68r
Date: 1100–1099

Rome: Library, Bibl.
Vaticana, gr.747
Octateuch, fol. 34v
Date: 1000–1099

Rome: Library, Bibl.
Vaticana, gr.747
Octateuch, fol. 36v
Date: 1000–1099

Smyrna: Library,
Evang. School, A.1
Octateuch, fol. 28r
Date: 12th cent.

Strasbourg: Library,
Bibl. de la Ville
Herradis of Landsberg,
Hortus Delic., fol. 32v
Date: 12th cent.

SCULPTURE

San Quirico d'Orcia:
Palazzo, Chigi
Relief
Date: 1100–1199

Abraham: Scene,
Meeting Melchisedek

FRESCO

Parma, Baptistry
Dome, zone 4, no. 08
Date: mid 13th cent.

ILLUMINATED
MANUSCRIPT

New York: Library,
Morgan, S.2
Hours, fol. 144v
Date: 1496
(Fig. 169)

Rome: Library, Bibl.
Vaticana, gr.746
Octateuch, fol. 68r
Date: 12th cent.

Rome: Library, Bibl.
Vaticana, gr.747
Octateuch, fol. 36v
Date: 11th cent.

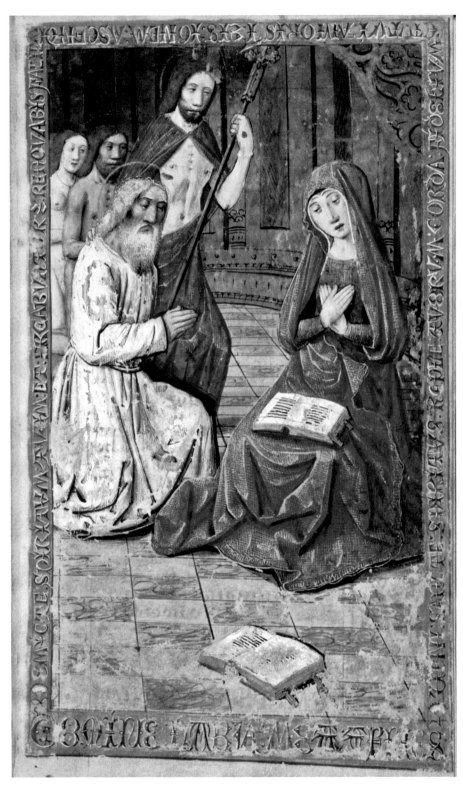

168. Christ appearing to the Virgin Mary. Christ's right hand resting on an unidentified kneeling figure, possibly Abraham. Full-page miniature from a Book of Hours now in The Morgan Library and Museum, New York, Ms. M. 7, fol. 20r. French, possibly Paris, by a follower of Jean Pichore, 1490–1501 (photo: Morgan Library and Museum).

Evang. School, A.1
Octateuch, fol. 28ʳ
Date: 12th cent.

Strasbourg: Library,
Bibl. de la Ville
Herradis of Landsberg,

169. Abraham meets Mel-
chisedek. Marginal detail
from a Book of Hours now
in The Morgan Library
and Museum, New York,
Ms. s.2, fol. 144ᵛ. Dutch,
possibly by Nicolas or Jan
Spierinck, Haarlem, 1496
(photo: Morgan Library and
Museum).

170. Abraham meets Melchi-
sedek. Mosaic (*detail*) from
the atrium (bay 5, dome) of
San Marco, Venice. Italian,
13th century (photo: Wiki-
media Commons).

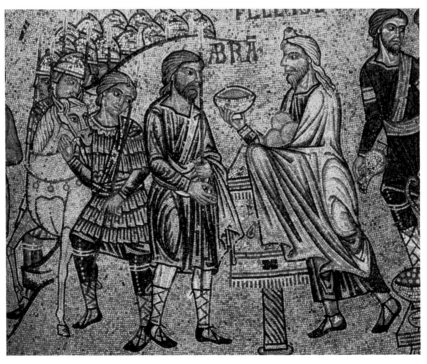

171. Abraham given idols by Terah. Half-page miniature from the Queen Mary Psalter, now in The British Library, London (Ms. Roy. 2 B.VII, fol. 7ᵛ). Pen drawing with color wash, English, 1310–1320 (photo: Index of Christian Art).

Abraham: Scene, Terah Making Idol

ILLUMINATED MANUSCRIPT

London: Library, British, Roy. 2 B.VII
Queen Mary Psalter, fol. 7ᵛ
Date: 1310–1320
(Fig. 171)

London: Library, British, Roy. 2 B.VII
Queen Mary Psalter, fol. 8ʳ
Date: 1310–1320
(Fig. 172)

Abraham: Smoking Furnace

ILLUMINATED MANUSCRIPT

Istanbul: Library, Topkapi Sarayi, Cod. G.I.8
Seraglio Octateuch, fol. 74ʳ
Date: 11th cent.

Lilienfeld: Library, Stiftsbibl., 151
Ulrich of Lilienfeld, *Concordantiae caritatis*, fol. 121ᵛ
Date: mid 14th cent.

London: Library, British, Cott. Claudius B.IV
Ælfric, *Paraphrase*, fol. 27ʳ
Date: 1025–1049

Rome: Library, Bibl. Vaticana, gr. 746
Octateuch, fol. 70ʳ
Date: 1100–1199

Rome: Library, Bibl. Vaticana, gr. 747
Octateuch, fol. 37ʳ
Date: 1000–1099

Smyrna: Library, Evang. School, A.1
Octateuch, fol. 28ᵛ
Date: 12th cent.

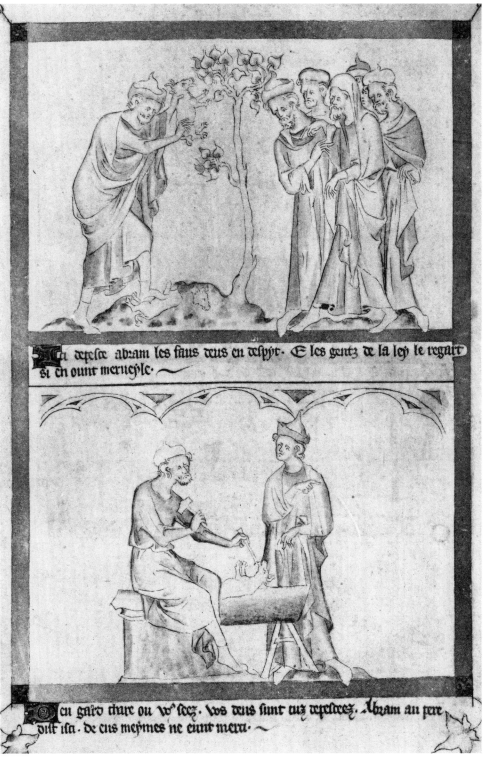

172. Abraham destroying the idols of Terah (*upper zone*) and Terah making an idol (*lower zone*). Full-page prefatory miniature from the Queen Mary Psalter, now in The British Library, London (Ms. Roy. 2 B. VII, fol. 8ʳ). Pen drawing with color wash, English, 1310–1320 (photo: Index of Christian Art).

Abraham: Spoil of Allies

ILLUMINATED MANUSCRIPT

London: Library, British,
Cott. Otho B.VI
Cotton Genesis,
fol. 21v
Date: 400–599

MOSAIC

Venice: Church, S. Marco
Atrium
Date: 13th cent.

Abraham: Taken to Canaan

ILLUMINATED MANUSCRIPT

London: Library, British,
Cott. Claudius B.IV
Ælfric, *Paraphrase*, fol. 20r
Date: 1000–1099

London: Library, British,
Cott. Claudius B.IV
Ælfric, *Paraphrase*,
fol. 20v
Date: 1000–1099

London: Library, British,
Cott. Otho. B.VI
Cotton Genesis, fol. 17v
Date: 400–599

London: Library, British,
Egerton 1894
Genesis, fol. 6v
Date: 14th cent.

Oxford: Library,
Bodleian, Auct. D.4.4
Psalter, fol. 55v
Date: 2nd half 14th cent.

Oxford: Library,
Bodleian, Junius 11
Cædmon, *Poems*, p. 82
Date: 10th–11th cent.

Rome: Library, Bibl.
Vaticana, gr. 746
Octateuch, fol. 63r
Date: 12th cent.

Rome: Library, Bibl.
Vaticana, gr. 747
Octateuch, fol. 34r
Date: 12th cent.

Smyrna: Library,
Evang. School, A.1
Octateuch, fol. 25r
Date: 12th cent.

Smyrna: Library,
Evang. School, A.1
Octateuch, fol. 25v
Date: 12th cent.
(Fig. 173)

Smyrna: Library,
Evang. School, A.1
Octateuch, fol. 26r
Date: 12th cent.

Smyrna: Library,
Evang. School, A.1
Octateuch, fol. 26v
Date: 12th cent.

Smyrna: Library,
Evang. School, A.1
Octateuch, fol. 27r
Date: 12th cent.

Smyrna: Library,
Evang. School, A.1
Octateuch, fol. 27v
Date: 12th cent.

Abraham: Told to Sacrifice Isaac

ILLUMINATED MANUSCRIPT

London: Library, British,
Cott. Nero C.IV
Winchester Psalter, fol. 3r
Date: 1150–1160

London: Library, British,
Roy. 2 B.VII
Queen Mary Psalter,
fol. 11r
Date: 1310–1320

New York: Library,
Morgan, M.677
Hours of Anne of France,
fol. 106r
Date: 1470–1480

MOSAIC

Monreale: Cathedral
Nave, north wall,
zone 3, no. 1
Date: 1180–1199

Abraham & Abimelech: Treaty

ILLUMINATED MANUSCRIPT

London: Library, British,
Cott. Claudius B.IV
Ælfric, *Paraphrase*,
fol. 36v
Date: 1025–1049

London: Library, British,
Cott. Claudius B.IV
Ælfric, *Paraphrase*,
fol. 37r
Date: 11th cent.

London: Library, British,
Egerton 1894
Genesis, fol. 11v
Date: 14th cent.

Paris: Library, Bibl.
Nationale, fr. 15397
Bible, Jean de Sy,
fol. 34r
Date: *c.* 1356

Paris: Library, Bibl.
Nationale, fr. 15397
Bible, Jean de Sy, fol. 34v
Date: *c.* 1356

173. Abraham taken to Canaan. Miniature from the Smyrna Octateuch, formerly in The Evangelical School, Smyrna (Ms. A.1, fol. 25ᵛ). Constantinople, 12th century (photo: Index of Christian Art).

174. Abraham and Abimelech make a treaty. Miniature from the Smyrna Octateuch, formerly in The Evangelical School, Smyrna (Ms. A.1, fol. 34ᵛ). Constantinople, 12th century (photo: Index of Christian Art).

Prague: Library, University, XXIII.C.124 Velislaus Misc., fol. 21ᵛ
Date: 14th cent.

Rome: Library, Bibl. Vaticana, gr. 746 Octateuch, fol. 81ʳ
Date: 1100–1199

Rome: Library, Bibl. Vaticana, gr. 747 Octateuch, fol. 42ᵛ
Date: 1000–1099

Rovigo: Library, Bibl. Academic dei Concordi, 212 —*cont.*

Picture Bible, fol. 13ᵛ
Date: 14th cent.

Smyrna: Library, Evang. School, A.1 Octateuch, fol. 34ᵛ
Date: 12th cent.
(Fig. 174)

Abraham & Lot:
Agreeing to Separate
•═•═•═•═•═•═•═•═•═•═•═•

FRESCO

Bury St. Edmunds:
Church, Abbey
Choir
Date: 1100–1199

ILLUMINATED
MANUSCRIPT

London: Library, British,
Cott. Claudius B.IV
Ælfric, *Paraphrase*, fol. 23ʳ
Date: 1025–1049

London: Library, British,
Egerton 1894
Genesis, fol. 8ʳ
Date: 14th cent.

London: Library, British,
Egerton 1894
Genesis, fol. 7ᵛ
Date: 14th cent.

New York: Library,
Morgan, M.394
Bible Historiale of
Guyart des Moulins,
fol. 14ʳ
Date: 1400–1425
Attribution: Boucicaut
Master, workshop
(Fig. 175)

Oxford: Library,
Bodleian, 270b
Bible, Moralized,
fol. 12ʳ
Date: 1st half 13th cent.

Oxford: Library,
Bodleian, Auct.D.4.4
Psalter, fol. 70ʳ
Date: 2nd half 14th cent.

Paris: Library, Bibl.
Nationale, fr. 15397
Bible, Jean de Sy,
fol. 14ʳ
Date: *c.* 1356

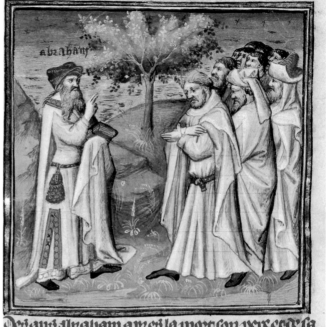

175. Abraham and Lot agreeing to separate, from the Bible Historiale of Guyart des Moulins, now in The Morgan Library and Museum, New York, Ms. M.394, fol. 14ʳ. French, 1400–1425 (photo: Morgan Library and Museum).

Prague: Library,
University, XXIII.C.124
Velislaus Miscellany,
fol. 14ʳ
Date: 14th cent.

Abraham & Lot:
Separating
•═•═•═•═•═•═•═•═•═•═•═•

ILLUMINATED
MANUSCRIPT

London: Library, British,
Cott. Claudius B.IV
Ælfric, *Paraphrase*, fol. 23ᵛ
Date: 1025–1049

London: Library, British,
Cott. Otho B.VI
Cotton Genesis, fol. 19ᵛ
Date: 1025–1049

Paris: Library, Bibl.
Nationale, gr. 923
John of Damascus,
Sacra Parallela,
fol. 248ʳ
Date: 800–899

Rome: Library, Bibl.
Vaticana, gr. 746
Octateuch, fol. 65ᵛ
Date: 1100–1199

Rome: Library, Bibl.
Vaticana, gr. 747
Octateuch, fol. 35ʳ
Date: 1100–1199

Smyrna: Library,
Evang. School. A.1
Octateuch, fol. 26ᵛ
Date: 12th cent.

MOSAIC

Rome: Church,
Sta. Maria Maggiore
Nave
Date: 432–440

SCULPTURE

Lyons: Cathedral
Exterior, west,
central portal,
embrasures
Date: 1308–1332

Abraham & Lot:
Shepherds' Quarrel
••─•─•─•─•─•─•─•─•─•─•─••

ILLUMINATED
MANUSCRIPT

London: Library, British,
Egerton 1894
Genesis, fol. 7ᵛ
Date: 14th cent.

Oxford: Library,
Bodleian, 270b
Bible, Moralized, fol. 12ʳ
Date: 1st half 13th cent.

Prague: Library,
University, XXIII.C.124
Velislaus Misc., fol. 14ʳ
Date: 14th cent.

SCULPTURE

Lyons: Cathedral
Exterior, west
Date: 1st half 14th cent.

Abraham & Sarah:
Before Abimelech
••─•─•─•─•─•─•─•─•─•─•─••

ILLUMINATED
MANUSCRIPT

Amiens: Library,
Bibl. de la Ville, 108
Pamplona Picture Bible,
I, fol. 9ᵛ
Date: 1197

Amiens: Library,
Bibl. de la Ville, 108
Pamplona Picture Bible,
I, fol. 10ʳ
Date: 1197

Augsburg: Library,
Univeritätsbibl.,
I.2.qu.15
Pamplona Picture Bible,
II, fol. 18ʳ
Date: 1195–1205

Augsburg: Library,
Universitätsbibl.,
I.2.qu.15
Pamplona Picture Bible,
II, fol. 18ᵛ
Date: 1195–1205

London: Library, British,
Cott. Claudius B.IV
Ælfric, *Paraphrase*,
fol. 34ʳ
Date: 1025–1049

London: Library, British,
Cott. Claudius B.IV
Ælfric, *Paraphrase*,
fol. 35ʳ
Date: 1025–1049

London: Library,
British, Egerton 1894
Genesis, fol. 11ʳ
Date: 14th cent.

Paris: Library,
Bibl. Nationale,
Nouv. Acq. Lat. 2334
Ashburnham Pentateuch,
fol. 18ʳ
Date: 7th cent.

Rome: Library, Bibl.
Vaticana, gr. 746
Octateuch, fol. 78ᵛ
Date: 1100–1199

Rome: Library, Bibl.
Vaticana, gr. 747
Octateuch, fol. 41ᵛ
Date: 1000–1099

Rovigo: Library,
Bibl. Accademia dei
Concordia, 212
Picture Bible,
fol. 11ᵛ
Date: 14th cent.

Rovigo: Library,
Bibl. Accademia dei
Concordi, 212
Picture Bible,
fol. 12ʳ
Date: 14th cent.

Smyrna: Library,
Evang. School, A.1
Octateuch, fol. 33ʳ
Date: 12th cent.
(Fig. 176)

Abraham & Sarah:
Before Pharaoh
••─•─•─•─•─•─•─•─•─•─•─••

GLASS

Erfurt: Cathedral
Windows, choir
Date: 2nd half 14th –
early 15th cent.

ILLUMINATED
MANUSCRIPT

Amiens: Library,
Bibl. de la Ville, 108
Pamplona Picture Bible,
I, fol. 6ʳ
Date: 1197

Augsburg: Library,
Universitätsbibl.,
I.2.qu.15
Pamplona Picture Bible,
II, fol. 13ᵛ
Date: 1195–1205

London: Library, British,
Cott. Claudius B.IV
Ælfric, *Paraphrase*,
fol. 22ʳ
Date: 1025–1049

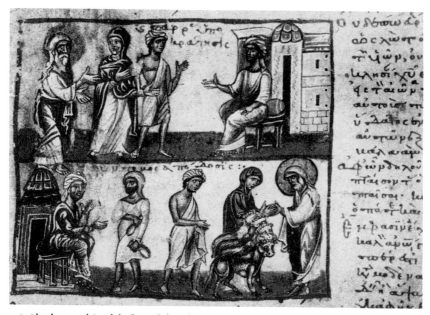

176. Abraham and Sarah before Abilmech. Miniature from the Smyrna Octateuch, formerly in The Evangelical School, Smyrna (Ms. A.1, fol. 33ʳ). Constantinople, 12th century (photo: Index of Christian Art).

London: Library, British, Egerton 1894
Genesis, fol. 7ʳ
Date: 14th cent.

New York: Library, Morgan, M.338
Psalter, fol. 176ᵛ
Date: c. 1200
(Fig. 177)

New York: Library, Morgan, M.338
Psalter, fol. 181ᵛ
Date: c. 1200
(Fig. 178)

Oxford: Library, Bodleian, 270b
Bible, Moralized, fol. 11ᵛ
Date: 1st half 13th cent.

Paris: Library, Bibl. Geneviève, 20-21
Guyart des Moulins, Bible, I, fol. 18ᵛ
Date: 1st half 14th cent.

Paris: Library, Bibl. Nationale, gr. 923
John of Damascus, *Sacra Parallela*, fol 205ᵛ
Date: 800–899

Prague: Library, University, XXIII.C.124
Velislaus Misc., fol. 13ʳ
Date: 14th cent.

Prague: Library, University, XXIII.C.124
Velislaus Miscellany, fol. 20ᵛ
Date: 14th cent.

Rome: Library, Bibl. Vaticana, gr. 746
Octateuch, fol. 65ʳ
Date: 1100–1199

Rome: Library, Bibl. Vaticana, gr. 747
Octateuch, fol. 35ʳ
Date: 1000–1099

Rovigo: Library, Bibl. Academic dei —*cont.*

Concordi, 212
Picture Bible, fol. 7ᵛ
Date: 14th cent.

Smyrna: Library, Evang. School, A.1
Octateuch, fol. 26ᵛ
Date: 12th cent.

IVORY

Salerno: Museum, Museo Diocesano
Altar frontal
Date: late 11th cent.

Abraham &
Sarah: Complaint
Against Hagar

ILLUMINATED MANUSCRIPT

London: Library, British, Cott. Claudius B.IV
Ælfric, *Paraphrase*, fol. 27ᵛ
Date: 1025–1049

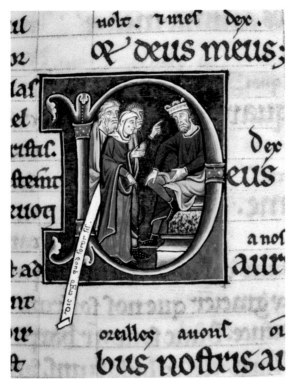

177. Abraham (*holding scroll*), accompanied by Sarah and an attendant, stands before Pharaoh. Historiated initial in illustration of Psalm 44 from a Psalter now in The Morgan Library and Museum, New York, Ms. M. 338, fol. 176ᵛ. French, *c.* 1200 (photo: Morgan Library and Museum).

178. Abraham and Sarah before a crowned Pharaoh. Miniature in illustration of Psalm 45 from a Psalter now in The Morgan Library and Museum, New York, Ms. M. 338, fol. 181ᵛ. French, *c.* 1200 (photo: Morgan Library and Museum).

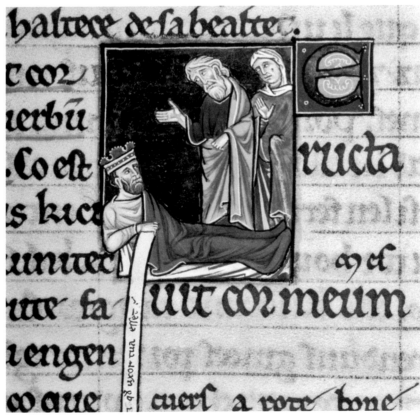

Munich: Library,
Staatsbibl., gall. 16
Queen Isabella Psalter,
fol. 26ᵛ
Date: *c.* 1303–1308

New York: Library,
Morgan, M.394
Bible Historiale of
Guyart des Moulins,
fol. 16ʳ
Date: 1400–1425
Attribution: Boucicaut
Master, workshop

Oxford: Library,
Bodleian, 270b
Bible, Moralized, fol. 13ᵛ
Date: 1st half 13th
cent.

Prague: Library,
University, XXIII.C.124
Velislaus Miscellany,
fol. 16ᵛ
Date: 14th cent.

Rovigo: Library,
Bibl. Academic dei
Concordia, 212
Picture Bible, fol. 9ʳ
Date: 14th cent.

MOSAIC

Venice: Church, S. Marco
Atrium, bay 5, dome
Date: 1200–1299

*Abraham &
Sarah: Complaint
Against Ishmael*

ILLUMINATED
MANUSCRIPT

Amiens: Library,
Bibl. de la Ville, 108
Pamplona Picture Bible,
I, fol. 10ᵛ
Date: 1197

Augsburg: Library,
Universitätsbibl.,
I.2.qu.15
Pamplona Picture Bible,
II, fol. 19ʳ
Date: 1195–1205

Cambridge: Library,
Trinity College, R.17.1
Canterbury Psalter,
fol. 10ʳ
Date: mid 12th cent.

London: Library, British,
Cott. Claudius B.IV
Ælfric, *Paraphrase*,
fol. 35ᵛ
Date: 1025–1049

London: Library, British,
Egerton 1894
Genesis, fol. 11ᵛ
Date: 14th cent.

Munich: Library,
Staatsbibl., gall. 16
Queen Isabella Psalter,
fol. 28ᵛ
Date: *c.* 1303–1308

Paris: Library, Bibl. de
l'Arsenal, 5212
Bible Historiale,
fol. 29ᵛ
Date: late 14th cent.

Paris: Library,
Bibl. Nationale,
Nouv. Acq. Lat. 2334
Ashburnham Pentateuch,
fol. 18ʳ
Date: 7th cent.

Prague: Library,
University, XXIII.C.124
Velislaus Miscellany,
fol. 20ᵛ
Date: 14th cent.

Rome: Library, Bibl.
Vaticana, gr. 746 —*cont.*

Octateuch, fol. 80ʳ
Date: 1100–1199

Rome: Library, Bibl.
Vaticana, gr. 747
Octateuch, fol. 42ʳ
Date: 1000–1099

Rovigo: Library,
Bibl. Academic dei
Concordi, 212
Picture Bible,
fol. 12ᵛ
Date: 14th cent.

Smyrna: Library,
Evang. School, A.1
Octateuch, fol. 33ᵛ
Date: 12th cent.

*Abraham & Sarah:
Leaving Egypt*

ILLUMINATED
MANUSCRIPT

Lilienfeld: Library,
Stiftsbibl., 151
Ulrich of Lilienfeld,
Concordantiae caritatis,
fol. 17ᵛ
Date: mid 14th cent.

London: Library, British,
Cott. Claudius B.IV
Ælfric, *Paraphrase*,
fol. 23ʳ
Date: 1025–1049

Oxford: Library,
Bodleian, 270b
Bible, Moralized,
fol. 12ʳ
Date: 1st half 13th
cent.

Prague: Library,
University XXIII.C.124
Velislaus Miscellany,
fol. 13ᵛ
Date: 14th cent.

179. Marriage of Abraham and Sarah. Detail from a full-page prefatory miniature from the Queen Mary Psalter, now in The British Library, London (Ms. Roy. 2 B.VII, fol. 8ᵛ). Pen drawing with color wash, English, 1310–1320 (photo: Index of Christian Art).

Abraham & Sarah: Marriage

ILLUMINATED MANUSCRIPT

London: Library, British, Cott. Claudius B.IV
Ælfric, *Paraphrase*, fol. 23ʳ
Date: 2nd quarter 11th cent.

London: Library, British, Cott. Otho. B.VI
Cotton Genesis, fol. 17ʳ
Date: 400–599

London: Library, British, Egerton 1894
Genesis, fol. 6ᵛ
Date: 14th cent.

London: Library, British, Roy. 2 B.VII
Queen Mary Psalter, fol. 8ᵛ
Date: 1310–1320
(Fig. 179)

New York: Collection, Hearst, 8
Histoire Ancienne, fol. 18ᵛ
Date: late 14th cent.

Abraham & Sarah: Ordered from Egypt

GLASS

Erfurt: Cathedral Windows, choir
Date: 2nd half 14th–early 15th cent.

ILLUMINATED MANUSCRIPT

Amiens: Library, Bibl. de la Ville, 108
Pamplona Picture Bible, I, fol 6ʳ
Date: 1197

Augsburg: Library, Universitatsbibl., I.2.qu.15
Pamplona Picture Bible, II, fol. 13ᵛ
Date: *c.* 1200

London: Library, British, Cott. Claudius B.IV
Ælfric, *Paraphrase*, fol. 22ᵛ
Date: 1000–1099

London: Library, British, Egerton 1894
Genesis, fol. 7ᵛ
Date: 14th cent.

Oxford: Library,
Bodleian, 270b
Bible, Moralized, fol. 12ʳ
Date: 1st half 13th cent.

Rovigo: Library,
Bibl. Academic dei
Concordi, 212
Picture Bible, fol. 8ʳ
Date: 14th cent.

Abraham & Sarah: Pharaoh Plagued

GLASS

Erfurt: Cathedral
Windows, choir
Date: 2nd half 14th–
early 15th cent.

ILLUMINATED MANUSCRIPT

London: Library, British,
Egerton 1894
Genesis, fol. 7ʳ
Date: 14th cent.

Prague: Library,
University XXIII.C.124
Velislaus Miscellany
Date: 14th cent.

Rovigo: Library,
Bibl. Academic dei
Concordi, 212
Picture Bible, fol. 7ᵛ
Date: 14th cent.

Smyrna: Library,
Evang. School, A.1
Octateuch, fol. 26ᵛ
Date: 12th cent.

Abraham & Sarah: Promised Seed

FRESCO

Bury St. Edmunds:
Church, Abbe —cont.

Choir
Date: 1100–1199

GLASS

Assisi: Church,
S. Francesco, Upper
Window, transept
Date: 13th cent.

Esslingen: Church,
St. Dionys
Windows, choir
Date: 13th–14th cent.

Hohenzollern: Castle
Windows
Date: late 13th cent.

ILLUMINATED MANUSCRIPT

Lilienfeld: Library,
Stiftsbibl., 151
Ulrich of Lilienfeld,
Concordantiase caritatis,
fol. 1ᵛ
Date: mid 14th cent.

New York: Library,
Morgan, M.739
Hedwig of Silesia Hours,
fol. 10ᵛ
Date: 1204–1219
(Fig. 180)

Oxford: Library,
Bodleian, 270b
Bible, Moralized, fol. 14ᵛ
Date: 1st half 13th cent.

Prague: Library,
University, XXIII.C.124
Velislaus Miscellany,
fol. 18ʳ
Date: 14th cent.

Rome: Library, Bibl.
Vaticana, gr. 746
Octateuch, fol. 73ʳ
Date: 1100–1199

Smyrna: Library,
Evang. School, A.1
Octateuch, fol. 30ᵛ
Date: 12th cent.

Smyrna: Library,
Evang. School, A.1
Octateuch, fol. 35ᵛ
Date: 12th cent.

MOSAIC

Rome: Church,
Sta. Maria Maggiore
Nave
Date: 432–440

SCULPTURE

León: Church, S. Isidoro
Exterior, south,
tympanum
Date: late 11th–early
12th cent.
(Fig. 181)

Piacenza: Cathedral
Decoration
Date: 1122–1150

Abraham, Isaac, Jacob: Representing Paradise

FRESCO

Abu Gosh: Church
Sanctuary, apse
Date: 1165–1175

Asinou: Church, Panagia
Narthex
Date: *c.* 1170

Bominaco: Chapel,
S. Pellegrino
Decoration, nave, bay 1
Date: 1263

Clayton: Church,
St. John the Baptist
Nave
Date: 11th cent.

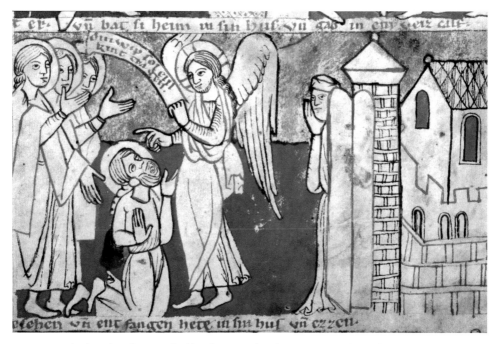

180. Abraham kneeling, flanked by three angels; Christ-Logos with Sarah at open door of building. Miniature (*detail*) from a German manuscript (Hedwig of Silesia Hours), now in The Morgan Library and Museum, New York, Ms. M. 739, fol. 10ᵛ. Possibly Bohemian, 1204–1219 (photo: Morgan Library and Museum).

181. Sarah standing before a roofed building, holding the doorpull. Carving from the south tympanum of the Church of San Isidoro, León. Spanish, late 11th to early 12th centuries (photo: Colum Hourihane).

Fossa: Church,
Sta. Maria ad Cryptas
Nave
Date: 12th–13th cent.

Gülşehir: Church,
Karşı Kilise
Nave
Date: 1212

Hagia Thekla: Church
Transept
Date: 1380–1420

Ihlara: Church,
Yilanli Kilise
Decoration
Date: 10th–11th cent.

Irsina: Church,
S. Francesco
Crypt
Date: 14th cent.

Loreto Aprutino:
Church, Sta. Maria in
Piano
Decoration
Date: 14th–15th cent.

Mantua: Palazzo della
Ragione
Decoration
Date: 13th cent.

Mileševa: Monastery,
Church
Narthex, outer
Date: 2nd half 13th cent.

Naples: Church, Sta.
Maria di Donna Regina
Nave
Date: 1st half 14th
cent.

Payerne: Church, Abbey
Narthex
Date: 11th–13th cent.

Pomposa: Monastery,
Church
Nave
Date: 1351

Soğanlı: Church,
Canavar Kilise
Chapel 11
Date: 11th cent. or later

Soleto: Chapel,
S. Stefano
Nave
Date: 14th cent.

Vladimir: Cathedral,
Assumption
Aisle, west
Date: 1161; 1189; 1408

Vladimir: Church,
St. Dimitri
Narthex
Date: late 12th cent.

Wadi al-Natrun:
Monastery, Deir Anba
Antonius, St. Anthony
Khurus, west wall
Date: 1232–1233

Wadi al-Natrun:
Monastery, Deir
al-Surian, Church of
Virgin
Nave
Date: 900–999

ILLUMINATED
MANUSCRIPT

Admont: Library,
Stiftsbibl., lat. 73
Godfrey I of Admont,
Homiliae, fol. 1ʳ
Date: *c.* 1150

Florence: Library,
Bibl. Laurenziana,
Plut. XVI.21
Burchardus of Worms,
Collectio Canonum,
fols. 3ᵛ, 4ʳ
Date: 11th cent.

Klagenfurt: Museum,
Landes, VI.19 —*cont.*

Millstatt Misc., fol. 83ʳ
Date: late 12th–early
13th cent. (Fig. 182)

Milan: Library,
Bibl. Ambrosiana,
E.49–50 inf.
Gregory Nazianzen,
Homilies, p. 467
Date: 800–899

Munich: Library, Staats-
bibl., Slm. 13601, Clm. 54
Lectionary of Uta, fol. 5ᵛ
Date: 1002–1025

Oxford: Library, Bod-
leian, Canon. lit. 393
Psalter, fol. 239ʳ
Date: 13th cent.

Rome: Monastery,
S. Paolo fuori le Mura
Bible, fol. 50ᵛ
Date: *c.* 870

Rome: Library, Bibl.
Vaticana, Barb. gr. 372
Barberini Psalter, fol. 65ʳ
Date: 1050–1099

MISC.

Metz: Library, Bibl. Mu-
nicipale et Archives, 130
Drawing
Date: 11th cent.

MOSAIC

Florence: Baptistry
Dome
Date: 1250–1299

Otranto: Cathedral,
Sta. Maria Annunziata
Pavement
Date: 1156–1165

SCULPTURE

Arles: Church,
St.-Trophime
Exterior, frieze
Date: 1160–1180
(Fig. 183)

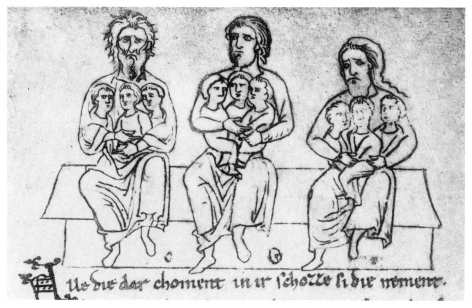

182. Abraham, Isaac, and Jacob representing Paradise. Pen drawing from the Millstatt Miscellany, now in Landesmuseum, Klagenfurt (Ms. VI.19, fol. 83r). Austrian, late 12th to early 13th centuries (photo: Index of Christian Art).

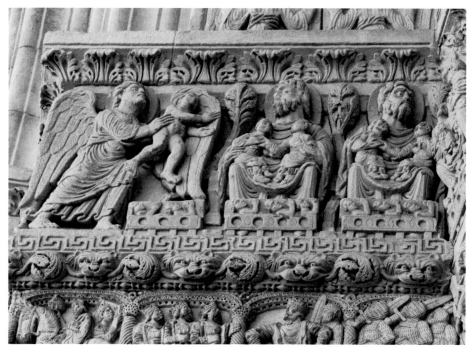

183. Abraham, Isaac, and Jacob seated among trees, holding souls in cloths on their laps. The dead rise from sarcophagi at their feet while angels are shown to the left. Frieze from the portal of the Church of St.-Trophime, Arles. French, c. 1160–1180 (photo: Colum Hourihane).

Gülşehir: Karşı Kilise:
Nave
Date: 1212

Pomposa: Monastery,
Church
Nave, west wall
Date: 1351

Soleto: Chapel,
S. Stefano, Nave
Date: 14th cent.

Treviso: Cathedral,
S. Pietro
Relief (wood)
Date: 14th cent.

Vladimir: Cathedral,
Assumption
Aisle, west
Date: 1161; 1189; 1408

Vladimir: Church,
St. Dimitri, Narthex
Date: late 12th cent.

LIST OF ABRAHAM SCENES
IN ISLAMIC ART

Compiled by

RACHEL MILSTEIN,
HEBREW UNIVERSITY OF JERUSALEM

*The following eight subject terms
are used here to classify representations of
Abraham in Islamic Art*

CATALOGUE OF
ABRAHAM SCENES IN
ISLAMIC ART

Portrait

MANUSCRIPT

Ankara: Museum,
Ethnographic, 8457
Silsilname
School of Ottoman
Baghdad
Date: *c.* 1600

Dublin: Library, Chester
Beatty, Turk. 423
Silsilname
School of Ottoman
Baghdad
Date: 1598 (H. 1006)

Istanbul: Museum,
Topkapi Saray, A. 3110
Silsilname, fol. 6ᵃ
School of Ottoman
Baghdad
Date: *c.* 1600

Istanbul: Museum,
Topkapi Saray, H. 1591
Silsilname, fol. 21ᵇ
School of Ottoman
Baghdad
Date: 1597 (H. 1006)

Istanbul: Museum,
Topkapi Saray, H. 1624
Silsilname, fol. 6ᵃ
School of Ottoman
Baghdad
Date: *c.* 1600–1610

Los Angeles: Museum,
County Museum of Art,
M. 85.237.38
Silsilname —cont.

School of Ottoman
Baghdad
Date: *c.* 1600

Abraham Destroys the Idols of the Sabians

MANUSCRIPT

Edinburgh: Library,
University, ORMS 161
Al-athar al-baqiya by
al-Biruni, fol. 88ᵇ
Tabriz (?)
Date: 1307

In the Fire of the Chaldeans

MANUSCRIPT

Berlin: Library,
Staatsbibl. zu Berlin,
Diez A, Fol. 3
Qisas al-anbiya' by
Nishapuri, fol. 32ᵇ
Date: 1577 (H. 984)

Berlin: Museum,
für Islamische Kunst,
Staatliche Museen zu
Berlin
Qisas al-anbiya' by
Nishapuri, fol. 42ᵇ
Date: *c.* 1570–1580

Cambridge (Mass.):
Museum, Harvard Univ.
Arthur M. Sackler,
1985.275 —cont.

Qisas al-anbiya' by
Nishapuri, fol. 33ᵃ
Date: *c.* 1570–1580

Dublin: Library, Chester
Beatty, Pers. 231
Qisas al-anbiya' by
Nishapuri, fol. 37ᵃ
Date: *c.* 1570–1580

Dublin: Library, Chester
Beatty, Turk. 414
Zubdat al-tawarikh by
Luqman, fol. 68ᵇ
Istanbul
Date: *c.* 1590

Edinburgh: Library,
University, ORMS 20
Jami' al-Tawarikh by
Rashid al-Din,
fol. 3ᵇ
Tabriz school
Date: 1314

Istanbul: Library,
Beyazit Devlet, 5275
Qisas al-anbiya' by
Dayduzami, fol. 75ᵇ
Date: *c.* 1570–1580

Istanbul: Library,
Süleymaniye, H.980
Qisas al-anbiya by
Nishapuri, fol. 23ᵇ
Date: *c.* 1570

Istanbul: Library,
Süleymaniye,
Damant Ibrahim 906
Rawdat al-Safa by
Mirkhwand,
fol. 37ᵇ
Date: 1528 (H. 934)

Istanbul: Library, Süley-
maniye, Fatih 4321
Hadiqat al-suʿada' by
Fuduli, fol. 18ᵃ
School of Ottoman
Baghdad
Date: 1593–1594
(H. 1002)

Istanbul: Museum,
Topkapi Saray, B.249
Qisas al-anbiya' by
Nishapuri, fol. 29ᵃ
Date: *c.* 1570–1580

Istanbul: Museum,
Topkapi Saray, B.282
Kulliyyat by Hafiz Abru,
fol. 30ᵃ
Herat
Date: *c.* 1430–1450

Istanbul: Museum,
Topkapi Saray, E.H. 1430
Qisas al-anbiya' by
Nishapuri, fol. 28ᵃ
Date: *c.* 1570–1580

Istanbul: Museum,
Topkapi Saray, H. 1226
Qisas al-anbiya' by
Nishapuri, fol. 33ᵇ
Date: *c.* 1570–1580

Istanbul: Museum,
Topkapi Saray, H. 1227
Qisas al-anbiya' by
Nishapuri, fol. 33ᵃ
Date : *c.* 1570–1580

Istanbul: Museum,
Topkapi Saray, H. 1228
Qisas al-anbiya' by
Nishapuri, fol. 22ᵇ
Date: *c.* 1570–1580

Istanbul: Museum,
Topkapi Saray, H. 1321
Zubdat al-tawarikh by
Luqman, fol. 26ᵇ
Ottoman, Istanbul
Date: 1586

Istanbul: Museum,
Topkapi Saray, H. 1653
Majmaʿ al-tawarikh by
Hafiz Abru, fol. 30ᵇ
Herat
Date: *c.* 1425

Istanbul: Museum,
Topkapi Saray, H. 1654
Jamiʿ al-tawarikh by
Rashid al-Din, fol. 5ᵇ
Herat
Date: 1317

Istanbul: Museum,
Topkapi Saray, H.1703
Kalender *Fal-name*,
fol. 10
Ottoman
Date: *c.* 1590

Istanbul: Museum, of
Turkish and Islamic
Arts, 1973
Zubdat al-tawarikh by
Luqman, fol. 26ᵇ
Ottoman
Date: 1583

Jerusalem: Library,
Jewish National Library,
Yah. Arab 1115
Hadiqat al-suʿada' by
Fuduli
Date: 18th cent.

Lisbon: Museum,
Calouste Gulbenkian,
L.A. 161
Anthology of Iskandar
Sultan, fols. 324ᵇ–325ᵃ
Herat
Date: 1410–1411

Location unknown:
(Sotheby's, 3 May 1977)
Qisas al-anbiya' by
Nishapuri, fol. 26ᵇ
Date: *c.* 1570–1580

Location unknown:
(formerly Paris: Soustiel
Collection) —*cont.*

Hadiqat al-suʿada' by
Fuduli, fol. 18ᵇ
School of Ottoman
Baghdad
Date: late 16th or early
17th cent.

London: Library, British,
Or. 12009
Hadiqat al-suʿada' by
Fufuli, fol. 15ᵇ
School of Ottoman
Baghdad
Date: *c.* 1600

London: Library, British,
Or. 7301
Hadiqat al-suʿada' by
Fuduli, fol. 15ᵇ
School of Ottoman
Baghdad
Date: *c.* 1590–1600

London: Library, British,
Add. 7763
Diwan by Hafiz, fol. 20ᵃ
Kashmir
Date: 18th cent.

Los Angeles: Collection,
Catherine and Ralph
Benkaim
Hadiqat al-suʿada' by
Fuduli
Date: 16th cent. or
later

Los Angeles: Museum,
County Museum of Art,
M.85.237.35
Hadiqat al-suʿada' by
Fuduli
School of Ottoman
Baghdad
Date: *c.* 1590–1600

New York: Library,
Columbia University,
Smith Collection,
x 892.8 Q1/Q
Qisas al-anbiya' by
Juwayri, fol. 28ᵃ
Date: 1574–1575 (H. 982)

New York: Library,
Public, Spencer Collection, Persian 1
Qisas al-anbiya' by
Nishapuri, fol. 23[b]
Date: 1577 (H. 984)

New York: Library,
Public, Spencer Collection, Persian 46
Qisas al-anbiya' by
Nishapuri, fol. 26[a]
Date: c. 1570–1580

Paris: Library, Bibl.
Nationale,
Or. Suppl. Pers. 160
Kulliyyat by Hafiz
Abru, fol. 49[a]
Date: unknown

Paris: Library, Bibl.
Nationale,
Or. Suppl. Pers. 1030
Hamle-ye haydari,
fol. 466[b]
Kashmir
Date: c. 1808

Paris: Library, Bibl.
Nationale,
Or. Suppl. Pers. 1313
Qisas al-anbiya by
Nishapuri, fol. 31[b]
Date: c. 1580

Paris: Library, Bibl.
Nationale,
Or. Suppl. Pers. 1567
Rawdat al-safa by Mirkhwand, fol. 40[a]
School of Ottoman
Baghdad
Date: c. 1600

Paris: Library, Bibl.
Nationale,
Or. Suppl. Turc. 242
Matal' al-sa'ada,
fol. 132[a]
Ottoman, Istanbul
Date: 1582

Paris: Library, Bibl.
Nationale,
Or. Suppl. Turc. 1088,
Hadiqat al-su'ada' by
Fuduli, fol. 17[a]
School of Ottoman
Baghdad
Date: c. 1590–1600

Sofia: Library, National,
Cyril and Methodius,
OP 130
Qisas al-anbiya' by
Juwayri, fol. 47[b]
Date: 1576 (H. 983)

Washington, D.C.:
Museum, Freer Gallery
of Art, 68.8
Ottoman
Date: 17th cent.

Washington, D.C.:
Museum, Freer Gallery
of Art, F 1957
Ta'rikhnama by Bal'ami,
fol. 24[b]
Al-Jazira (?)
Date: c. 1300–1330

Angels Announce the Birth of his Son

MANUSCRIPTS

Istanbul: Library, Beyazit
Devlet, 5275
Qisas al-anbiya' by
Dayduzami, fol. 88[b]
Date: c. 1570–1580

Sacrifice of Isaac

MANUSCRIPTS

Ankara: Museum,
Ethnographic, 8457
Silsilname or *Zubdat
al-tawarikh*, fol. 5[a]
Ottoman
Date: c. 1595–1605

Ankara: Museum,
Ethnographic, M-millat
Hadiqat al-su'ada' by
Fuduli
Date: 1599

Baltimore: Museum,
Walters Art, W. 676A
Majma' al-tawarikh by
Hafiz Abru
Date: c. 1425

Berlin: Library,
Staatsbibl. zu Berlin,
Diez A, Fol. 3
Qisas al-anbiya' by
Nishapuri, fol. 41[b]
Date: 1577 (H. 984)

Berlin: Museum,
für Islamische Kunst,
Staatliche Museen zu
Berlin
Qisas al-anbiya' by
Nishapuri, fol. 56[b]
Date: c. 1570–1580

Cambridge (Mass.):
Museum, Harvard
University, Arthur M.
Sackler, 1985.275
Qisas al-anbiya' by
Nishapuri, fol. 42[b]
Date: c. 1570–1580

Dresden: Library, Sächsischen Landsbibl., E 445
Fal-name, fol. 6[b]
Ottoman
Date: c. 1590

Dublin: Library, Chester
Beatty, Pers. 231
Qisas al-anbiya' by
Nishapuri, fol. 35[b]
Date: c. 1570–1580

Dublin: Library, Chester
Beatty, Turk. 414
Zubdat al-tawarikh by
Luqman, fol. 68[b]
Ottoman school, painter:
Sun'i
Date: 1583 (H. 991)

Istanbul: Library,
Beyazit Devlet, 5275
Qisas al-anbiya' by
Dayduzami, fol. 75ᵇ
Date: *c.* 1570–1580

Istanbul: Museum, of
Turkish and Islamic Art,
T. 1967
Hadiqat al-su'ada' by
Fuduli, fol. 19ᵇ
School of Ottoman
Baghdad
Date: *c.* 1595–1600

Istanbul: Museum,
Topkapi Saray, B.282
Kulliyyat by Hafiz Abru,
fol. 35ᵇ
Date: 1415–1416

Istanbul: Museum,
Topkapi Saray,
E.H. 1430
Qisas al-anbiya' by
Nishapuri, fol. 35ᵃ
Date: *c.* 1570–1580

Istanbul: Museum,
Topkapi Saray, H. 1225
Qisas al-anbiya' by
Nishapuri, fol. 42ᵇ
Date: *c.* 1570–1580

Istanbul: Museum,
Topkapi Saray, H. 1228
Qisas al-anbiya' by
Nishapuri, fol. 29ᵃ
Date: *c.* 1570–1580

Istanbul: Museum,
Topkapi Saray, H. 1321
Zuubdat al-tawarikh by
Luqman, fol. 26ᵇ
Ottoman, Istanbul
Date: 1586

Istanbul: Museum,
Topkapi Saray, H. 1653
Majma' al-tawarikh by
Hafiz Abru, fol. 277ᵇ
Herat
Date: *c.* 1430

Istanbul: Museum,
Topkapi Saray, H. 1703
Kalender *Fal-name*, fol. 11
Ottoman
Date: *c.* 1590

Istanbul: Museum,
Topkapi Saray, H. 2153
Album, fol. 119ᵃ
Date: *c.* 1430

Istanbul: Museum, of
Turkish and Islamic Art,
1973
Zubdat al-tawarikh by
Luqman, fol. 26ᵇ
Ottoman, Istanbul
Date: 1583

Konya: Museum,
Mevlana, 93
Hadiqat al-su'ada' by
Fuduli, fol. 16ᵇ
School of Ottoman
Baghdad(?)
Date: 1585 (H. 994)

Lisbon: Museum,
Calouste Gulbenkian,
L.A. 161
Anthology of Iskandar
Sultan, vol. 2, fol. 326ᵇ
Herat
Date: 1410–1411

Location unknown:
(Sotheby's, 3 May 1977)
Qisas al-anbiya' by
Nishapuri, fol. 35ᵇ
Date: *c.* 1570–1580

London: Library, British,
Add. 18576
Qisas al-anbiya' by
Nishapuri, fol. 33ᵇ
Date: *c.* 1570–1580

London: Library, British,
Or. 7301
Hadiqat al-su'ada' by
Fuduli, fol. 19ᵇ
School of Ottoman
Baghdad
Date: *c.* 1590–1600

London: Library, British,
Or. 12009
Hadiqat al-su'ada' by
Fuduli, fol. 19ᵇ
School of Ottoman
Baghdad
Date: *c.* 1600

London: Library, British,
India Office
1342
Yusuf-o Zuleikha
by Jami
Date: 1599

London: Collection,
Nour (Khalili)
Jami' al-tawarikh by
Rashid al-Din,
fol. 2087ᵃ
Tabriz
Date: 1307

New York: Library,
Columbia University,
Smith Collection,
X 892.8 Q1/Q
Qisas al-anbiya' by
Juwayri,
fol. 36ᵃ
Date: 1574–1575 (H. 982)

New York: Library,
Public, Spencer Collec-
tion, Persian 1
Qisas al-anbiya' by
Nishapuri, fol. 29ᵇ
Date: 1577 (H. 984)

New York: Library,
Public, Spencer Collec-
tion, Persian 46
Qisas al-anbiya' by
Nishapuri, fol. 32ᵇ
Date : *c.* 1570–1580

New York: Museum,
Brooklyn, 70.143
Hadiqat al-su'ada' by
Fuduli, fol. 20ᵃ
School of Ottoman
Baghdad
Date: 1602–1603 (H. 1011)

Paris: Library, Bibl.
Nationale, Or. Pers. 54
Qisas al-anbiya' by
Nishapuri, fol. 32ᵇ
Date: 1581 (H. 989)

Paris: Library, Bibl.
Nationale,
Or. Suppl. Pers. 160
Kulliyyat by Hafiz Abru,
fol. 55ᵃ
Date: *c.* 1430–1440

Paris: Library, Bibl.
Nationale,
Or. Suppl. Pers. 1313
Qisas al-anbiya' by
Nishapuri, fol. 40ᵃ
Date: *c.* 1580

Paris: Library, Bibl.
Nationale,
Or. Suppl. Turc. 242
Matali' al-s'ada,
fol. 132ᵇ
Ottoman, Istanbul
Date: 1582

Paris: Library, Bibl.
Nationale,
Or. Suppl. Turc. 1088
Hadiqat al-su'ada' by
Fuduli, fol. 20ᵇ
School of Ottoman
Baghdad
Date: *c.* 1590–1600

Philadelphia: Library,
Free, 32 P 88
Style of Tabriz
Date: *c.* 1530–1560

PAINTING

Berlin: Museum,
für Islamische Kunst,
Staatliche Museen zu
Berlin
Das Aleppo-Zimmer
Oil on wood
Aleppo
Date: 1600–1603

Jerusalem: Museum,
Israel, Dawud Collection,
91.80.349
Oil on wood
Iran, Qajar style
Date: 19th cent.

New York: Collection,
Elghanayan
Watercolor on cardboard
Isfahan style
Date: 18th–19th cent.

WOOD ENGRAVING

Washington, D.C.:
Museum, Dumbarton
Oaks, 41.4
Mamluk
Date: 14th cent.

Building the Ka'ba in Mecca

MANUSCRIPT

Ankara: Museum,
Ethnographic, 8457
Silsilname or *Zubdat
al-tawarikh*, fol. 5ᵃ
Ottoman
Date: *c.* 1595–1605

Berlin: Library,
Staatsbibl. zu Berlin,
Diez A, Fol. 3
Qisas al-anbiya' by
Nishapuri, fol. 46ᵃ
Date: 1577 (H. 984)

Dublin: Library, Chester
Beatty, Pers. 231
Qisas al-anbiya' by
Nishapuri, fol. 53ᵇ
Date: *c.* 1570–1580

Istanbul: Museum,
Topkapi Saray, H. 1226
Qisas al-anbiya' by
Nishapuri, fol. 47ᵃ
Date: *c.* 1570–1580

New York: Library,
Public, Spencer Collec-
tion, Persian 1
Qisas al-anbiya' by
Nishapuri, fol. 33ᵇ
Date: 1577 (H. 984)

Abraham & the Birds

MANUSCRIPT

Baltimore: Museum,
Walters, W. 593
'Aja'ib al-makhluqat by
al-Tusi, fol. 3ᵇ
Date: *c.* 1560–1580

Istanbul: Museum,
Topkapi Saray, H. 404
'Aja'ib al-makhluqat by
al-Tusi, fol. 5ᵇ
Date: *c.* 1570–1580

Istanbul: Museum,
Turkish and Islamic Art,
T. 2013
'Aja'ib al-makhluqat by
al-Tusi, fol. 4ᵇ
Date: 1562–1563

Paris: Library, Bibl.
Nationale,
Or. Suppl. Pers. 332
'Aja'ib al-makhluqat by
al-Tusi, fol. 3ᵃ
Date: 1388

Abraham with the Fire-worshiper

MANUSCRIPT

Istanbul: Museum,
Topkapi Saray,
H. 1483
Haft awrang by Jami,
fol. 19ᵃ
Date: 1571–1572

LIST OF ABRAHAM SCENES IN THE BEZALEL NARKISS INDEX OF JEWISH ART

Compiled by

ARIELLA AMAR AND MICHAL STERNTHAL,
THE CENTER FOR JEWISH ART,
HEBREW UNIVERSITY OF JERUSALEM

The following subject terms are used to classify representations of Abraham in the Bezalel Narkiss Index of Jewish Art. They are followed, where applicable, by the pertinent textual references. The subjects follow the narrative in Genesis, interlaced with Midrashic interpretations.

CATALOGUE OF
ABRAHAM SCENES IN THE BEZALEL
NARKISS INDEX OF JEWISH ART

Abraham as an Infant

(*Pirkei de-Rabbi Eliezer*, chapter 26)

MANUSCRIPT

Budapest: Library of the Hungarian Academy of Sciences, Kaufmann Collection, A 387
Heilbronn *Mahzor*, fol. 157v
Germany, Heilbronn (?)
Date: 1370–1400

Liturgical hymn: "*You whose powerful deeds no one can equal*" (Davidson, *Thesaurus*, I, p. 376, no. 8307; based on Deuteronomy 3:24) recited in the Morning Prayer of the second day of New Year.

Abraham before Nimrod &
Abraham Saved from the Fiery Furnace

(Genesis *Rabbah* [Theodor-Albeck], 38:28; T.B., *Pesahim* 118a;
Pirkei de-Rabbi Eliezer, chapter 26)

MANUSCRIPTS

Ashkenaz—Northern France &
Germany

Leipzig: Universitätsbibl.,
V.1102/II
Leipzig *Mahzor*, fol. 164v
Germany, south
Date: *c.* 1320
Liturgical hymn: "*Eitan (i.e., stead-fast—Abraham) who perceived Thy faith*" (Davidson, *Thesaurus*, I, p. 150, no. 3204) recited during Afternoon Prayer in the Day of Atonement.

London: David Sofer Collection, (formerly Jerusalem, Schocken Library, 24087)
Second Nürnburg *Haggadah*, fol. 30v
Germany, south
Date: 1450–1500
Haggadah: Hallel (Psalm 115).

Jerusalem: Israel Museum,
180/50
Yahudah *Haggadah*, fol. 29v
Germany, south
Date: 1450–1500
Haggadah: Hallel (Psalm 115).

Spain

London: British Library,
Add. 14761
Barcelona *Haggadah*, fol. 36v
Spain, Barcelona (?)
Date: mid 14th cent.
Haggadah: "*In the beginning our Fathers were worshipers of idols (strange gods)*" (based on Joshua 24:2; T.B., *Pesahim* 116a).

London: British Library, Add. 27210
Golden *Haggadah*, fol. 3
Spain, Barcelona —*cont.*

Date: *c.* 1320
Biblical narrative cycle.

London: British Library,
Or. 2884
Sister *Haggadah*, fol. 3
Spain, Barcelona
Date: mid 14th cent.
Biblical narrative cycle.

Italy

Darmstadt: Hessische Landes- und
Hochschulbibl., Or. 28
Second Darmstadt *Haggadah*, fol. 4ᵛ
Italy, north
Date: 1480–1500
Haggadah: "*In the beginning our Fathers
were worshipers of idols (strange gods)*"
(based on Joshua 24:2; T.B., *Pesahim*
116a).

Zurich: Floersheim Collection
Floersheim *Haggadah*, p. 7
Italy, north
Date: 1502 —*cont.*

Haggadah: "*In the beginning our Fathers
were worshipers of idols (strange gods)*"
(based on Joshua 24:2; T.B., *Pesahim*
116a).

Greece

Chantilly: Musée Condé, 732
Chantilly *Haggadah*, fol. 11
Greece, Crete
Date: 1550–1580
Haggadah: "*In the beginning our fathers
were worshipers of idols (strange gods)*"
(based on Joshua 24:2; T.B., *Pesahim*
116a).

Paris: Bibl. Nationale,
héb. 1388
Greek *Haggadah*, fol. 7ᵛ
Greece, Crete
Date: 1583
Haggadah: "*In the beginning our fathers
were worshipers of idols (strange gods)*"
(based on Joshua 24:2; T.B., *Pesahim*
116a).

The Promise to Abraham

(Genesis 12:1–3)

MANUSCRIPTS

Greece

Chantilly: Musée Condé, 732
Chantilly *Haggadah*, fol. 11ᵛ
Greece, Crete
Date: 1550–1580
Haggadah: "*Blessed be He who observes
His promise to Israel: blessed be He!*"

Paris: Bibl. Nationale,
héb. 1388
Greek *Haggadah*, fol. 7ᵛ
Greece, Crete
Date: 1583
Haggadah: "*Blessed be He who observes His
promise to Israel: blessed be He!*"

Abraham's
Departure from Ur of Chaldees or
from Haran

(Genesis 11:31 or 12:4)

MANUSCRIPTS

Ashkenaz—Northern France & Germany

Munich: Bayerische Staatsbibl.,
heb. 5/1
Würzburg Biblical Commentaries,
fol. 9ᵛ (formerly Rashi's of Würzburg)
Germany, Würzburg
Date: 1232/3
Opening of the Pericope "*Lekh-Lekha
(Get thee out)*"(Genesis 12).

Rome: Bibl. Vaticana,
ebr. 14
Liturgical Pentateuch, fol. 12
France
Date: 1239
"*So Abram departed ...*"
(Genesis 12:4).

Greece

Chantilly: Musée Condé, 732
Chantilly *Haggadah*, fol. 11
Greece, Crete
Date: 1550–1580
*Haggadah: "Then I took your father
Abraham from beyond the river and led him
throughout all the Land of Canaan ..."*
(Joshua 24:3).

Paris: Bibl. Nationale,
héb. 1388
Greek *Haggadah*, fol. 7ᵛ
Greece, Crete
Date: 1583
*Haggadah: "Then I took your father
Abraham from beyond the river and led him
throughout all the Land of Canaan ..."*
(Joshua 24:3).

Abraham Crossing the River

(Joshua 24:2–3)

MANUSCRIPTS

Greece

Chantilly: Musée Condé,
732
Chantilly *Haggadah*, fol. 11
Greece, Crete
Date: 1550–1580
*Haggadah: "Then I took your father
Abraham from beyond the river and led him
throughout all the Land of Canaan ..."*
(Joshua 24:3).

Paris: Bibl. Nationale,
héb. 1388
Greek *Haggadah*, fol. 7ᵛ
Greece, Crete
Date: 1583
*Haggadah: "Then I took your father
Abraham from beyond the river and led him
throughout all the Land of Canaan ..."*
(Joshua 24:3).

The Strife between
Abraham's and Lot's Shepherds

•-•

(Genesis 13:6–12)

MANUSCRIPT

Cambridge: University Library,
Add. 468
Cambridge Illustrated Small Bible,
fol. 8ᵛ
Franco-Spanish
Date: Last quarter of 15th cent.
Genesis 13:6–12.

Abraham: Covenant between
the Portions

•-•

(Genesis 15:9–21)

MANUSCRIPTS

Ashkenaz—Northern France &
Germany

Hamburg: Staats- und Universitäts-
bibl., heb. 37
Hamburg Miscellany,
fol. 26
Germany, Mainz
Date: 1420s–1438
Haggadah: "Blessed be He who observes His
promise to Israel: blessed be He … He had
said to Abraham our father in the Pact be-
tween the Portions" (referring to Genesis
15:12).

Oxford: Bodleian Library, Opp. 14
Liturgical Pentateuch, fol. 14ᵛ
France, south (Dauphiné)
Date: 1340
Commentary to Genesis 15.

Spain

Cambridge: University Library,
Add. 468
Cambridge Illustrated Small Bible,
fol. 9ᵛ
Franco-Spanish —*cont.*

Date: last quarter of 15th cent.
Genesis 15:9–21.

Italy

Darmstadt: Hessische Landes- und
Hochschulbibl.,
Or. 28
Second Darmstadt *Haggadah*,
fol. 5
Italy, north
Date: 1480–1500
Haggadah: "Blessed be He who observes
His promise to Israel: blessed be He …
He had said to Abraham our father in the
Pact between the Portions" (referring to
Genesis 15:12).

Zurich: Floersheim Collection,
Floersheim *Haggadah*,
p. 8
Italy, north
Date: 1502
Haggadah: "Blessed be He who observes
His promise to Israel: blessed be He …
He had said to Abraham our father in the
Pact between the Portions" (referring to
Genesis 15:12).

Abraham as an Old Man

(Genesis 17:1)

MANUSCRIPT

Oxford: Bodleian Library, Opp. 14
Liturgical Pentateuch, fol. 16
France, north (Dauphiné)

Date: 1340
Rashi's commentary on
Genesis 17:1.

Abraham's Hospitality and the Promised Seed to Abraham and Sarah

(Genesis 18:1–8 and 18:13–15)

MOSAIC FLOOR

Galilee: Sepphoris Synagogue
Mosaic floor (reconstruction)
Date: 5th cent.
Eastern panel of the main nave, entrance.

MANUSCRIPTS

Ashkenaz—Northern France & Germany

Budapest: Library of the Hungarian
Academy of Sciences, Kaufmann
Collection, A 387
Heilbronn *Mahzor*, fol. 417ᵛ
Germany, Heilbronn (?)
Date: 1370–1400
Liturgical Hymn: "*The Father (Abraham) who had perceived your faith, since he was a youth ... protect us, you who sit in the heat of the day*" (Davidson, *Thesaurus*, I, p. 4, no. 47; alluding to Genesis 18:1), recited in the Closure (*Ne'ilah*) Prayer on the Day of Atonement.

London: British Library, Add. 11639
London Miscellany, fols. 118, 118ᵛ
France, north
Date: *c.* 1280
Biblical narrative cycle.

Munich: Bayerische Staatsbibl.,
heb. 5/1
Würzburg Biblical Commentaries,
fol.13ᵛ (formerly Rashi of Würzburg)

Germany, Würzburg
Date: 1232/3
Opening of the Pericope "*Vayare (And the Lord appeared unto him)*" (Genesis 18).

Oxford: Bodleian Library,
Laud Or. 321
Laud *Mahzor*, fol. 278
Germany, south
Date: *c.* 1290
Liturgical hymn: "*Eitan (i.e., steadfast—Abraham) who perceived Thy faith*" (Davidson, *Thesaurus*, I, p. 150, no. 3204), recited during Afternoon Prayer in the Day of Atonement.

Rome: Bibl. Vaticana, ebr. 14
Liturgical Pentateuch, fol. 17
Ashkenaz, France (?)
Date: 1239
Genesis 18:1–8.

Spain

London: British Library, Add. 27210
Golden *Haggadah*, fol. 3
Spain, Barcelona
—cont.

Date: *c.* 1320
Biblical narrative cycle.

London: British Library, Or. 2884
Sister *Haggadah*, fol. 3ᵛ
Spain, Barcelona
Date: mid 14th cent.
Biblical narrative cycle.

Italy

Jerusalem: Israel Museum,
180/51
Rothschild Miscellany, fol. 165
Italy, Ferrara (?)
Date: *c.* 1470
Haggadah: liturgical hymn: "*The bravery
of Your strength (miracles and wonders),
You amazingly revealed upon us on Pass-
over*" (Davidson, *Thesaurus*, I, p. 87, no.
1871).

Zurich: Floersheim Collection,
Floersheim *Haggadah*, p. 31
Italy, north
Date: 1502
Haggadah: liturgical hymn: "*The bravery
of Your strength (miracles and wonders),
You amazingly revealed upon us on Pass-
over*" (Davidson, *Thesaurus*, I, p. 87, no.
1871).

Greece

Chantilly: Musée Condé, 732
Chantilly *Haggadah*,
fol. 25ᵛ
Greece, Crete
Date: 1550–1580
Haggadah: Grace over meal: "*And Abra-
ham hastened into the tent unto Sarah, and
said, 'Make ready quickly three measures of
fine meal, knead it, and make cakes upon the
hearth'*" (Genesis 18:6).

*Abraham Arguing with
God before the Destruction of Sodom*

•-•--•-•--•-•--•-•--•-•--•-•--•-•--•-•--•-•--•-•--•-•--•-•--•-•-•

(Genesis 18:23–19:1)

MANUSCRIPT

Oxford: Bodleian Library, Opp. 14
Liturgical Pentateuch, fol. 18
France, north (Dauphiné)

Date: 1340
Rashi's commentary on Genesis
18:23–19:1.

Abraham Circumcising Isaac

•-•--•-•--•-•--•-•--•-•--•-•--•-•--•-•--•-•--•-•--•-•--•-•--•-•-•

(Genesis 21:4)

MANUSCRIPTS

*Ashkenaz—Northern France &
Germany*

Jerusalem: Israel Museum, 180/52
Regensburg Liturgical Pentateuch,
fol. 18ᵛ
Germany, Bavaria, Regensburg (?)

Date: *c.* 1300
Full page between the end of the Peri-
cope "*Vayare* (*And the Lord appeared unto
him*)" (Genesis 22) and the following
Pericope "*Hayei Sarah* (*the life of Sarah*)"
(Genesis 23).

Oxford: Bodleian Library,
Laud Or. 321
Laud *Mahzor*, fol. 303
Germany, south
Date: *c.* 1290
Liturgical hymn: "*The Father (Abra-*

*ham) who had perceived your faith, since he
was a youth ... protect us, you who sit in
the heat of the day*" (Davidson, *Thesaurus*, I, p. 4, no. 47; alluding to Genesis 18:1); recited in the Closure (*Ne'ilah*) Prayer on the Day of Atonement.

Sacrifice of Isaac

(Genesis 22:1–18)

WALL PAINTING

Damascus: National Museum of Syria,
Dura-Europos Synagogue
Date: 244/245
Western wall, panel above the Torah
Ark's niche.

SMALL ITEM

Jerusalem: Bible Lands Museum,
Private Collection
Amulet
Middle East (?)
Date: 5th cent.

MOSAIC FLOOR

Beit Shean Valley: Beit Alpha
Synagogue
Date: 518–527 (Justin I) or 567–578
(Justin II).

Gallile: Sepphoris Synagogue
(reconstruction)
Date: 5th cent.
East, main nave, second panel.

MANUSCRIPTS

Ashkenaz—Northern France & Germany

Budapest: Library of the Hungarian
Academy of Sciences,
Kaufmann Collection, A77/III
Kaufmann *Mishneh Torah*, fol. 81
France, northeast
Date: 1296
Opening to Book X: Book of Purity
Laws.

Budapest: Library of the Hungarian
Academy of Sciences,
Kaufmann Collection, A 387
Heilbronn *Mahzor*, fols. 315v, 403v
Germany, Heilbronn (?)
Date: 1370–1400
Musaf Prayer of the Closure (*Ne'ilah*)
Prayer for the Day of Atonement.

Darmstadt: Hessische Landes- und
Hochschulbibl., Or. 13
Darmstadt *Mahzor*, fol. 202v
Germany, Hammelburg
Date: 1348
Full page illustrating the *Musaf* Prayer
for the second day of New Year.

Hamburg: Staats- und Universitäts-
bibl., heb. 37
Hamburg Miscellany, fol. 1
Germany, Mainz
Date: 1420s–1438
Musaf Prayer for New Year and the
Day of Atonement.

Hamburg: Staats- und Universitäts-
bibl., Levy 19
Levy Liturgical Pentateuch,
fol. 34v —*cont.*

Belgium, Brussels
Date: 1309
Genesis 22.

Jerusalem: Israel Museum, 180/50
Yahudah *Haggadah*, fols. 30, 30ᵛ
Germany, south
Date: 1450–1500
Haggadah: Hallel (Psalm 115).

Jerusalem: Israel Museum,
180/52
Regensburg Liturgical Pentateuch,
fol. 18ᵛ
Germany, Bavaria, Regensburg (?)
Date: *c.* 1300
Full-page illustration between the end
of the Pericope *"Vayare (And the Lord
appeared unto him)"* (Genesis 22) and
following Pericope *"Hayei Sarah (the life
of Sarah)"* (Genesis 23).

Jerusalem: Israel Museum,
180/57
Birds Head *Haggadah*, fol. 15ᵛ
Germany, Upper Rhine
Date: *c.* 1300
Haggadah: *"And when we cried unto the
Lord God of our fathers"* (Deuteronomy
26:7)… *"And God heard our voice: As it
is written: 'And God heard their groaning,
and God remembered His covenant with
Abraham, with Isaac, and with Jacob'"*
(Exodus 2:24).

Jerusalem: Schocken Library,
14840 (now in an unknown private
collection)
Schocken Bible, fol. 1ᵛ
Germany, south
Date: *c.* 1300
Opening to the book of Genesis,
among forty-six medallions with bibli-
cal episodes.

Leipzig: Universitätsbibl.,
V. 1102/11
Leipzig *Mahzor*, fols. 26ᵛ, 66
Germany, south
Date: *c.* 1320
Initial word of the liturgical hymn

"O king, girt with Power," recited in the
Morning Prayer for the first day of
New Year (Davidson, *Thesaurus*, III, p.
139, no. 1529); liturgical hymn *"I shall
praise my Lord"* recited in *Musaf* for the
second day service of New Year (Da-
vidson, *Thesaurus*, I, p. 69, no. 1494).

London: British Library,
Add. 11639
London Miscellany, fol. 521ᵛ
France, north
Date: *c.* 1280
Biblical narrative cycle.

London: British Library,
Add. 15282
Duke of Sussex Liturgical Pentateuch,
fol. 28
Germany, south, Lake Constance
Date: *c.* 1300
Genesis 22:1–18.

London: David Sofer Collection
(formerly Jerusalem, Schocken Library,
24087)
Second Nürnburg *Haggadah*,
fols. 31, 31ᵛ
Germany, south
Date: 1450–1500
Haggadah: Hallel (Psalm 116).

Milan: Bibl. Ambrosiana,
B. 30 INF
Ambrosian Bible, fol. 102
Germany, Ulm (?)
Date: 1236–1238
Opening to the book of Leviticus.

Munich: Bayerische Staatsbibl.,
heb. 5/1
Würzburg Biblical Commentaries (for-
merly Rashi's of Würzburg), fol. 18ᵛ
Germany, Würzburg
Date: 1232/3
Opening of the Pericope *"Hayei Sarah
(the life of Sarah)"* (Genesis 23).

New York: Jewish Theological Semi-
nary, 8972
Tiny *Ashkenazi Mahzor*, fol. 121 —*cont.*

Germany, Franconia
Date: *c.* 1300
Liturgical hymn for *Shavou'ot* (Pentecost): "*Isaac said to his father Abraham 'how beautiful is the altar which you have built for me'*" (Davidson, *Thesaurus*, I, p. 265, no. 5812; illustrating the fifth commandment: Exodus 20:11).

Oxford: Bodleian Library,
Laud Or. 321
Laud *Mahzor*, fol. 184
Germany, south
Date: *c.* 1290
Liturgical hymn "*O king, Your word is truthful*," recited in the second day of the New Year service (Davidson, *Thesaurus*, III, p. 140, no. 1543).

Oxford: Bodleian Library,
Mich. 619
Tripartite *Mahzor*, fol. 5ᵛ
Germany, south, Lake Constance
Date: *c.* 1322
Liturgical hymn: "*O king, girt with Power*," recited in the Morning Prayer for the first day of New Year (Davidson, *Thesaurus*, III, p. 139, no. 1529).

Oxford: Bodleian Library,
Opp. 14
Liturgical Pentateuch,
fols. 22ᵛ, 120
France, south (Dauphiné)
Date: 1340
Genesis 22:9–13; Leviticus 1.

Oxford: Bodleian Library,
Reggio 1
Reggio *Mahzor*, fol. 159ᵛ
Germany, south
Date: 14th cent.
Initial word of the liturgical hymn: "*O king, girt with Power*," recited in the Morning service for the first day of New Year (Davidson, *Thesaurus*, III, p. 139, no. 1529).

Paris: Bibl. Nationale,
héb. 36 —*cont.*

Poligny Liturgical Pentateuch,
fol. 283ᵛ
France, Poligny
Date: 1300
Preceding the "Song of Songs."

Parma: Bibl. Palatina, 3518
Siddur, fol. 25ᵛ
France
Date: *c.* 1305
Amidah Prayer for New Year.

Wrocław: State and University Library, Or. 1.1
Wrocław *Mahzor* (formerly "The Double *Mahzor*"), fol. 46ᵛ
Germany, Lower Rhine
Date: *c.* 1300
Prayers for the *Amidah* in the morning of the second day of the New Year service: "*account to His people the Sacrifice of Isaac, according to Your oath, and reserve [Your decree] from stern judgment to mercy.*"

Spain

Copenhagen: Det Kongelige Bibl., heb. 37
Copenhagen *Moreh Nevukhin* (*Guide to the Perplexed*), fol. 194ᵛ
Spain, Barcelona
Date: 1348
Illustrating Part II, chapter 45—a text relating to the revelations of God, among them the angel in the sacrifice of Isaac.

London: British Library,
Add. 27210
Golden *Haggadah*, fol. 4ᵛ
Spain, Barcelona
Date: *c.* 1320
Biblical narrative cycle.

London: British Library,
Or. 2737
Hispano Moresque *Haggadah*, fols. 92, 92ᵛ, 93, 93ᵛ
Spain, Barcelona —*cont.*

Date: *c.* 1300
Biblical narrative cycle.

Sarajevo: National Museum,
Sarajevo *Haggadah,*
fols. 7ᵛ, 8
Spain, Barcelona
Date: mid 14th cent.
Biblical narrative cycle.

Italy

Darmstadt: Hessische Landes- und
Hochschulbibl., Or. 28
Second Darmstadt *Haggadah,* fol. 5
Italy, north
Date: 1480–1500
*Haggadah: "May the Lord, who keeps His
promise to Abraham, be blessed."*

Abraham Buying the Cave of Machpelah

(Genesis 23:3–18)

MANUSCRIPT

Oxford: Bodleian Library, Opp. 14
Liturgical Pentateuch, fol. 23ᵛ
France, south (Dauphiné)
Date: 1340
Commentary illustrating Genesis 23:9.

God Reiterating His Covenant with Abraham, Isaac, and Jacob

(Exodus 6:2–5 and its commentary)

MANUSCRIPT

Ashkenaz—Northern France & Germany

Munich: Bayerische Staatsbibl.,
heb. 5/1
Würzburg Biblical Commentaries,
fol. 47ᵛ (formerly Rashi's of Würzburg)

Germany, Würzburg
Date: 1232/3
Pericope "*Vaera (And God spake)*"
(Exodus 6:2–9:35).

Abraham as One of the Patriarchs

MANUSCRIPT

Jerusalem: Israel Museum, 180/57
Birds Head *Haggadah,* fol. 33
Germany, Upper Rhine
Date: *c.* 1300
Haggadah: Hallel (Psalm 118).

INDEX

INDEX OF
CATALOGUED OBJECTS

(Italic numbers indicate text illustrations)

PRINTED BY
PURITAN CAPITAL
HOLLIS, NEW HAMPSHIRE

BOUND BY
ACME BOOKBINDING
CHARLESTOWN, MASSACHUSETTS

DESIGNED AND COMPOSED BY
MARK ARGETSINGER
ROCHESTER, NEW YORK